Learn

DISCOVER AFRICAN, ARABIC, CHINESE, ETHIOPIC, GREEK, HEBREW, INDIAN,

WORLD

JAPANESE, KOREAN, MONGOLIAN, RUSSIAN, THAI, TIBETAN CALLIGRAPHY, AND BEYOND

Calligraphy

MARGARET SHEPHERD

Published in the United States
by Watson-Guptill Publications,
an imprint of the Crown Publishing Group,
a division of Random House, Inc., New York.
www.crownpublishing.com
www.watsonguptill.com

WATSON-GUPTILL is a registered trademark
and the WG and Horse designs are trademarks
of Random House, Inc.

Working with a large brush,
the Korean calligrapher on the
following page adds a vertical
signature to his work.

Left, Tibetan prayer flags spell
out "Om mani padme hum," a
mantra repeated by Buddhists.

Below, in a *calligram* from the
9ᵗʰ century *Masoretic Bible,*
Hebrew letters outline a little
creature riding a donkey.

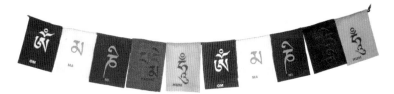

Cover design, Jess Morphew. Details, Vasil Chebanik and
Margaret Shepherd.

Library of Congress Cataloging-in-Publication Data
Shepherd, Margaret.
 Learn world calligraphy : discover african, arabic, chinese, ethiopic, greek,
hebrew, indian, japanese, korean, mongolian, russian, thai, tibetan calligraphy,
and beyond / Margaret Shepherd. -- 1ˢᵗ ed.
 p. cm.
 Includes index.
 ISBN 978~0~8230~3346~1
 1. Calligraphy--Technique. I. Title.
 NK3600.S534 2011
 745.6'19--dc22

 2010035341

Printed in China

Designed and handlettered by Margaret Shepherd.

10 9 8 7 6 5 4 3 2 1

First Edition

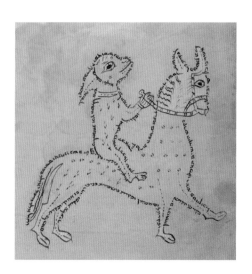

CONTENTS

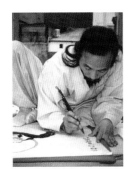

4

THANKS

Dozens of people—not just my own friends and relatives but their friends and relatives, too—gave generously of their time and expertise to help me write and correct this book.

Kwezi Arthur
Adrienne Ingrum
Annie Zeybekoglu
Lois Russell
Saki Mafundikwa
Calestous Juma
Marion Kilson
Chaz Maviyane-Davies
Carolyn Newberger
Imam Razokov Gafurjon
Barbara Whitesides
Sheila Sondik
Rick Doubleday
Smith College students of
 Abdelkader Berrahmoun
Anita Lincoln
Kitty Clark
Patricia Watts
Emily Neumeier
Grethe Shepherd
Marilyn Brandt
Paula Cronin
Christy and Hali Tsang
Gail Bernstein
Lisbeth Shepherd
Erica Wessmann
Wei Yang
Nancy Boulton-LeGates
Anna Davol
Sharon Hogan
Felix Doolittle
Sallie Gouverneur
David Thomas
Haile Getachew
Nesanet Alemayhu
Fetelulork Alemayhu
Bettie Abebe
Andrew Staad
Joy, Stahis, and Dafnis
 Panagides
Robert Fitzwilliam
Pam Steel
Jay Boggis

Marina Hatsopoulous
Daphne Hatsopoulous
Hannah Sarvasy
Peter Banos
Elliot Rothman
Abby Rosenfeld
Cynthia Bell
Amelie Bell-Kamen
Liz and Ethan Offen
Rev. Stephen Kendrick
Jonathan Kremer
Indira Peterson
Aye Moh
Swami Kumaresan
Ruby Seung He
Theodore Kim
Christopher Atwood
Nancy Atwood
Purevjav Jambalragchaa
Elena Napier
Clark Abt
Francis Randall
Crystal Woodward
Galina and Viktor Khatutsky
Theodora Shepherd
Ron Sampson
Sherman Lewis IV
Alison Lewis
Gordon Shepherd
John Wawrzonek
Steve Dunwell
Deborah Paddock
Cathleen Schaad
Stephanie Luke
Lisa Abitbol
Katya Popova
Leslie Miller
Candace Raney
Autumn Kindelspire
Jessica Morphew
Alyn Evans
Alison Hagge
Colleen Mohyde

Above, Greeks say efharisto, "thank you," for an answered prayer by tying a silver tag on their saint's icon.

In addition, many calligraphers, photographers, and other artists contributed their work; they have my deepest gratitude.

Enya Keshet
Richard Widhu
Konrad Tuchscherer
Andrew van der Merwe
Jocelyne Santos
Lalla Essaydi
Hamed Saber
Valerie Elliott
Monica Dengo
Chun Liu
Anne Garland
Shinichi Maruyama
Linda Liu
Thích Nhất Hanh
Xu Bing
Lê Quốc Việt
Sandy Diamond
Haji Noor Deen
Y.T. Feng and Ti Fen Wang
Diedrik Nelson
Peter Williams
Carl Rohrs
Kan Kozaki
Jan Owen

Hambis Tsangaris
Marc Michaels
Robert Indiana
Minh Đức Triêù Tâm Ánh
Betsy Teutsch
Kensaku and Michiko Mori
Sivia Katz
Muhammad Akbar Daftari
Rabbi Lawrence Kushner
Stewart Thomas
Ed Scher
Kyle McCreight-Carroll
Claudia Wang
Krista Basis
Tashi Mannox
Gary Westergren
Jeanée Redmond
Yoo Sung Lee
Myoung-Won Kwon
Ju-hyung Jo
Zolbayar Sukhbaatar
Delger
Leonid Pronenko
Dmitry Babenko
Ivan Gulkov
David Oei/Carol Hesselink
Jean-François Bodart
Tatiana and Yuri Zieman
Tom Costello
Alexander Mikaberidze
Ron Esplin and Julie Woods
Rick Cusick
Sallie Porfido
Michael Schwartz
Carl Hostetter
Patrick Wynne
Mehdi Saeedi
SPECIAL THANKS
David Friend
Lily, Zoë, Zack, Jasper

Turn to page 192 for a list of all artists and sources.

AUTHOR'S NOTE

This practical guide to calligraphy helps you understand how to write every script in the world. I do not try to explain how each language sounds—a different, much longer book—but how it looks when an artist writes it. You will get to know each kind of calligraphy by looking carefully at its shape, studying its masterpieces, grasping its structure, and learning its basic techniques.

Once your fingers have written a foreign script, your eyes own it. It becomes part of your world. Learning to write letters you don't read, however, is only the first step. That souvenir you picked up can be a tool that applies your new script's techniques and tools to the familiar Roman alphabet.

Simple brush strokes change pen words to **O**pen worlds.

Many of the world's scripts have survived by rejecting outside influences; Roman letters thrive by embracing them. The Roman alphabet makes friends easily; when it meets a new script, it has always liked to get married and give birth to vigorous hybrid offspring. Whenever you copy a Roman hybrid or create your own, you carry on a tradition that started thousands of years ago. Those second-generation "virtual" alphabets make this book more than just a package tour marching you through the written world. It encourages you to spend time in exotic places without stumbling over language barriers, absorb what you see, and bring home new ways to write.

This book has something to offer everyone, whether you want scholarly insight, artistic inspiration, classroom projects, or a theme for your next party. You don't have to be a calligrapher to enjoy it; with or without a pen in your hand you can learn something useful right away. You will realize that your everyday life surrounds you with beautiful, exotic scripts. If you plan a trip somewhere outside the sphere of the Roman alphabet—or have just got back from one—knowing even a little about its writing will add a whole new dimension to your visit.

At the very least, you will find fascinating insights about the lives of those who grapple with pen and ink, and love it; you may even want to join them in the world that beckons you beyond the ABC's.

Margaret Shepherd

Visual VOCABULARY

To help beginners learn the underlying principles, general categories, and basic techniques common to all calligraphy, some of these definitions are necessarily simplistic; they can be added to as you go along

ALPHABET A set of characters that spell the sounds of speech.
SYLLABARY A set of characters for the sounds of syllables. May be made from *alphabet* letters by combining a vowel with a consonant.
IDEOGRAPH A symbol that portrays the meaning or appearance of a word, not its sound.

GRID Boxes that contain separate letters, syllables, or characters. May include diagonal lines.
GUIDELINES Parallel lines that guide horizontal or vertical rows of writing.

JOINS How strokes connect.
Touch Meet Overlap Cross

LETTER FAMILY
A group of letters that share similar strokes or proportions.

LETTER HEIGHT A size customarily measured with the pen's width.
LETTER SLANT The degree a letter leans from vertical.

LINE CONTRAST The ratio between the thinnest and thickest parts of a stroke.

LINE ENDINGS
Hairline Serif Bounce Swash

LOWERCASE LETTER STROKES
Ascender★
Letter body
Descender★
★ Collectively called "extenders."

PEN ANGLE Determines where a *broad-edged pen* will put the thick and thin parts of a stroke. Customarily expressed as degrees away from horizontal.
NIB ANGLE Adjusts *pen angle* to a more comfortable hand position.

ROTATABILITY A word's capacity to reveal a different meaning when turned 90° or 180°, or mirrored.

STROKE DIRECTION Arrow
STROKE SEQUENCE Numeral

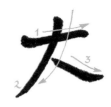

VIRTUAL ALPHABET Roman letters that have a non-Roman calligraphic style. Sometimes called a "Faux" alphabet.

WORD Letters that make meaning when grouped or connected, as shown below in the Arabic word for "word" in Kufic style.

WRITING TOOLS Monoline pen makes strokes of equal width. Flexible brush or pen widens a stroke when pressed down. Broad-edged pen makes thin or thick strokes, depending on *pen angle* and *stroke direction.* Stylus digs or presses grooves without ink. Stamp transfers inked images onto surfaces, or presses down into soft material.

INTRODUCTION

This book guides you on a virtual trip around the world—and beyond—to visit the native land of any calligraphy that interests you. It maps out the landscape of writing and suggests where to go on your visual voyage, offering you many perspectives on the world's scripts and the calligraphers who write them.

From the base of a 14th-century Maya scribe's inkwell, the glyph for "ink-pot" looks inky in any language.

IMMEDIATE VISUAL UNDERSTANDING

This book lets you skip, or postpone, learning how to read foreign languages while you learn how to write foreign scripts. Just as you don't have to speak Italian to enjoy Italian opera, you don't have to know Thai to be charmed by Thai calligraphy, or speak Arabic to recognize the most common phrases. In fact, you see more clearly if you do not try to decode a message while you look at a form.

EXPERT TECHNIQUES

Words on a page tell the story of the hand that wrote them. You will learn to find clues in any piece of calligraphy about how it was made. Nearly invisible marks on an Ethiopic parchment page, for instance, explain the whole book's design when you learn their purpose. Like knowing about what is hidden under the sidewalks and behind the walls, this book lets you bring X-ray vision to every kind of writing you see.

Ethiopic scribes ruled faint guidelines with a stylus by joining the pinholes shown on page 93.

THE MIND OF THE MAKER

The calligraphy in this book will raise your visual and spiritual IQ. With or without knowing a language, you will learn first-hand why its letters look the way they do. Once you have made the effort to grind your own ink and create a simple circle with a Chinese brush, you will know things about Buddhist philosophy you couldn't discover in years of research. And each new insight helps you see more in the next script you encounter.

Meditate by writing calligraphic circles.

8

SELECTED GEMS

Another benefit of this book is that you won't have to travel from country to country in order to see the best and most instructive examples of each script. Every chapter offers a rich choice, from national treasures to money to improvised signage. Each image is chosen to help you see through a calligrapher's eyes.

Enya Keshet's lacy half-circles of very small Hebrew text surround a prayer for safe pregnancy, lettered by Sharon Binder.

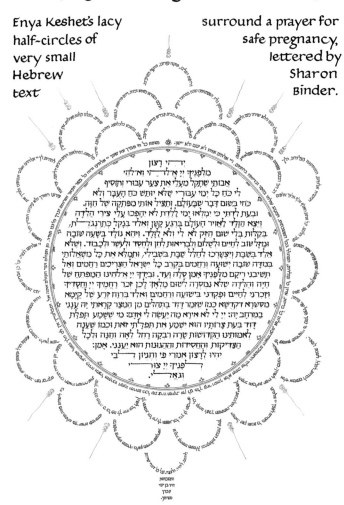

Painter Robert Motherwell's 1978 "Reconciliation Elegy" evokes bold Chinese calligraphy brushstrokes.

Forming pre-Roman runes from a material that alludes to their Norse origins, calligrapher Richard Widhu arranges birch twigs on a richly colored background of birch bark. (Rune-writers long ago named their alphabet styles "Long Branch" and "Short Twig," as shown on page 58.)

OPEN STUDIOS

This book gives you privileged entry into the studios of calligraphers who will share their lives with you. You will see how they sit, make their pens, and organize their desks, and learn how they feel about what they write—not only the traditionalists at the core of the craft but also the innovators at its cutting edge.

If you linger to enjoy the view from the studio, you will also learn how these calligraphers dream up what else a letter can do beside just make words visible. Some arrange letters into pictures, while others integrate pictures into letters; many experiment with color. A few who are not trained as calligraphers have been inspired by calligraphy to explore new ideas in their own art.

Mao Tse-tung is shown in a 1967 poster writing, "Heavenly Thunderstorm Opens up a New Universe; Bomb the Headquarters."

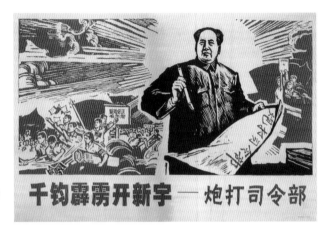

While condemning so many other arts in mid-century China as decadent, Chairman Mao took special pride in his own calligraphy, which has been immortalized in a typeface.

CULTURAL CATALYSTS

Calligraphy opens a window into the politics, religion, and culture of any place you visit in this book, framing the historical forces, as well as individuals, that shape what gets written. You will learn, for instance, how Korea's "One Morning" alphabet protected it for 500 years from Chinese bureaucrats and Japanese colonialists, or why the French erased a promising African script.

Above, calligraphy can sum up a time and place better than the most scholarly article. Government propaganda about progress in rural electrification was celebrated inside these Mongolian words, much like the scenes that fill medieval illuminated capitals. The scribe's ingenuity replaced pointed strokes with tiny lightbulbs, and made swashes out of sheaves of wheat.

You can add a stylized red sig~nature with the kind of chop that Chinese, Korean, Mongolian, or Japanese calligraphers use to finish their work.

SOUVENIRS

Like any traveler, you will collect mementos from your virtual journey to bring home and use in your own designs, whether you carve, sew, paint, illuminate, dance, or rhyme. Suggestions for a Japanese scroll, for instance, describe not only the brushwork and characters, but also the signature stamp, mat proportions, and room arrangement that help it look authentic, and that can add an Asian touch to anything else you write. Like a new cuisine that you can't wait to cook at home, the scripts you meet in this book will infuse your own calligraphy with the flavor of abroad.

HOMECOMING

The biggest benefit of any trip away is how different your home town looks when you come back; travel changes your perspective. The layout itself immerses you in new ways to read words on a page. The "virtual" alphabets in each chapter show you how to add exotic spice to the familiar ABC's, giving them foreign flavors that inspire fresh designs. Many of the ideas you try out with the Roman alphabet will change how you read and write calligraphy from now on.

This calligraphic world tour begins in Africa, where the human race was born, and where you will see some of its oldest and newest writing systems. You will then visit every major script of the present, including several that most English-speaking calligraphers have never seen, and get glimpses of the future that matter as much as traditions of the past. The journey ends at the horizon, where the world of reading leaves off, to let you see other worlds, with other senses. Bon voyage!

African Calligraphy

Home to 2000 of the world's 6000 languages, Africa offers a rainbow of calligraphic choice, from which this chapter selects just four scripts: Bamum characters each stand for the sound of a consonant plus a vowel; Adinkra, Bantu, and Nsibidi symbols show different ways that visual images represent meaning.

has flourished for centuries in dozens of different forms. While adopting the Arabic script of Islam and the Roman alphabet imposed by colonialism, Africans have not just kept their sophisticated writing systems alive but also invented new ones. Today, many African artists have found new roles for their own local scripts, which range from alphabets that spell out sounds to iconic symbols that stand for entire proverbs. ●

MADE IN AFRICA:
A CAMEROON MODEL FOR INVENTED SCRIPTS

Bamum writing was created a hundred years ago by King Njoya of Cameroon. Obeying a dream, he gathered a blue-ribbon symposium of artists and intellectuals to think up symbols, which he then winnowed down from 465 to 80.*

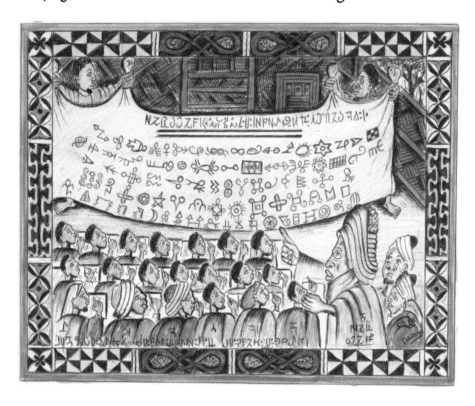

AN ALPHABET'S EVOLUTION

Created as an ideograph for meaning, each Bamum symbol now stands for a sound—a process that takes most alphabets thousands of years.

Bamum letters offer a time-lapse case study of calligraphic streamlining and simplifying. Compare the three versions above from 1896, 1930, and 2010.

Left, King Njoya teaches the new Bamum writing system to his subjects.

* If an N at the beginning of a word is followed by another consonant, it is pronounced as a separate syllable, "en."

The alphabet was so successful, and became such a powerful symbol of Bamum identity, that local French colonial administrators moved to suppress it. By 1930 they had closed King Njoya's Bamum writing schools and forbidden the teaching of any other script but Roman letters. In a fit of rage, the king, just before being exiled, destroyed his unique Bamum press.

Today, working from hand copies of old manuscripts, a consortium of academics, scribes, typographers, and historians has revived Bamum writing. While not a replacement for the now ubiquitous Roman alphabet, it serves as a model for the revival of Africa's many other local scripts.

Bamum illustrates the historian's adage, "Alphabet follows empire." Its rise and fall and recovery tells a universal—yet also very African—story about how writing can be a weapon of political conquest, cultural resistance, and national renewal.

Right, a French teacher points to Roman ABC's in a colonial-era classroom.

Far right, Nji Oumarou Nchare explains modern Bamum letters.

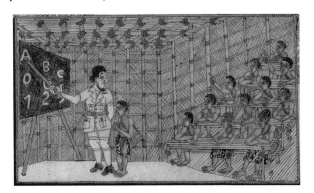
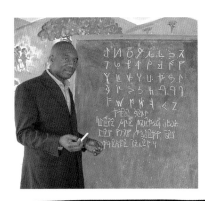

Numerals

Dots represent simplified letter strokes.

BAMUM
SYLLABARY

Pairs of letters have similar pronunciation.

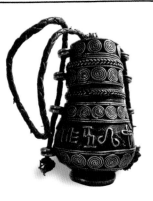

A MASTER'S MARK

King Njoya's scribe used his ink jug as a signature stamp by inking its raised letters and pressing them onto a finished manuscript.

Modern Bamum

| a | ka | u | ku | é | re | te | o | nyi | i | la | pa | ń | ñé | lé | mé | ta | da | njem | m |

| su | mu | shi | si | shù | sù | ké | két | noue | nou | njoue | yo | shou | you | shi | sha | kú | pou | jé | té |

| pü | wi | pé | fé | rou | lou | mì | ni | rú | re | kén | kwen | ga | nga | cho | poue | fou | fem | wa | na |

| li | pi | lo | ke | mben | rèn | mèn | ma | ti | ki | | 1 | 2 | 3 | 4 | 5 | 6 | 7 | 8 | 9 | 0 |

Using pens made of reeds or porcupine quills, Bamum scribes wrote on banana leaves, where they scratched shallow grooves to provide guidelines, or followed the veins of the leaves. Ink was made from boiled leaves and ashes. ● Words go from left to right.

Bamum
1930

Start
here

Bamum
1930

Numerals

 TABON Strength, perseverence
 ADINKRAHENE Charisma, leadership
 NSIREWA Unity, harmony
 AKOBEN Vigilance

AFRICAN SCRIPTS SYMBOLIZE IDEAS

Some African writing systems, instead of spelling out the sound of a word, use an image to represent its meaning. Different symbol systems come from Ghana's Adinkra, South Africa's Bantu, and Nigeria's Nsibidi.

ADINKRA

Adinkra symbols are based on everyday items such as a spiderweb, comb, crocodile, or hairstyle that stand for key Ghanaian cultural values. Sometimes a single symbol can convey a whole proverb. Chosen for their meaning and repeated on lengths of fabric, they signify support when worn at solemn occasions.

Calligrapher Andrew van der Merwe carves Adinkra-inspired symbols on beach sand, where the tide will eventually take them.

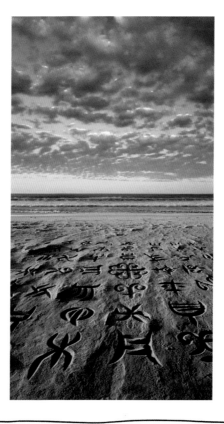

An image of turning the other cheek signifies forgiveness.

Joined crocodiles, making unity of diversity, symbolize democracy.

 AKOMA NTOASO Hearts agree
 FIHANKRA Security, safety
 NSOROMMA Guardianship
 DMANIMEN Strength

There are more than 200 symbols, and new ones are still being created.

MAKE YOUR OWN PRINT

- Hand-copy a symbol that means something special to you. Use a heavy pen for your rough draft, avoiding sharp corners, thin lines, and isolated parts.
- Carve your design ¼ ~ ½ " deep (0.5~ 1 cm) in material like balsa, cork, gourd, eraser, soap, or potato.
- Ink the carved stamp using a sponge in a dish, a stamp pad, or a wet brush.
- Print symbols in multiples onto posters, scarves, wrapping paper, greeting cards, bedspreads, walls, or T-shirts.

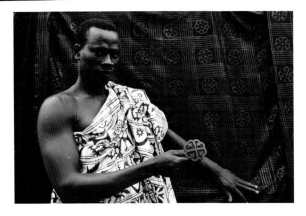
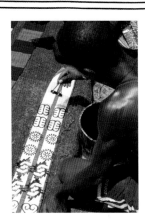

Above left, Gabriel, wearing Kente cloth of his own design, displays block used to print the fabric behind him. Above right and below, two ways to press the inked block onto the cloth.

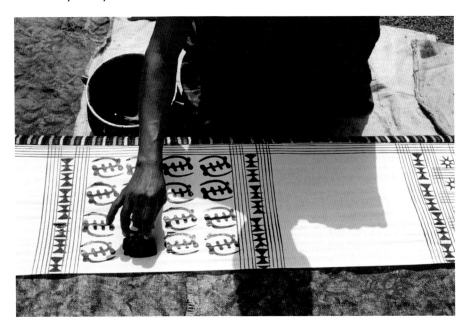

 Sunlight, daytime
 Conver-sation
 Fire, lust, passion
 Bride

BANTU

South Africa's Bantu symbols represent abstract pictures of actions, objects, qualities, or creatures, often adding extra colors to a basic geometric shape to refine its meaning. Although originally restricted to ritual use by medicine men and elders, the symbols have recently blossomed in the hands of Ndebele women, who paint them as blessings on new homes.

COLOR AND
LINE ADD DEPTH
TO MEANING

Woman Man

Wife Old man

Beautiful Warrior
visitor with shield

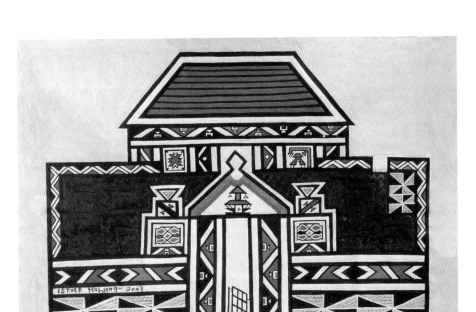

Artist Esther Mahlungu used only natural earth tones to paint this picture of a typical decorated Bantu village house.

 Home
 Marriage, unity, love
 Pleasure, joy
 Mother-in-law

 Giving birth

 Sunrise, new life

 Baby girl

 Obedi-ence

Esther Mahlungu's clay pots carry brightly colored symbols.

Jocelyne Santos's figures echo Bantu forms and colors.

Earth tones decorate this wall and window frame.

 See

 Eat

 Skilled person, planter

 Wisdom, silence

 Love vs. Hatred

 Compat‑ibility

 Dancing motion

 Journey

NSIBIDI

Ancient in origin and secret in ritual use, Nsibidi symbols stand for abstract concepts. Today in Nigeria they are written on paper, sculpted in relief, or printed on fabric.

Symbol patterns can be made by sewing lines of raffia tightly to cloth before it is dyed, leaving white lines when the strands are removed.

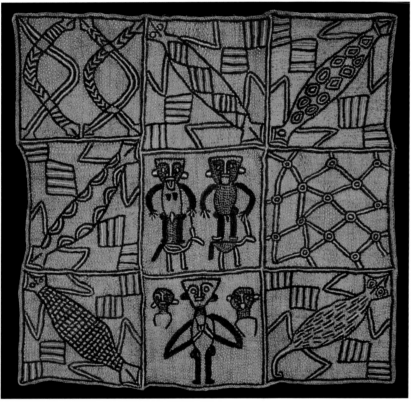

This wall‑sized mat from Cameroon, left, is tightly woven of banana or plantain fiber with darker stitching.

 Contradictory witnesses

 Trouble, speech at crossroads

 Python, eternity

 Congress

Arabic formats coexist with local African scripts. Above right, Nigerian artist Victor Ekpuk painted "A Man, His Wife, and Son at the Mirror," his rendering of an Nsibidi symbol for "unity" on a Moslem *wahala* board, which usually carries prayers, lessons, and Koran texts.

VIRTUAL AFRICAN CALLIGRAPHY

Ways to write Roman alphabet letters with the visual flavor of African calligraphy

HOW TO GIVE THE ALPHABET THE FLAVOR OF AFRICAN SYMBOLS AND LETTERS

Like sculptors, painters, and musicians around the world over the last hundred years, calligraphers can look to Africa for fresh ideas and new directions in their own art.

Combine Bamum syllables with Roman capitals, borrowing and inventing letters.

Use Adinkra, Bantu, and Nsibidi symbols to shape Roman letters that can spell words in both Swahili and English. Add color.

Move the letters off the page and make them from typical African materials.

CHOOSE ROMAN CAPITALS FROM BAMUM LETTERS

Many old and new Bamum letters look like Roman capitals already. You can also borrow the way they add extra dots and circles, curl the endings, and double some strokes.

VIRTUAL
BAMUM

Review Bamum characters on pages 12~15.
Practice on African Guidelines from page 15.

A B ·C :D E F

Letter width ≈ ⅔ letter height.

G H I J K L M

N O P Q R S

T U V W X Y Z

PENS NOT TO USE
Flexible •Broad

CHOOSE THE KIND OF PEN
Write African letters with a line that does not change its width, using a Speedball dip pen with a B or C nib, a bull-nosed marker, or soft pencil.

CHOOSE THE SIZE OF PEN
Virtual Bamum letters should be about 9 times as tall as the width of the pen stroke.

Λ to ▤ **SET THE VISUAL THERMOSTAT ON COOL OR WARM** Virtual Pan-African letters can range from the cool, calm restraint shown A to N in the border above, to the hot, busy energy shown O to Z in the border below.

CHOOSE THE SIZE OF PEN

H ⋮ ‖ ℍ

The height of a Virtual Pan-African letter should be 5~8 times the width of the stroke, either one wide line or several thin parallel lines.

AFRICAN SYMBOLS RE-ENERGIZE ROMAN LETTERS

Filling the negative spaces inside letters with primary and secondary colors creates a pleasing array of geometric shapes reminiscent of Bantu designs.

"Yes" in Swahili

ORNAMENT CAN BE STRUCTURAL

Simple lines and dots can form the strokes of a Virtual Pan-African alphabet that adapts to many designs. It harmonizes with Swahili, a language widely used across Africa.

United Nations Universal Declaration of Human Rights, Article 27

KILA MTU
EVERYONE HAS
ANAYO HAKI
THE RIGHT TO
YA KUFUAHIA
ENJOY THE ARTS
UTADI WA KAZI

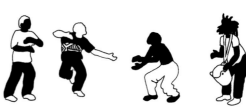

CREATE VIRTUAL CALLIGRAPHY CARVINGS

Many African letters are carved in wood or gourd, giving them extra simplicity and vigor. You can imitate these strokes by writing on handmade scratchboard.

MAKE AND SCRAPE YOUR OWN SCRATCHBOARD

● Choose a short word that you want to spotlight. Estimate the dimensions of the writing area it needs. (Outline the area with masking tape if you want straight edges)
● Lay rough pastel paper or newsprint on a hard, flat surface. Fill the writing area with solid crayon in narrow bands of bright colors.
● Cover the crayon area with a thick coat of black poster paint, and let it dry.
● Scrape away the letterstrokes of your design with a blunt tool to let the color show.

Other Swahili words: "hongera," congratulations; "ujinga," wisdom; "amandla," we shall overcome; "furaha," joy; "nakupenda," I love you.

WRITING WITH SCISSORS

Cut cloth also can suggest the forms of African carving

CELEBRATE!

FABRIC LETTERS Draw letter shapes to cut from stiff paper. Pin them to African-themed cloth to guide your scissors or craft knife. (To stabilize soft fabric, first attach it to heat-activated interfacing) A complete Virtual African alphabet suitable for patchwork or appliqué, with optional seam allowances, can be printed out at margaretshepherd.com.

CALLI · GRAPHY
TURKISH Arabic PERSIAN
FOR ENGLISH SPEAKERS

Nearly fourteen hundred years ago Arabia, through Muhammad, gave the world not only the word of Allah, but also the alphabet that spread it from Spain to Indonesia! Arabic calligraphy reached its peak with writing that fills the pages of the Koran and covers the walls of mosques. Sacred calligraphy also inspired the secular arts of Turkish bureaucracy and Persian literature, where scribes elevated documents into art—elaborate royal monograms, magnificent court decrees, and exquisitely illuminated poems.

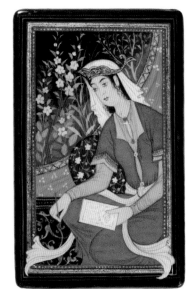

The Koran says that "Allah teaches by means of the pen". Austere purity and timeless form make calligraphy the key to the word, and world, of Islam.

Wide margins protect calligraphy from being touched by the hands that hold a book and turn its pages. Readers also add their own comments and translations by hand around the text.

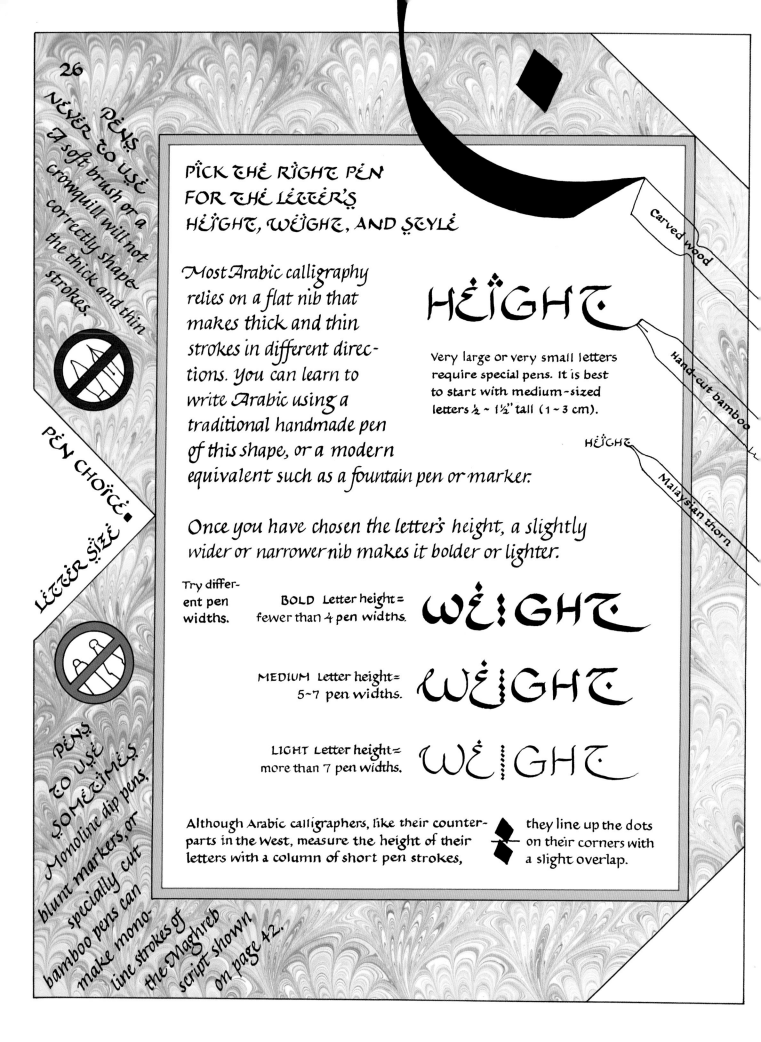

PENS
NEVER TO USE
A soft brush or a crowquill will not correctly shape the thick and thin strokes.

PEN CHOICE:
LETTER SIZE

PENS
TO USE
SOMETIMES
Monoline dip pens, blunt markers, or specially cut bamboo pens can make monoline strokes of the Maghreb script shown on page 42.

PICK THE RIGHT PEN
FOR THE LETTER'S
HEIGHT, WEIGHT, AND STYLE

Most Arabic calligraphy relies on a flat nib that makes thick and thin strokes in different directions. You can learn to write Arabic using a traditional handmade pen of this shape, or a modern equivalent such as a fountain pen or marker.

HEIGHT

Very large or very small letters require special pens. It is best to start with medium-sized letters ½ ~ 1½" tall (1 ~ 3 cm).

HEIGHT

Carved wood

Hand-cut bamboo

Malaysian thorn

Once you have chosen the letter's height, a slightly wider or narrower nib makes it bolder or lighter.

Try different pen widths.

BOLD Letter height = fewer than 4 pen widths.

WEIGHT

MEDIUM Letter height = 5~7 pen widths.

WEIGHT

LIGHT Letter height = more than 7 pen widths.

WEIGHT

Although Arabic calligraphers, like their counterparts in the West, measure the height of their letters with a column of short pen strokes, they line up the dots on their corners with a slight overlap.

Newly cut bamboo can be too stiff and non-absorbent for easy writing. Traditional Arabic scribes first mellow their reed by burying it for half a year in warm compost. One devoted student aged his pens in the ground near his teacher's grave.

27

HAND-CUT an AUTHENTIC REED PEN

You can buy a precut bamboo pen, or learn to make one yourself from a reed, using a sharp knife on a hard surface.

Cut one end off a reed on a slant. Scrape out the inside fibers about 1" (2.5 cm).

If nib is to be wider than ⅛" (3 mm), cut an off-center ink slit.

Whittle the back to make it concave, and the sides to make them tapered.

Cut the tip off square, or at a 30° angle, as illustrated at the foot of this page.

HOLD THE PEN AT THE CORRECT ANGLE

Arabic letters have thick horizontals and thin verticals, because the Arabic pen angle is steeper than the customary Roman 20°–45° pen angle.

WRONG
Roman pen angles
45° 20°

CORRECT
Arabic pen angle 60°

If your pen nib is square, you must either move your elbow away from your body or shift the pen counterclockwise in your hand.

An oblique nib will automatically transform your Roman hand position into a correct Arabic pen angle. (You can make any marker oblique by cutting a small wedge off the tip.)

60° pen angle
square-cut pen nib

60° pen angle
oblique-cut pen nib

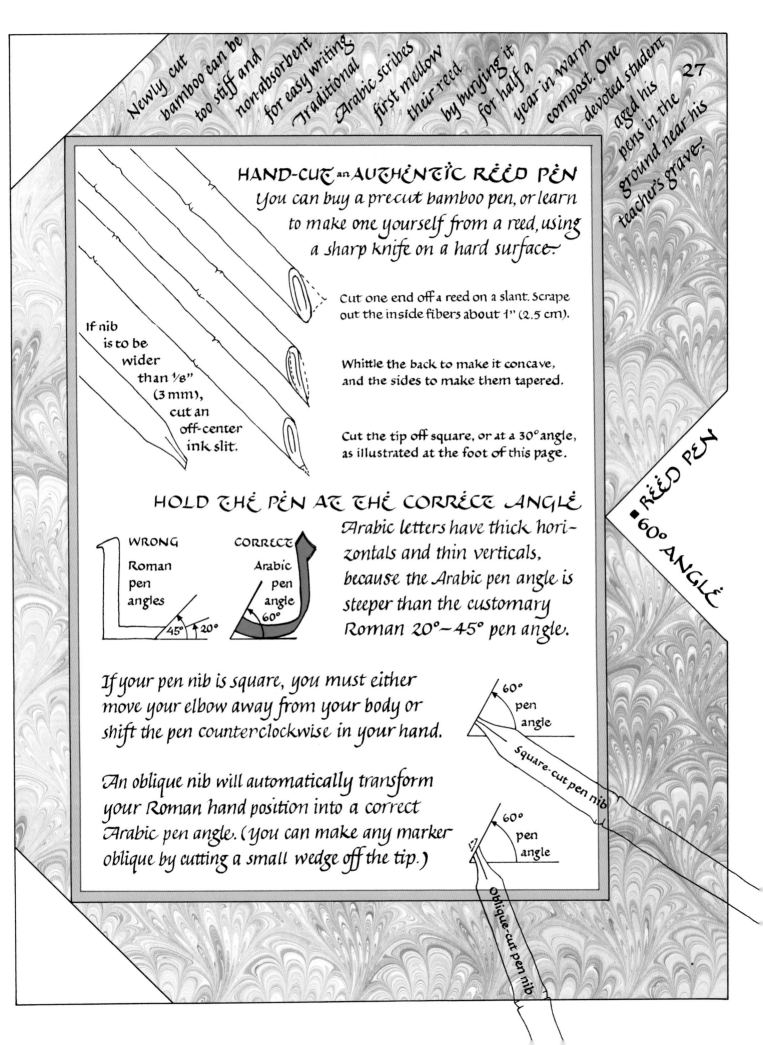

Whatever ink you use, the fiber padding in the bottle helps the traditional reed pen to absorb just the right amount. You can rinse and wipe the pen, but you don't need to scrub away the ink residue that clings to the reed.

MAKE OR BUY YOUR INK, AND BOTTLE IT

Arabic calligraphers make ink from burnt-wool soot, distilled water, and gum Arabic, boiling the mixture down with walnut hulls, oak galls, alum, bones, and scraps of iron. Dried in small disks and aged, it is later pulverized and diluted for daily use. You can substitute fountain pen ink or India ink.

Fold the ink disk up in heavy paper; pound it to dust.

Mix ink powder with water in a small bottle.

Add a little scrap of silk, or nylon hose.

To fill the pen nudge the fiber.

Fibers also prevent spilled ink if the bottle tips over.

SIT THE ARABIC WAY

Arabic rooms hold very few tables or chairs. People sit on the floor to talk, eat, pray, read, and write. To write in this position, attach your paper to a clipboard or thick backing and hold it on your knee, propped on a cushion for stability. Or just sit on a chair to write at a desk with a fountain pen or marker.

In detail at right, a portable penbox and inkwell allow a scribe to write anywhere.

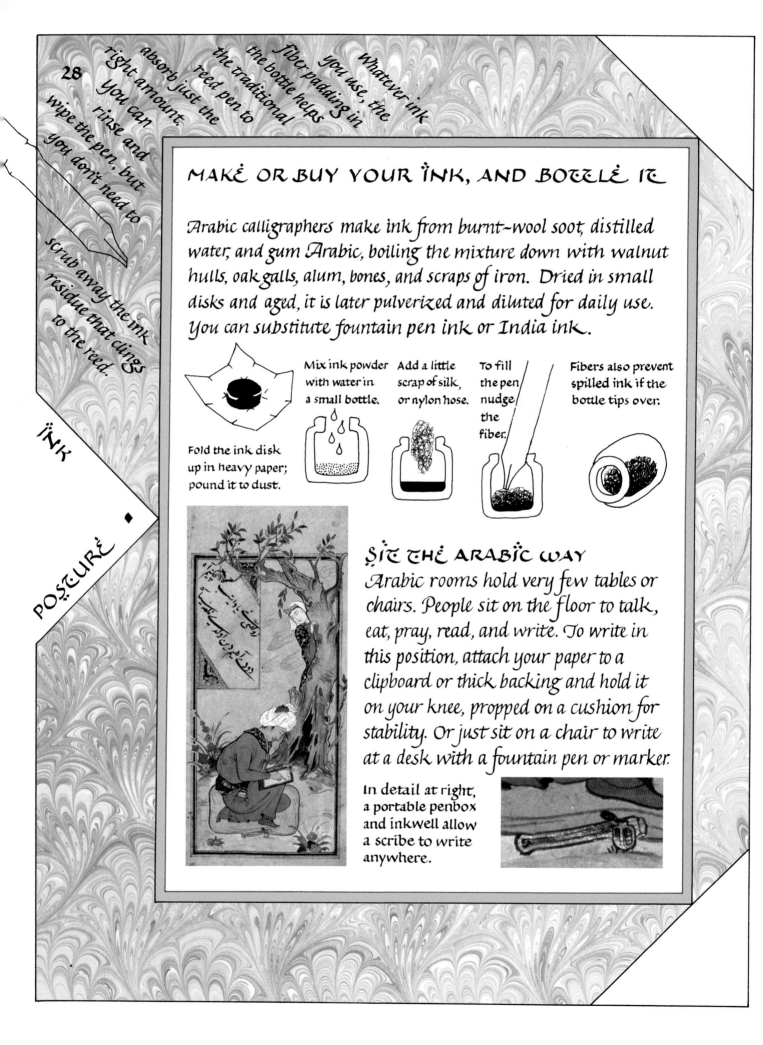

CHOOSING AND WRITING ON ARABIC PAPER

The paper you write on makes a difference, whether you plan to master some Arabic words, or just want to learn enough strokes to improvise your own Virtual Arabic. Originating in the Far East, paper was refined by Islamic scribes, who spread it along the medieval Silk Road, all over the Muslim world, and throughout Renaissance Europe.

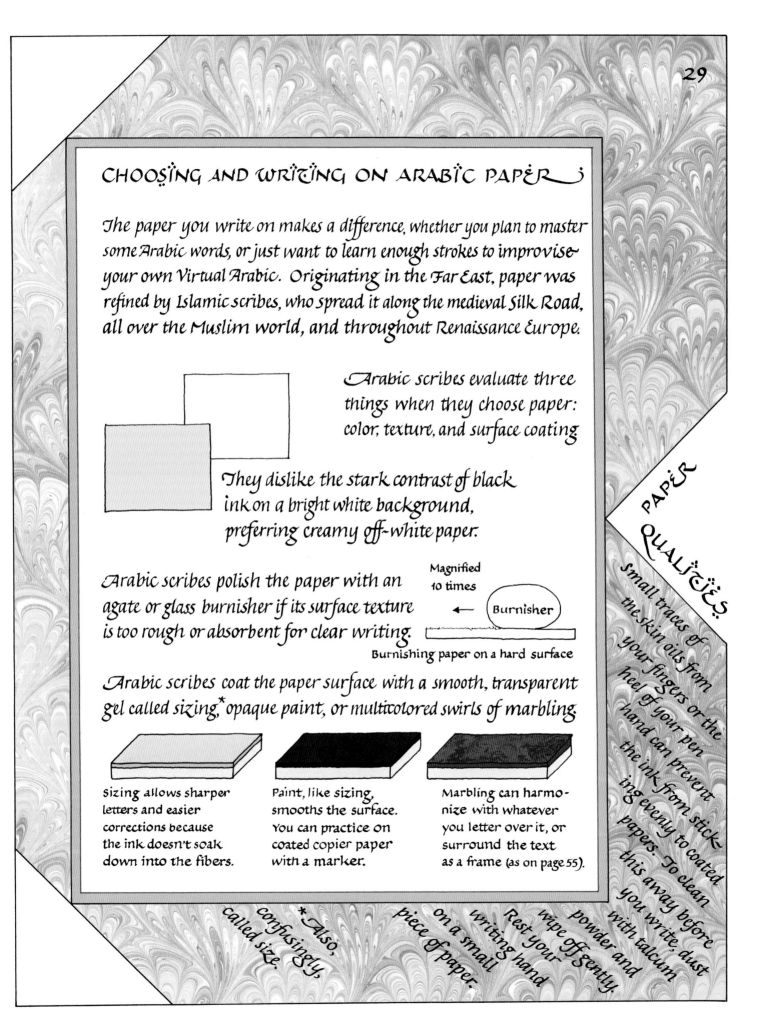

Arabic scribes evaluate three things when they choose paper: color, texture, and surface coating

They dislike the stark contrast of black ink on a bright white background, preferring creamy off-white paper.

Arabic scribes polish the paper with an agate or glass burnisher if its surface texture is too rough or absorbent for clear writing.

Magnified 10 times

← Burnisher

Burnishing paper on a hard surface

Arabic scribes coat the paper surface with a smooth, transparent gel called sizing,* opaque paint, or multicolored swirls of marbling.

sizing allows sharper letters and easier corrections because the ink doesn't soak down into the fibers.

Paint, like sizing, smooths the surface. You can practice on coated copier paper with a marker.

Marbling can harmonize with whatever you letter over it, or surround the text as a frame (as on page 55).

PAPER QUALITIES?

small traces of the skin oils from your fingers or the heel of your pen hand can prevent the ink from sticking evenly to coated papers. To clean this away before you write, dust with talcum powder and wipe off gently. Rest your writing hand on a small piece of paper.

*Also, confusingly, called size.

GETTING STARTED

Arabic writing differs from Roman in three fundamental ways: stroke direction, connectedness, and diversity.

STROKE DIRECTION

Almost all the horizontal strokes are pushed, from right to left. (Only a few are pulled, from left to right.) This uses other muscles than Roman and changes the ink flow. It may also make a metal nib dig into the paper; you can avoid this with a reed pen or marker.

stop start

The letters HĀ, MĪM and ṢĀD change their shape when they connect to spell the word "hummus."

S ← M ← H

S M H
Letter sounds

CONNECTEDNESS

Arabic letters always* connect when they form words, changing shape to fit each other.

DIVERSITY

Unlike Roman, Arabic letters come in different sizes. They float at various levels inside a horizontal band. As whole words they trail downward to end in a tail. As sentences they pile up to the left in parallel curves.

Letter size varies.

Letter level varies.

Words trail downward to the left.

Sentences pile upward to the left.

Arabic writing is inherently cursive; most letters have three or even four slightly different forms, depending on their placement at the beginning, middle, or end of a word.

* No letters except ALIF stand alone, with only a few exceptions, they connect either to the letter before or the letter after. In practice, words sometimes break partway through.

To teach your hand each basic motion, use this stroke path as a crutch; then continue by aiming for the dots, until you can repeat the motions on your own.

60°

Start here

It is important to keep the pen at the correct angle.

BASIC MOTIONS

When you begin, you should focus mainly on the unfamiliar new right-to-left motion your arm and hand are learning to make. Later, you can pay attention to the specific shape of each stroke.

Rather than write in the book, copy these guidelines or print out from margaretshepherd.com.

Calligraphers learning Roman* capitals are taught to let the curved strokes (+) = join at their thinnest point. In contrast, Arabic calligraphers overlap the joins and build up the serifs. *(The strokes of Gothic letters also seldom overlap, barely [+] = touching each other at their corners to connect.)

OVERLAPS •

PILE-UPS

STROKES CONNECT IN A CONTINUOUS LINE

The pen stays in touch with the paper throughout each letter, except for the separate dots and one serif that are added later to some letters. To start a new stroke, stop and reverse direction without lifting the pen.

Overlapped strokes reverse direction.

Connected curves overlap.

Strokes overlap themselves later on.

SMALL DETAILS MATTER WHEN SEVERAL STROKES CROSS

The initial form of the letter HĀ' has four strokes piled up at its center, challenging the writer to make visual sense of them for the reader.

initial form of HĀ'

The loops are very different from each other: one is pointed, the other is round.

This little protruding corner, almost invisible, is the clue that helps the eye untangle the overlap and understand it.

STROKES BUILD UP OR TAPER OFF AT THEIR ENDS

+ plus ◇ equals ◆

SERIFS ATTACH TWO WAYS
One kind of serif is added in a separate motion before writing the main stroke.

The other kind of serif is added to the main stroke by changing direction without lifting the pen.

ENDINGS TAPER OFF
Arabic calligraphers modify the pen's predictable geometry by pulling out a thin trail of ink with one corner of the nib.

Start here

The shape of this serif is refined by the tapering technique shown below.

whole nib

Corner

Start the stroke on one corner of the nib; push the stroke up; finish it on the whole nib, ready for the downstroke.

The "missing ink" from some common tapered strokes is shown in gray. Lifting one corner of the nib transforms square endings into points.

All the other tapered strokes end, not start, with one corner lifted.

Push ← Start here → Pull

corner — whole nib — corner

Start the stroke on the whole nib; push it across; finish it on one corner.

Start the stroke on the whole nib; pull it across; finish it on one corner.

MĪM

Whole nib start here

corner

Start the stroke on the whole nib; pull the stroke down; finish it on one corner.

BUILD UP

• TAPER OFF

A reed pen can write more easily on one corner than a metal pen because its fibers soak up a little residual ink (and because it may have an off-center ink slit, as shown on page 27). A marker also writes easily on one corner.

Tapering is a useful technique for subtly shaping any script written with a broad-edged pen.

CRITIQUING BASIC FORMS

BASIC FORMS OF THE ALPHABET

ب ح د ر رِ or سِ

60°

ص ط ع ف ق

ل م ن ه و ى

THREE WAYS TO LOOK AT WHAT YOU WRITE

The next three pages explain classic systems for evaluating your own calligraphy.

I. IMAGINE
Make visual metaphors based on real things and creatures.

II. MEASURE
Measure each letter with strings and clusters of square dots.

III. SORT
Look for shared shapes and family resemblances.

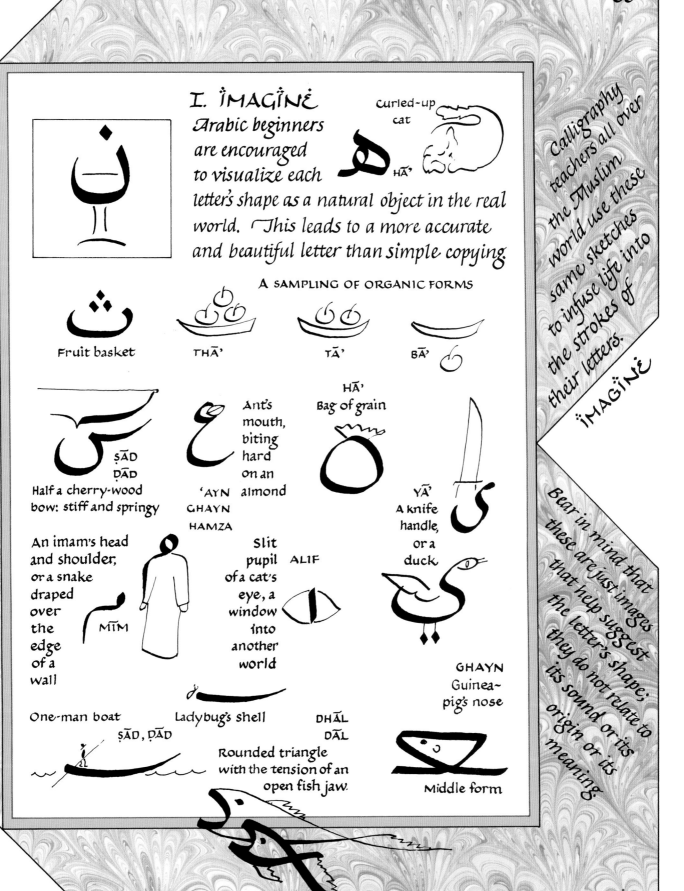

I. IMAGINE

Arabic beginners are encouraged to visualize each letter's shape as a natural object in the real world. This leads to a more accurate and beautiful letter than simple copying.

Curled-up cat — HĀ'

A SAMPLING OF ORGANIC FORMS

Fruit basket — THĀ'

TĀ'

BĀ'

ṢĀD DĀD — Half a cherry-wood bow: stiff and springy

'AYN GHAYN HAMZA — Ant's mouth, biting hard on an almond

HĀ' Bag of grain

YĀ' A knife handle, or a duck

MĪM — An imam's head and shoulder, or a snake draped over the edge of a wall

ALIF — Slit pupil of a cat's eye, a window into another world

GHAYN Guinea-pig's nose

One-man boat

ṢĀD, DĀD — Ladybug's shell

DHĀL DĀL — Rounded triangle with the tension of an open fish jaw.

Middle form

Calligraphy teachers all over the Muslim world use these same sketches to infuse life into the strokes of their letters.

IMAGINE

Bear in mind that these are just images that help suggest the letter's shape; they do not relate to its sound or its origin or its meaning.

II. MEASURE WITH A PEN, IN AN IMAGINARY CIRCLE

The pen itself provides calligraphers with a measuring stick to check their letters. In addition, positioning the letter in a circle helps the scribe clarify the letter's form.

Teachers usually add these strings and clusters of square dots in red ink to distinguish them from the black dots that tell some nearly identical letters apart. In lieu of red ink, or to add contrast, they may substitute little circles of equivalent size.

A teacher critiques an advanced student's practice.

DECEPTIVE SIMPLICITY

Even master scribes consider the proportions of these four letters to be the most difficult.

You must master traditional proportions before you experiment with them.

Little red circles help to map out and quantify potential problem areas.

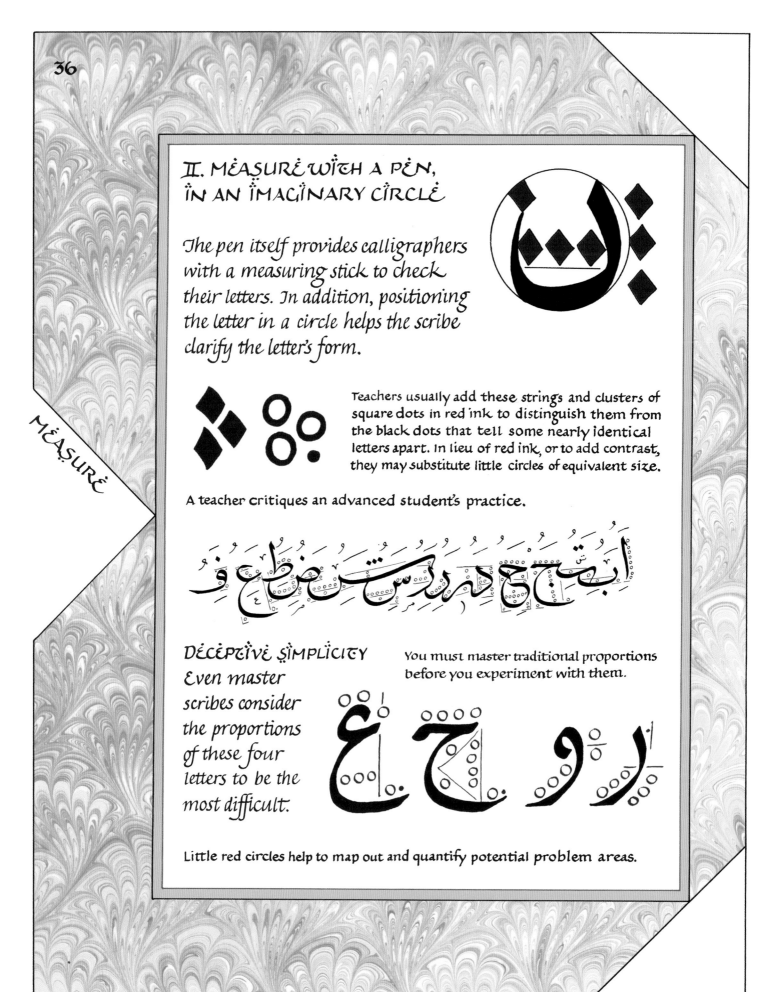

III. SORT BY SIMILARITIES

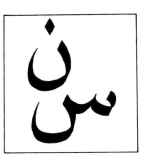

The Arabic letters, like many groups that have evolved over a long time, are a clan of individual relatives. Some share only a distant family resemblance, while others look like cousins, siblings, or twins.

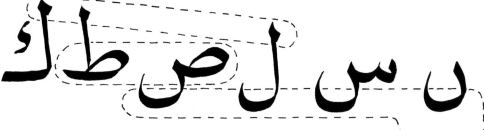

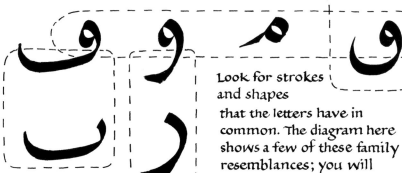

SORT

Look for strokes and shapes that the letters have in common. The diagram here shows a few of these family resemblances; you will discover others as you write.

THE WHOLE ALPHABET COMES NEXT

Now you are ready to learn the letters of the Arabic alphabet on page 38, and to evaluate your work as you go along. Practice each letter half a dozen times on plain paper or on copies of page 39.

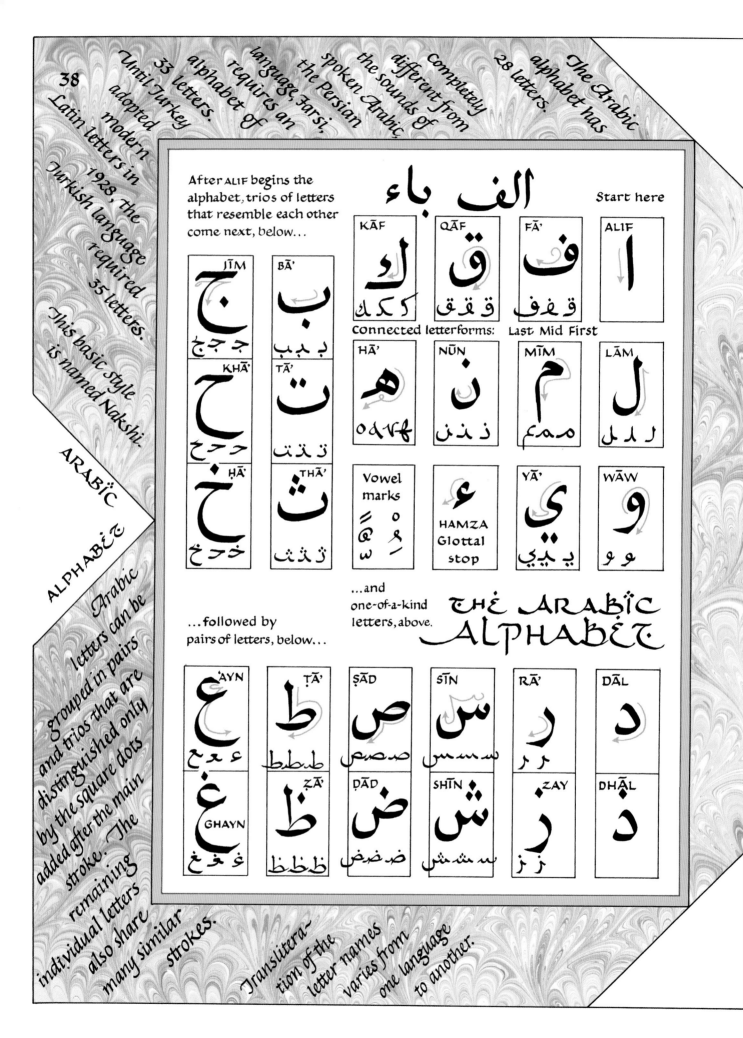

The Arabic alphabet has 28 letters.

Completely different from the sounds of spoken Arabic, the Persian language, Farsi, requires an alphabet of 33 letters.

Until Turkey adopted modern Latin letters in 1928, the Turkish language required 35 letters.

This basic style is named Nakshi.

38

Arabic letters can be grouped in pairs and trios that are distinguished only by the square dots added after the main stroke. The remaining individual letters also share many similar strokes.

Transliteration of the letter names varies from one language to another.

THE ARABIC ALPHABET

Start here

After ALIF begins the alphabet, trios of letters that resemble each other come next, below…

...and one-of-a-kind letters, above.

…followed by pairs of letters, below…

Connected letterforms: Last Mid First

ALIF ا ا

LĀM ل ل ل ل

WĀW و و و

FĀ' ف ف ف ف

MĪM م م م م

YĀ' ي ي ي ي

QĀF ق ق ق ق

NŪN ن ن ذ ن

HAMZA Glottal stop ء

KĀF ك ك ك ك

HĀ' ه ه

Vowel marks

BĀ' ب ب ذ ب

TĀ' ت ت ذ ت

THĀ' ث ث ذ ث

JĪM ج ج ج ج

KHĀ' ح ح ح ح

HĀ' خ خ خ خ

DĀL د د

DHĀL ذ ذ

RĀ' ر ر ر

ZAY ز ز ز

SĪN س س س س

SHĪN ش ش ش ش

ṢĀD ص ص ص ص

ḌĀD ض ض ض ض

ṬĀ' ط ط ط ط

ẒĀ' ظ ظ ظ ظ

'AYN ع ع ع ع

GHAYN غ غ غ

الف باء

60°

Start
here

ARABIC
GUIDELINES

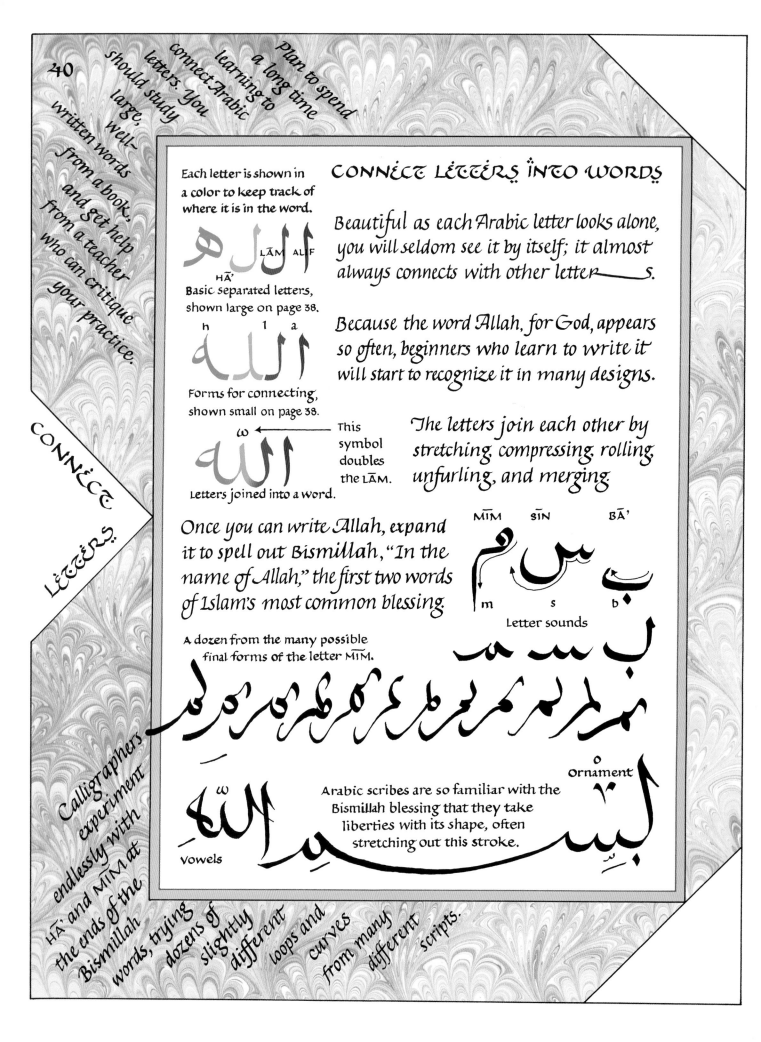

Plan to spend a long time learning to connect Arabic letters. You should study large, well-written words from a book, and get help from a teacher who can critique your practice.

CONNECT LETTERS

CONNECT LETTERS INTO WORDS

Each letter is shown in a color to keep track of where it is in the word.

HĀ' LĀM ALIF

Basic separated letters, shown large on page 38.

h l a

Forms for connecting, shown small on page 38.

This symbol doubles the LĀM.

Letters joined into a word.

Beautiful as each Arabic letter looks alone, you will seldom see it by itself; it almost always connects with other letter——s.

Because the word Allah, for God, appears so often, beginners who learn to write it will start to recognize it in many designs.

The letters join each other by stretching, compressing, rolling, unfurling, and merging.

Once you can write Allah, expand it to spell out Bismillah, "In the name of Allah," the first two words of Islam's most common blessing.

A dozen from the many possible final forms of the letter MĪM.

MĪM SĪN BĀ'

m s b

Letter sounds

Ornament

Arabic scribes are so familiar with the Bismillah blessing that they take liberties with its shape, often stretching out this stroke.

Vowels

Calligraphers experiment endlessly with HĀ' and MĪM at the ends of the Bismillah words, trying dozens of slightly different loops and curves from many different scripts.

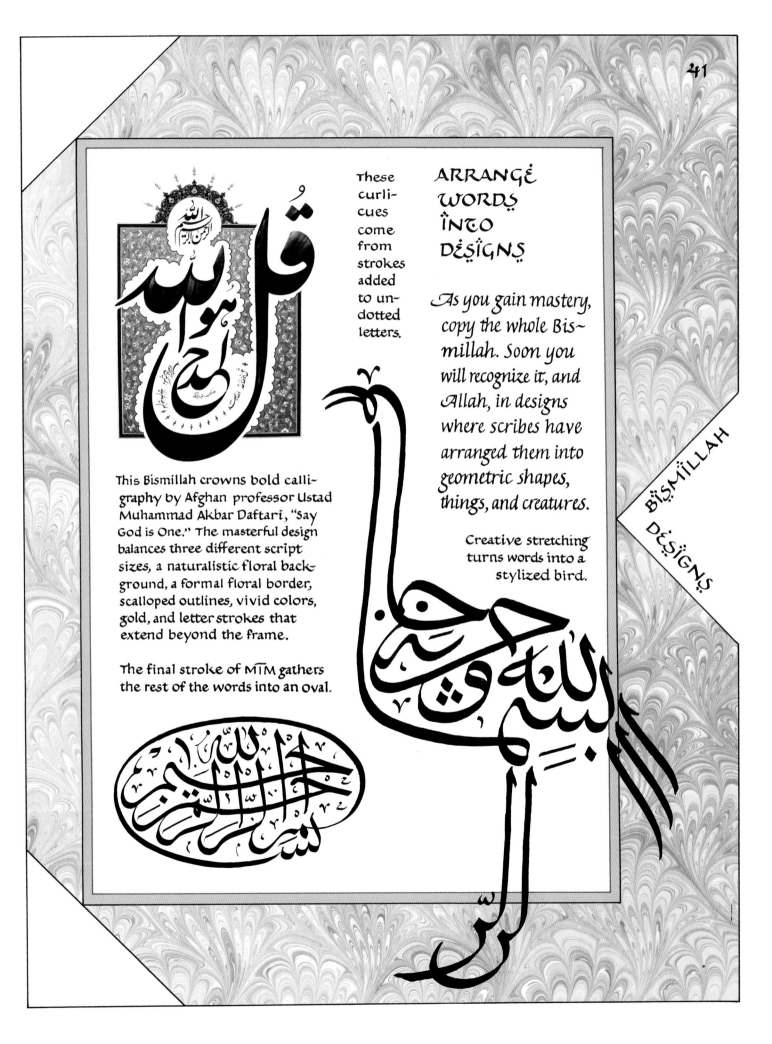

These curli-cues come from strokes added to un-dotted letters.

ARRANGE WORDS INTO DESIGNS

As you gain mastery, copy the whole Bis~millah. Soon you will recognize it, and Allah, in designs where scribes have arranged them into geometric shapes, things, and creatures.

Creative stretching turns words into a stylized bird.

This Bismillah crowns bold calli-graphy by Afghan professor Ustad Muhammad Akbar Daftari, "Say God is One." The masterful design balances three different script sizes, a naturalistic floral back-ground, a formal floral border, scalloped outlines, vivid colors, gold, and letter strokes that extend beyond the frame.

The final stroke of MĪM gathers the rest of the words into an oval.

Turn the broad-edged pen 90° to make wide strokes with square corners.

KUFIC

MAGHREB

Maghreb is characterized by a pen line that does not vary from thick to thin. Cut a reed pen as shown above, or write with a blunt marker or Speedball dip pen with a B or D nib. You still can write on one edge of the dip pen to taper the stroke ends.

Back Top side

DIFFERENT PEN LINES WRITE DIFFERENT STYLES

The basic Nakshi calligraphy you have learned is one of some half-dozen* major styles. Two of the most dramatic are shown here, illustrated by typical designs and the Bismillah blessing.

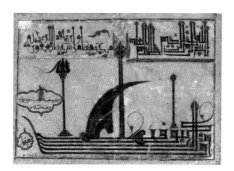

Photograph ©2011 Museum of Fine Arts, Boston

Scripture describing Noah's Ark and the Great Flood takes the shape of a ship complete with masts, rudder, and sail.

Thick pen strokes and heavy gold ornaments dramatize this West African calligraphy.

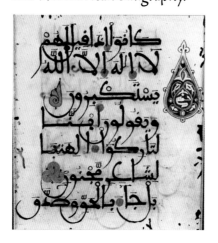

KUFIC

لبسم لله

The oldest script, Kufic, angles the letter bodies to make them with the broad-edged pen's thickest strokes. Arabic calligraphers shape words into schematic labyrinths or, in a favorite genre, add spires and domes to evoke a nighttime skyline. (page 62)

MAGHREB

لبسم الله

Maghreb, in contrast, is based on compact letter bodies, gracefully rounded curves, extended swashes, and flattened letter bottoms. This North African script requires a specially cut pen that writes only thick strokes in every direction.

TRADITIONAL PAGES

KORAN

Master calligraphers devote much of their life to hand-copying the Koran; some will write as many as fifty copies. Always written in the Arabic language, Korans range from palm-size to wall-size.

The layout of this chapter is based on the design of this book. The upper and lower borders are narrower than the outer but wider than the center. Handwritten commentary in Farsi fills many of its broad, well-worn margins.

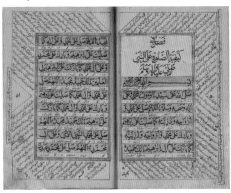

In this detail, the calligrapher on page 25 holds a vertical Kita.

KITA The Kita is prized by connoisseurs who collect it and student scribes who copy it. It is mounted on stiff board, bound to other Kitas, accordion-folded for safe storage, and unfolded to hang for display.

A DIPLOMA
THAT STARTS
WITH A BLESSING

This diploma was awarded to a Turkish calligrapher in 1765. The Bismillah begins its text, as well as the first paragraph in the open book above at right.

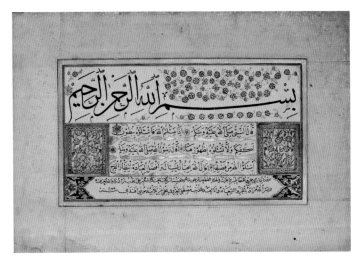

Because even today, large sheets of paper are made by hand. much harder to fabricate than small, any oversize calligraphy impresses the viewer with its lavish use of materials, beyond its visual impact.

EXTREME PROPORTIONS

Calligraphy techniques protect this land grant document against fraud. Each line is filled with densely packed text to prevent insertions and lettered on uncoated paper to let the ink soak in. A final mist of gold or gray dots creates a background texture that can not be replicated if tampered with.

BEYOND BOOK PAGES

Calligraphy designs can take dramatic proportions and sizes, stretching to cover walls and fill scrolls.

Some calligraphy extends more than 6 feet across (2 meters).

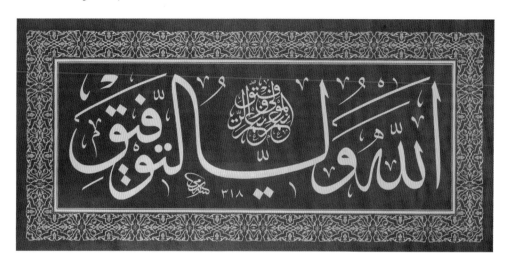

A sultan's stylized monogram heads this land grant, shown in a detail only an eighth of its full length.

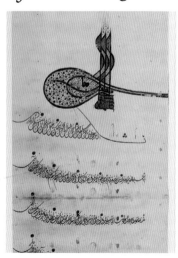

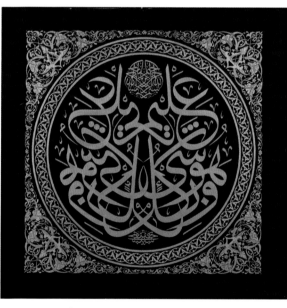

Square and circular designs are popular, especially if symmetrical.

Words on paper are just a springboard for calligraphy that permeates every aspect of life and finds expression in every kind of material. Creative artisans render traditional holy words in metalwork, ceramics, graffiti, mosaics, sculpture—and food.

45

CALLIGRAPHY BEYOND PEN, INK, AND PAPER

Clockwise from right:

U.S. postage stamp designed in 2001 by Mohamed Zakaria for *Eid*, the festivities that end Ramadan's fasting.

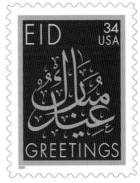

Letters made of cinnamon powder on *Sholezard*, a holiday custard.

A prayer to Allah in interlaced Kufic script on a ceramic wall panel.

The name of Allah in the shape of a ship.

A ceramic mosque lamp banded with prayers in white on blue.

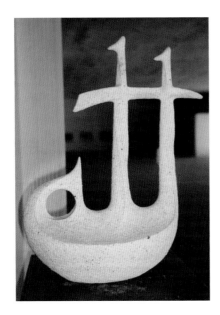

Compare to the word ١ll.

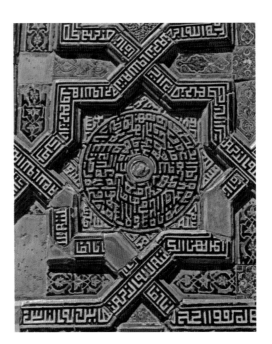

BEYOND THE PAGE

Blue and gold make a favorite color combination for calligraphers and other artists throughout the world of Islam.

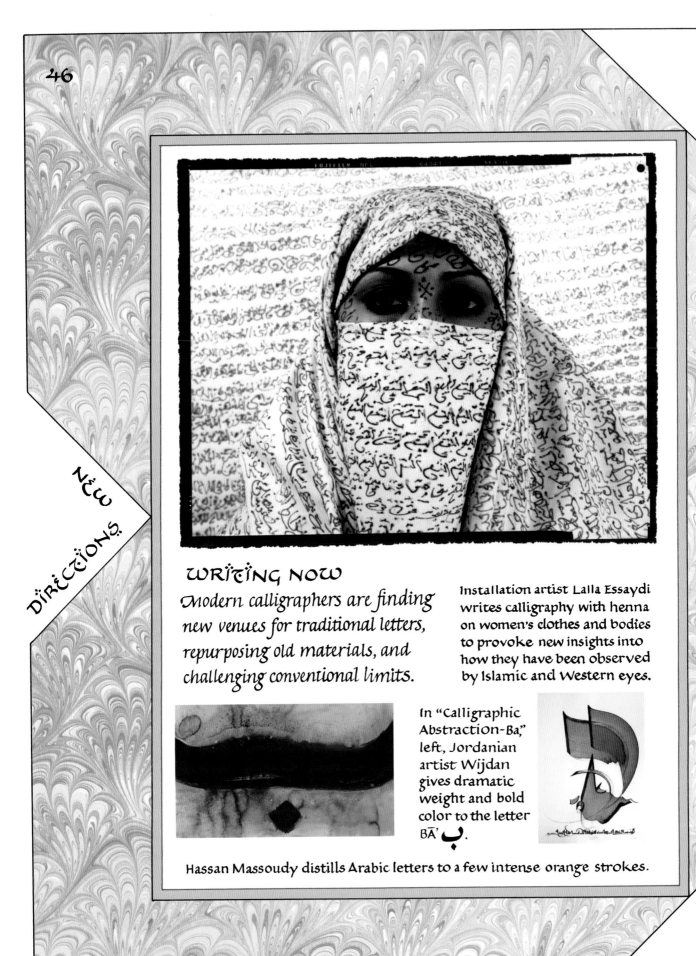

WRITING NOW

Modern calligraphers are finding new venues for traditional letters, repurposing old materials, and challenging conventional limits.

Installation artist Lalla Essaydi writes calligraphy with henna on women's clothes and bodies to provoke new insights into how they have been observed by Islamic and Western eyes.

In "Calligraphic Abstraction-Ba," left, Jordanian artist Wijdan gives dramatic weight and bold color to the letter BĀ' ب.

Hassan Massoudy distills Arabic letters to a few intense orange strokes.

Virtual Arabic

Ronde · *Legende*

Creative borrowing can give your calligraphy intense Arabic flavor.

Replace a few Roman letters with those Arabic letters that happen to look like them, or model an entire alphabet on an Arabic-themed type font.

Lay out the page to integrate calligraphy in Arabic with its translation in English.

Dress up and accessorize your Virtual Arabic calligraphy with real Arabic details: stretched strokes, tilted lines, ornaments, and marbled mats.

ALPHABEغT

alphabet

ᴧ BC

alphabet

VIRTUAL ARABIC

48

Letters sometimes act a lot like people. When grant joins an exotic immi- alphabet, the other letters try to make it by taking on feel at home some of its by taking on characteristics, so that it will not stick out quite so much.

These look-alikes are strictly coincidental, not based on meaning or shared origin.

TRANSPLANT LOOK-ALIKES

Don't overdo the transplanting, borrowing, and dotting, however. Help the reader to keep focused on the text by adding a whiff, not a wallop, of Arabic flavor.

TRANSPLANT A FEW LOOK-ALIKES

Many Arabic letters bear a striking resemblance to their Roman cousins. Your reader will accept them as substitutes if you use them sparingly and provide a context that blends them in. (You have already been reading them in this chapter's headlines.)

Roman pen angle and letter body

Although you should hold your pen at the usual Arabic pen angle of 60°, you will need to reverse the direction of some of the strokes.

Arabic pen angle and letter body

VIRTUAL ARABIC

a b c d غ or خ e f g h ن or ث j k l m
n o p q r s ت ü ý w x y z

Every exit is an entrance to somewhere else

Transform the Roman alphabet further with distinctive Arabic swashes, serifs, and tapered stroke ends.

Add one, two, or three dots to look-alikes where they occur in Arabic letters, and where they do not reduce legibility.

Allow ample white space around Virtual Arabic letters and between lines.

See swashes, joins, and dots on pages 31–33.

CREATE CAPS

You can go beyond look-alikes to build your own Roman capitals and small letters from Arabic strokes.

INITIALS À LA CARTE A collection of individuals rather than a cohesive font, this alphabet offers extra choices for capital letters you are likely to use frequently if you want to add a few of them to your own handwriting. Collect other letter ideas that you come across in this chapter's illustrations as you find ways to use them.

Images of Quiet

ARAB-ESQUE CAPS

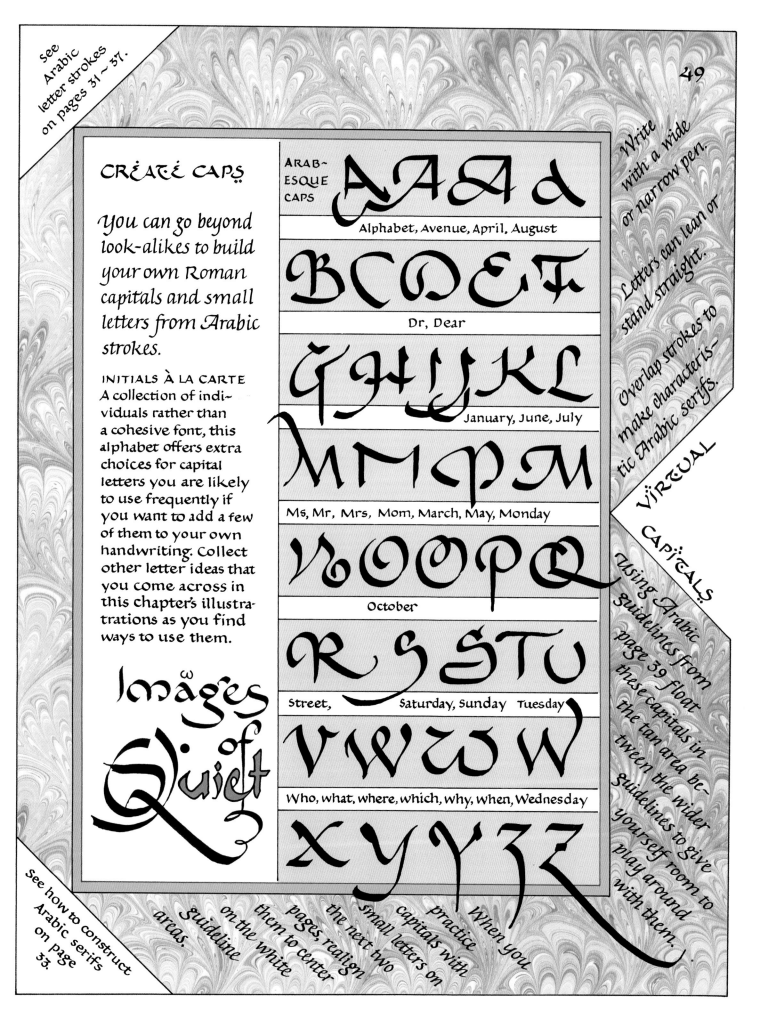

Alphabet, Avenue, April, August

Dr, Dear

January, June, July

Ms, Mr, Mrs, Mom, March, May, Monday

October

Street, Saturday, Sunday Tuesday

Who, what, where, which, why, when, Wednesday

Write with a wide or narrow pen.

Letters can lean or stand straight.

Overlap strokes to make characteris-tic Arabic serifs.

VIRTUAL CAPITALS

Using Arabic guidelines from page 39 float these capitals in the tan area be-tween the wider guidelines to give yourself room to play around with them.

When you practice capitals with small letters on the next two pages, realign them to center on the white guideline areas.

See how to construct Arabic serifs on page 33.

WORDS FORM PICTURES

The letters of "peace" and "salam" combine to look like a bird on a branch, a favorite design theme of Arabic calligraphers.

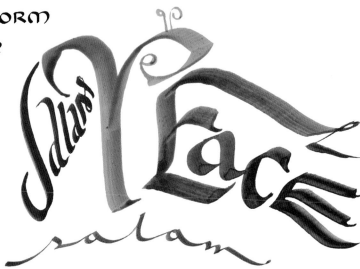

RONDÉ

Ascender height = 3 letter bodies.

Ascender loops lean away from vertical about 20°

a b c d e f g h i j k l m

Most letters are connected.

Dot I and J, and cross T, after finishing each word.

n o p q r s t u v w x y z

Descender height ≈ 3 letter bodies.

Space the letters far apart, to make them easy to read. Leave ample white space between lines of letters for ascenders and descenders to be lengthened, to dramatize these small, nearly identical letter bodies.

Designer Valerie Elliott's repeated script "alphabets" offset the square frame of heavy capitals.

RONDÉ SCRIPT

Using Arabic guidelines from page 39, confine the bodies of these small letters in the narrow white area, letting their ascenders and descenders extend into the tan area. The initials from page 49 can also extend above and below the white area, to cradle the script words that they capitalize.

ARABIC ANIMATES ALPHABET SCRIPTS

Shaped by constant calligraphic borrowing from Arabic, cursive scripts thrive on the writer's willingness to take graphic risks. Though based on 17th- and 18th-century copperplate quill script and early 20th-century type, they readily evolve into a personal, versatile cursive. Ronde and Legende rely on the distinctive swashes and serifs first created by Arabic pens.

LEGENDE

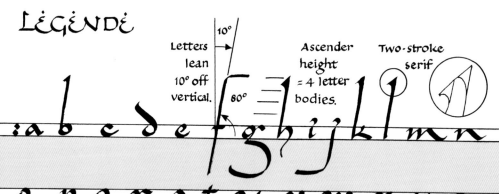

Letters lean 10° off vertical. 80°

Ascender height = 4 letter bodies.

Two-stroke serif

Descender height = 4 letter bodies.

LEGENDE SCRIPT

45°

Pen angle

The Alphabet teaches Ink to Think.

Letters in Gold

Understated swashes in this exhibition logo by Tom Costello give a hint of Ottoman splendor to Italic.

Simple capitals and script harmonize with an ornate floral border.

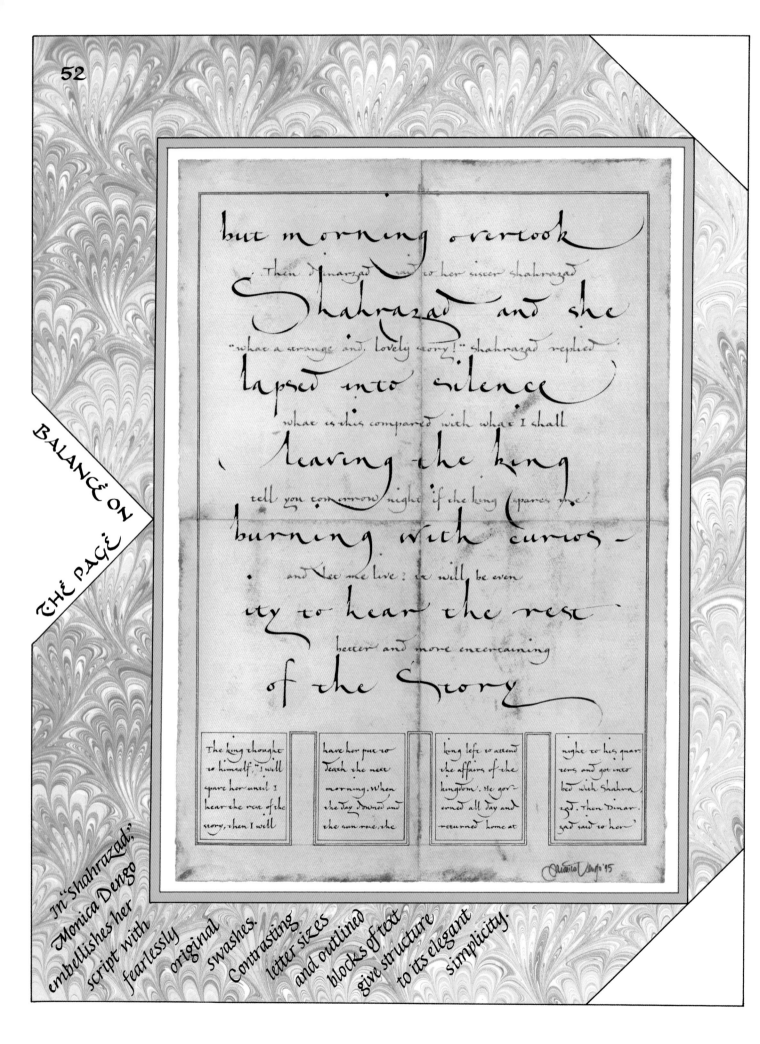

but morning overtook

Then Dinarzad said to her sister Shahrazad

Shahrazad and she

"what a strange and lovely story!" Shahrazad replied

lapsed into silence

what is this compared with what I shall

leaving the king

tell you tomorrow night if the king spares me

burning with curios-

and lets me live? it will be even

ity to hear the rest

better and more entertaining

of the Story

The king thought to himself, "I will spare her until I hear the rest of the story, then I will

have her put to death the next morning. When the day dawned and the sun rose, the

king left to attend the affairs of the kingdom. He governed all day and returned home at

night to his quarters and got into bed with Shahrazad. Then Dinarzad said to her

In "Shahrazad," Monica Dengo embellishes her script with fearlessly original swashes. Contrasting letter sizes and outlined blocks of text give structure to its elegant simplicity.

JUXTAPOSE TWO DISTINCT SCRIPTS

Whenever you put scripts of different styles or languages on the page together, you should give them enough contrast not to clash. Balance their size, slant, color, weight, and spacing.

Geometric letter bodies and interwoven ascenders in Kufic style from page 42 mingle these names in a monogram for a wedding. Writing the date in flowing script lightens the weight of the design.

Original text in Farsi from the *Rubaiyat* of Omar Khayyam decorates an illuminated square amid Virtual Arabic scripts.

davidlinda

21 September 1985

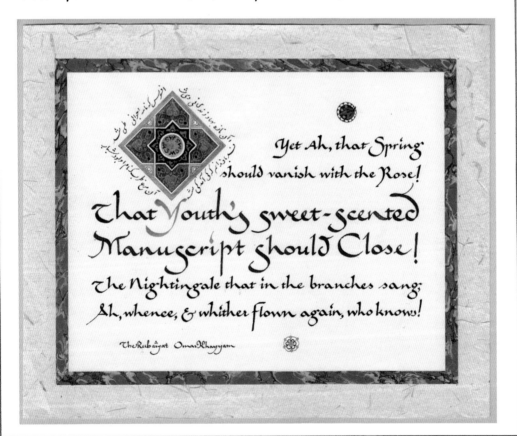

Yet Ah, that Spring should vanish with the Rose!
That Youth's sweet-scented Manuscript should Close!
The Nightingale that in the branches sang;
Ah, whence, & whither flown again, who knows!

The Rubaiyat Omar Khayyam

See stretched strokes on pages 40–41.

A few kinds of paper are shown on these two pages, including five different marbled papers.

OTHER INK ON THE PAGE

Especially opulent manuscripts are sometimes written in gold letters on solid backgrounds of purple, blue, or midnight blue.

Arabic scribes can choose from a wide variety of papers to write on or to frame their work.

WESTERN BODIES, IN ARABIC CLOTHING

Western letters can dress up in Arabic outfits and accessories. Curves become corners; letters make pictures; lines tilt; ornaments fill spaces.

Virtual Arabic letters lo——ve to stretch:

Beyond the square dots that identify letters, many other little marks can be borrowed from Arabic, using the nib's corner or a smaller pen.

Optional for pronunciation

Doubling and decoration

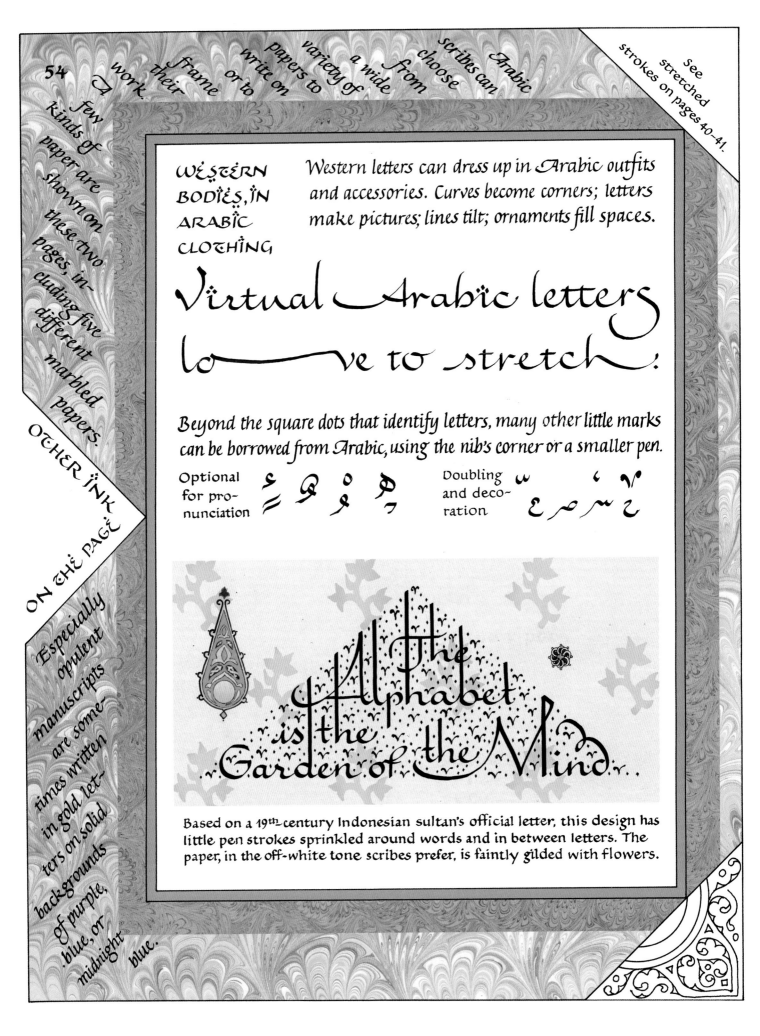

Based on a 19th-century Indonesian sultan's official letter, this design has little pen strokes sprinkled around words and in between letters. The paper, in the off-white tone scribes prefer, is faintly gilded with flowers.

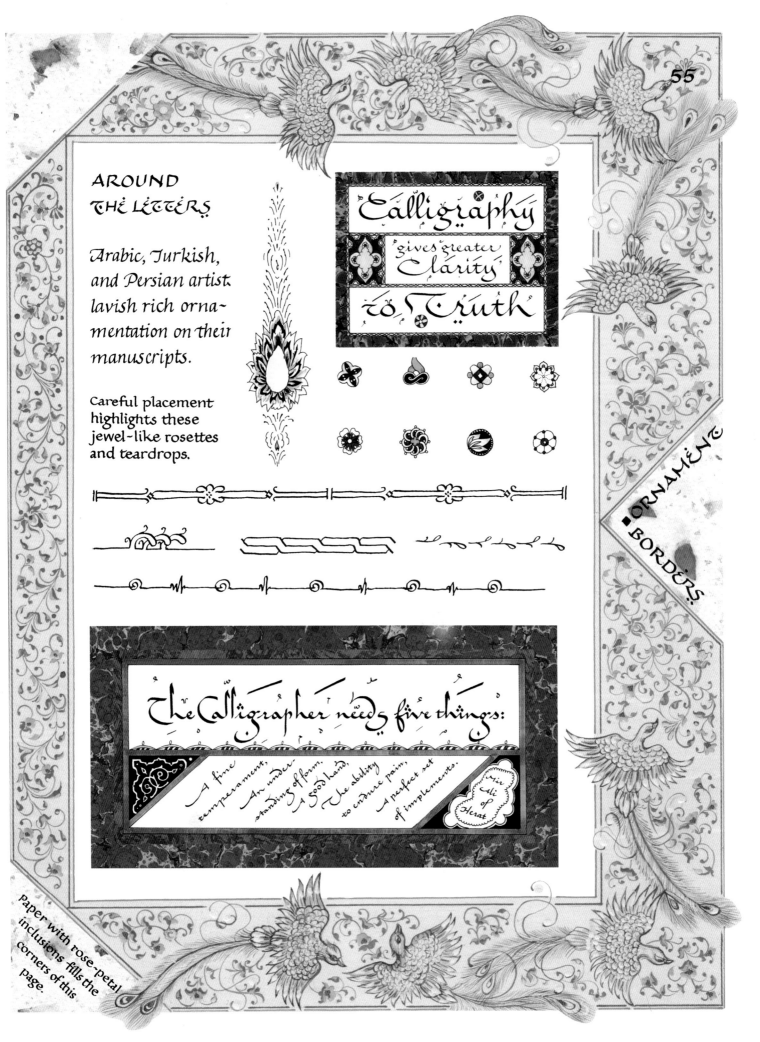

AROUND THE LETTERS

Arabic, Turkish, and Persian artists lavish rich ornamentation on their manuscripts.

Careful placement highlights these jewel-like rosettes and teardrops.

Calligraphy 'gives greater *Clarity* to *Truth***

The Calligrapher needs five things:

A fine temperament,
An understanding of form,
A good hand,
The ability to endure pain,
A perfect set of implements.

Mir Ali of Herat

ORNAMENT • BORDERS

Paper with rose-petal inclusions fills the corners of this page.

See a Chinese-Arabic hybrid on page 90.

WHEN ARABIC CALLI~ GRAPHY MINGLES

Arabic scribes, like their Western colleagues, constantly borrowed and lent ideas along their borders. Arabic interactions with early medieval Spain, with the bold scripts of North Africa, with brush characters in Western China, and with Russian Cyrillic in Central Asia, have bred a rich crop of hybrid letters.

Angular letters and heavy parallel ascenders of Kufic, right, resemble medieval Gothic. Calligraphy from 15th-century Valencia, left, shows how European and Islamic scribes built their alphabets with the same strokes.

26.04.99

Каллиграфиа

During most of the 20th century, scribes in the Central Asian Soviet republics dressed the official Cyrillic alphabet in the strokes, serifs, and swashes of their own local Arabic calligraphy. *Kalligraphia*, the Russian hybrid above, was written by Uzbek calligrapher Habibullo Saliev.

See Russian calligraphy on pages 163~170.

CELTIC CALLIGRAPHY RUNES

NORTHERN EUROPEANS WERE WRITING RUNES LONG BEFORE

foreign legionairies and missionaries introduced the Roman alphabet from the Mediterranean. Runes were widely spread all around the North Sea, throughout what is now Scandinavia, northern Germany, Ireland, the British Isles, Iceland, and as far west as Greenland.

In Insular manuscripts such as the Book of Kells and the Lindisfarne Gospels, Greek and Latin opening words were written in rune~like straight capitals that contrast with rounded text letters.

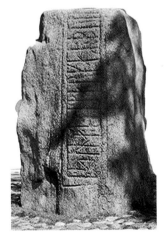

WHILE RUNES originated in the area where the tale of Beowulf is set, and often chronicled historic battles, they were not exclusively a script of war. Hundreds of runic inscriptions in fact were carved, often by or about women, for such prosaic purposes as gravestones, boundary line markers, and family memorials.

These 10th century runes say, "King Gorm made this monument for Tyra, his wife, the jewel of Denmark."

THE RUNE ALPHABET *is named for its first six letters:* F U Th A R K. *Evolving over the centuries, runes changed not only with the passage of time, the needs of local languages, and the tastes of artisans, but were also shaped by the demands of the very material they were written on. Runes were created by carving lines into solid material rather than adding pigment to a thin surface, making curves difficult.*

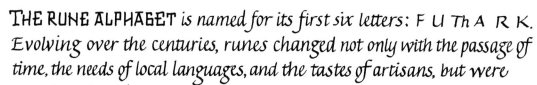

The relative hardness of stone and wood led to specialized "Long Branch" and "Short Twig" runes.

see "Birch Twig Runes" on page 8.

VIKING FUTHARK

Tailored to the Old Norse language of sagas and poems, but also of diplomacy and trade.

f u th a r k g w h n l j i p z s t b e m l ng o d

MEDIEVAL DANSK

For transliterating any language, old or new, or for use as single initials.

a b c th d e f g h i k l m n o p r s t u x y z æ ø

The guidelines from page 115 or 167 fit the size of the runes above.

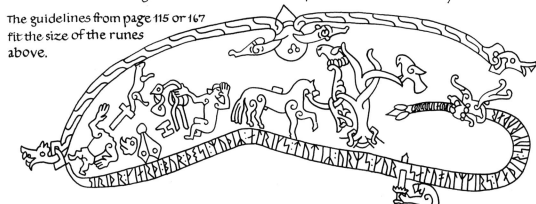

The 11th-century Ramsund stone carving shows a battle from the legend of Sigurd, framed with the first known inscription telling the story of the Nibelungs.

The *Codex Runicus*, on parchment, recorded the laws, history, and boundaries of 14th-century Denmark. One scribe, whose ink has faded to brown, extends his vertical strokes to touch the guidelines precisely; the other, whose black and red inks have kept their color, lets his runes float between the guidelines and spaces them farther apart. A large green ᚼ, equivalent to an S sound, may have been added and decorated with red curlicues by a third hand.

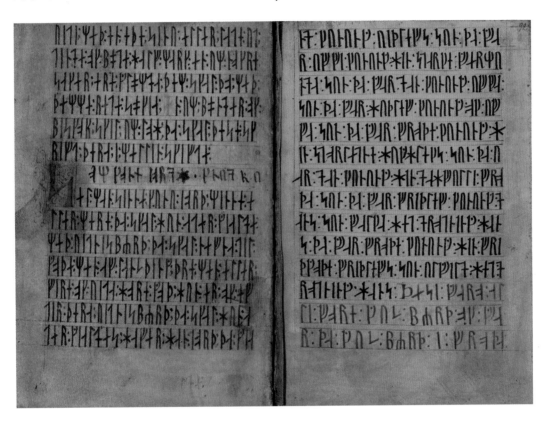

RUNES *prefigure many of the calligraphy techniques and visual principles that were to become hallmarks of medieval Gothic lettering.*

Most letter strokes are straight, not curved, and broad, not thin.

Tall and narrow letters are tightly packed both horizontally and vertically.

Richly decorated and brightly colored, large initials dominate pages of small letters.

<u>VIRTUAL RUNES</u> have been around ever since calligraphers in 5ᵗʰ century Ireland and Britain began to copy Greek and Latin sacred texts in a hybrid letter style inspired by the square shapes of their own local runes. From then on, runes happily coexisted with the Roman alphabet, infiltrating it, shaping it, decorating it, and swapping letters with it.

VIRTUAL RUNES Borrowed or derived from the *Book of Kells*, these runes are simple enough to write and read.

ABCDEFGHIJKLMN
OPQRSTUVWXYZ

Use the guidelines from page 115 or 167.

These are the ten letters most likely to begin words in English:

T A I S O
C W H R M

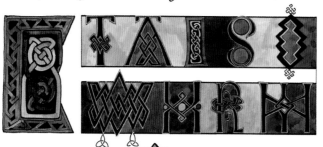

Words written in tiny black, tan, and blue Celtic letters ¹⁄₁₆" tall (2 mm) weave a rune-style coiled B.

THE FLOWERING of CELTIC ART from 500 to 1000 CE was headlined by runes, most famously in manuscript illumination. Often unable to read the languages they wrote, Celtic scribes added intricate rune capitals and playful decoration. Greek and Latin texts that had been lost in Europe by the fall of Rome were saved here, recopied, and reintroduced to the continent.

The *Book of Kells* represents the pinnacle of Celtic book art. The richly ornamented page at right from the gospel of Matthew in Latin begins *Nativitas*, "Born," in coiled letters, followed by *Christi in Bethlem*, "Christ in Bethlehem," in angular runes.

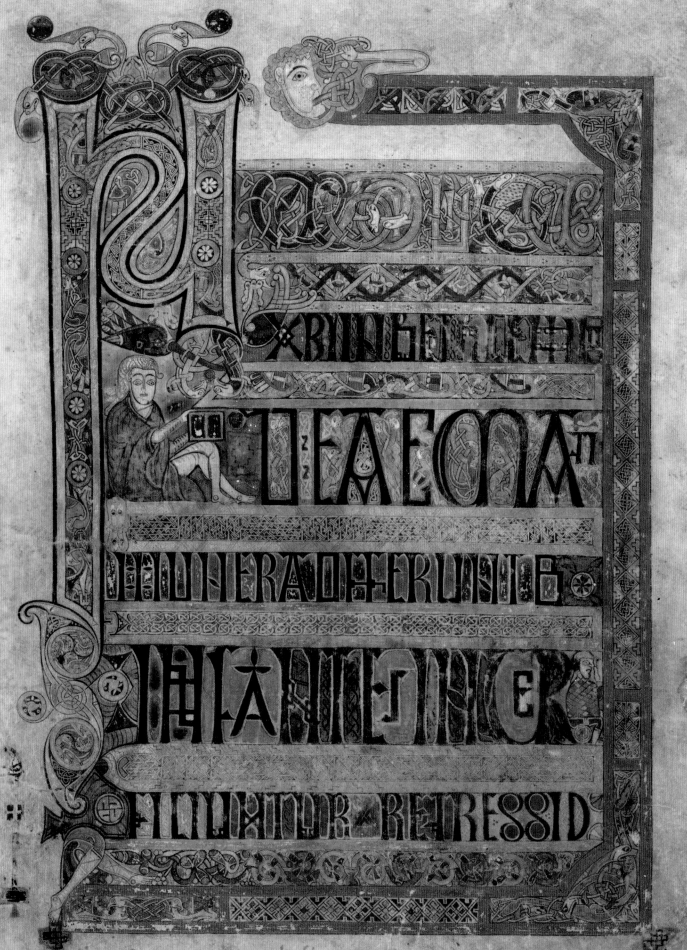

ꝑEOPLE CONTINUED TO READ ᚫ WRITE RUNES IN ᛠNGLAND *past the Middle Ages, and in Sweden well into the early 20th century. Recent rune revivals have focused on historical alphabets as emblems of a regional identity free of outside influences. As part of a related political movement, Celtic language and calligraphy has been advo-cated in Ireland for use in literature, art, education, and signage.*

The Lord of the Rings and Richard Wagner's Ring Cycle have rekindled interest in pre-Roman, pre-Christian mythology and visual art. Calligraphers have also created many designs using the runes and Celtic-based letterforms, shown on page 188, that J. R. R. Tolkien devised for writing the languages spoken by his dwarves and elves.

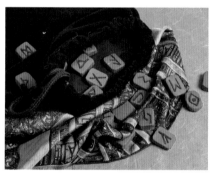

The word "rune" means SECRET or WHISPER. Like other early writing, runes were thought to be of divine origin. One reincarnation of runes has elevated them into a New Age oracle similar to Tarot cards or Chinese 1 Ching. Each letter is assigned a mystical meaning and inscribed on a pebble or wooden tile. A rune chosen at random from a pouch is supposed to foretell the future.

ᛖLSEWHERE, *many other scripts also began life looking like runes — stiff, straight, and simplified — or may have gone through a phase when calligraphers just preferred the look of this angular style.*

Arabic
Kufic,
page 42

Chinese
Seal Script,
page 74

Early
Greek,
page 100

Russian
Old Slavonic,
page 168

Mongolian
Folded,
page 162

Gothic
Blackletter

中國書法　日本

Coastal trade spread Chinese script all along the Pacific Rim. Calligraphers of early Japan, Vietnam, and Korea wrote the sounds of their own languages with Chinese characters, re-styling them for local usage but still looking to China for artistic standards.

This chapter covers the calligraphy of Japan, China, and precolonial Vietnam based on the brush techniques they have in common.

Chinese calligraphy reaches further back in history than any other written language still in use today. Originating around 4000 years ago in crude pictographs scratched on bones, it grew to artistic maturity as a brush script. Pictures can still be glimpsed in the lines of many everyday Chinese words.

China's traditions of respect for stability, for education, and for the wisdom of old people, have kept alive an ancient visual language that is written and read by Chinese people the world over. A special place of honor was reserved for the calligrapher, a cultivated amateur who combined the talents of public servant, painter, scholar, and poet. While other artists integrated the written character into mosaics, textiles, carvings, and ceramics, its purest format is still a philosophical or literary passage written in black ink with a brush on paper or silk and hung as a scroll on the wall for contemplation.

CHINESE and japanese
CALLIGRAPHY

文房四寶

TREASURES HELP YOU WRITE

Calligraphy purists revere their materials, which they call "the four treasures of the study." They take pride in choosing the finest brush, ink, inkstone, and paper they can afford, and giving them the most meticulous care.

Expert workmanship and fine ingredients make traditional tools expensive: brush hair from weasels, goats, or even horses; pigment from special pine tree soot; ceramic clay from the Anhui riverbed; paper fiber from cotton or the inner bark of mulberry. Age, also, adds to their value, not only for the collector as beautiful antiques but for the artist as tools of the utmost expressivity and control. Calligraphers seek out well-aged paper that has mellowed over decades, and pay extra for vintage sticks of ink. Some even insist that time continues to ripen the ink long after it has dried on the paper.

Accessories for the ideal studio can include a hanging rack for brushes to dry pointing down, pots for clean water and rinse water, a wrist rest for long practice or extra control, a stand to prop up inky brushes, and a pair of weights to hold the paper flat. Everyday objects or museum pieces, they will organize and inspire you while you write.

Wrist rest

Rinse pot

Markers, though less expressive, let you practice brush calligraphy just about anywhere, without cleanup or risk of a spill: especially useful with children.

Solid felt tip

Synthetic fiber brush tip

BRUSHES OLD AND NEW

Only a Chinese brush can teach you strokes that are both expressive and precise. You should start with a brush of medium size and price, to learn how to take care of it and to get a feel for your personal style, before you try more sizes and higher quality. If you have a limited budget, it is better to invest in the very best brushes and practice on the cheapest paper—even newsprint.

Soak your brush for a minute before first use and wash it immediately after every practice, twirling it with its hairs downward under a stream of running water. (Rinse the inkstone, too, but don't scrub it.) Squeeze it out gently, reshape its hairs to a point, and hang it by its loop. Wet or dry, it must never rest on its point.

A larger, less expensive brush can be reserved for dripping clean water into the ink while you grind it.

BRUSHES NOT TO USE

Soft Watercolor

Stiff oil paint

Roll brushes in a bamboo mat to carry safely.

INKSTICK
AND
INKSTONE

其它繁體 硬筆書

INKSTICK

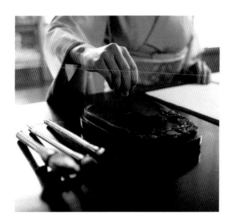

Calligraphers grind a small amount of ink from the stick with water for their daily practice, using those minutes of motion to relax.

Made of glue mixed with pine tree soot and burnt sesame oil, Chinese ink is hardened into shiny sticks. Fancier labeling means finer ink. "Warm tea ink", right, has a rich, mellow tone.

INKSTONE

Grind fresh ink each time you practice. Pour a little water into the inkstone ¼" (5 mm) deep. Holding the inkstone upright, gently rub it against the rough slanted surface, catching up a bit of water with each stroke. Feel the tug of friction and listen to the sound. Add a few drops of water to thin the ink; grind longer to thicken it.

See inkstone and brush in use on page 146.

Dampen a brush and dip it partway into the ink, rolling it on its side against the inkstone to shape it into a soft point. Press out the extra ink on the rim of the stone.

You can substitute bottled ink such as "Sumi" to simplify your everyday practice and cleanup.

Pour a little ink into a shallow dish rather than dip the brush into the bottle.

Don't dip

紙
印
章

The carved Chinese chop gives every~ one~educated or illiterate, artist or bureaucrat— a unique and legal signature stamp.

Chops are inked with a gummy red paste made of silk fragments, finely ground cinnabar, and castor oil.

Chop handles range from plain plastic rods to intricately carved antiques of horn, bone, ivory, and jade.

To design your own chop, see page 89.

PAPER

Chinese and Japanese calligraphers alike prefer smooth, white, uncoated paper. Made in the past from bamboo, hemp, worn-out fishing nets, and bark, what is today known as "rice paper" now comes from cotton or mulberry fiber.

Buy your practice paper as pads of separate sheets, or cut individual lengths off a roll. Some stores sell paper preprinted with squares.

DIFFERENT WEIGHTS

Thick paper sold as "Xuan" or "Sumi" has a smooth front and rough back; try writing on each side of the page to understand the difference in absorbency.
Thin paper is cheaper for practice, but because it allows some of the ink to soak through to the back rather than spreading out sideways, you may need to pad it with two extra sheets to protect the desk underneath.

DIFFERENT KINDS

Copier paper is not useful for practice, since ink just sits on the surface. Use it only if you have nothing else, and don't expect it to enhance what you write.
Newsprint will teach you more about technique and ink-flow. Newspapers, in fact, make good practice paper, since the narrow columns of type serve as vertical guidelines.

POSTURE
*Brush size governs hand,
arm, and body position.*

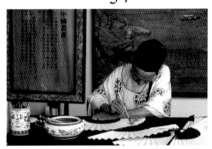

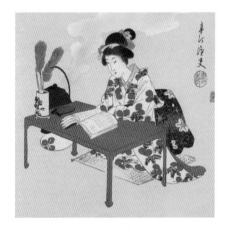

Counterclockwise from above:
kneel at a low table; sit at a desk;
kneel on the floor; stand on pave-
ment; stand—run!—on huge paper.

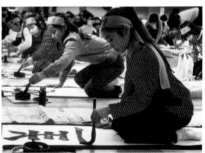

Print-
maker
Anne
Garland
shows a
sidewalk
writer us-
ing water,
not ink;
see why
on page 182.

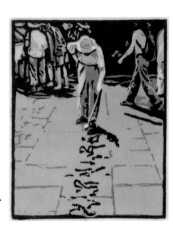

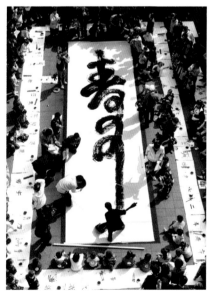

Always write on
a level surface,
to keep the ink
from pooling at
the lower end of
the stroke and
dripping, unless
you want that
effect.

Calligraphers who
write with a
huge brush made
of white horse-
tails have an
affectionate
nickname for it:
"the dirty mop."

Near left, a
plaza-sized
"longevity,"
the character
shown below.

This 15th-century scholar's long fingernails, a badge of gentle-manly leisure, do not seem to interfere with his deft hold on the brush.

HOW TO HOLD THE BRUSH

Fingers and thumb all touch the handle. Your palm should cup softly around a space the shape of an upside-down egg. Starting with the brush straight down, your fingers, wrist, and arm move it to form strokes.

When you write at a desk, your forearm and your index finger's first bone should be parallel with the surface. Cock your wrist at 45°.

Your wrist may rest on the paper for stability when you write very small. Some beginners prop their wrist on their fist or on a wrist rest like the one on page 64.

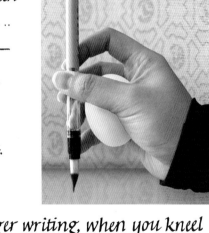

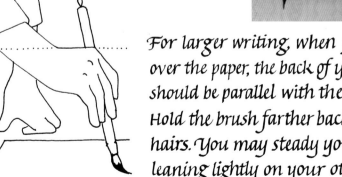

For larger writing, when you kneel over the paper, the back of your hand should be parallel with the surface. Hold the brush farther back from its hairs. You may steady yourself by leaning lightly on your other hand.

筆畫練習

MAKE YOUR OWN
PRACTICE PAPER

PRACTICE BASIC STROKES

Fold the paper into guidelines as shown at right, and ink your brush. Repeat each stroke at least twenty times, working slowly and critiquing it against the illustration. The brush should continue to move, deliberately and smoothly, whenever it is touching the paper.

Keep the tip of the moving brush in the middle of the stroke, not dragging along either edge.

Dots that evoke the natural shapes of pebbles are made by pressing the brush down and barely moving it in tiny circles.

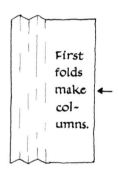

First folds make columns.

● Fold and unfold your paper the long way to to make parallel creases about 1" apart (2.5 cm). These columns guide your practice strokes.

Two dots form the ends of the horizontal stroke. Press the brush down in a small circle; lift it up a little as you move it across; pause and press a second dot; and then lift it up. (It flares at each end like a bamboo section, *not* a barbell.)

Practice these basic single strokes, pressing at the beginning or end.

One more kind of stroke adds a short triangular hook with a flick of the brush at the end of a stroke. It functions like a Roman serif.

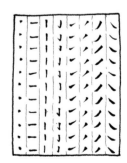

文字筆畫

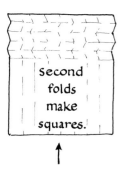

second folds make squares.

↑

• Fold and unfold your paper crosswise to make horizontal creases about 1" apart (2.5 cm). These boxes guide your practice characters.

• Add diagonal creases for the greatest precision.

STROKES COMBINE ACCORDING TO RULES

After practicing the most common brush strokes, you can learn how they make characters. Study how each one is built; copy its strokes in the numbered sequence; repeat; and then write it again from memory.

THE FIVE GOLDEN RULES FOR STROKE ORDER

Chinese construction follows these guiding principles:

 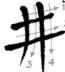 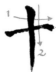 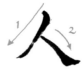 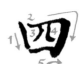

| From top to bottom | From left to right | Across before down | Diagonal left before right | Fill box before closing |

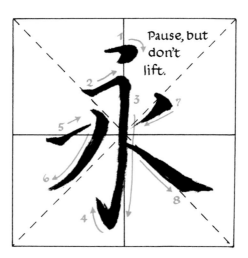

Pause, but don't lift.

THINK INSIDE THE BOX

Each character is sited in an imaginary box divided into square and diagonal quadrants.

This word, "lasting" or "forever," contains all eight basic strokes. This coincidence gives it extra meaning for Chinese calligraphers, who consider eight to be a lucky number.

PICTURES
EVOLVE INTO
CHARACTERS

IDEOGRAPHS GROW FROM SIMPLIFIED DRAWINGS

These practice characters have been chosen for you because they look so much like the pictures they came from. Most characters have evolved beyond these simplified sketches.

Study each character in its box, noting its structure and stroke order. Try to imagine the picture it is based on. Write it eight times, slowly and steadily. Compare it to the original. Some characters shrink to fit into component parts of other, more complicated characters.

To learn more characters, hand-copy the headlines translated into Chinese throughout this chapter or try characters you see in some illustrations.

12" square (30 cm) *shikishi* often spotlights a single character, such as "Congratulations," below, by Go~son.

MOUNTAIN

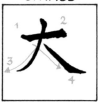

SMALL

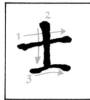

MAN

WOMAN

PEACE

FATHER

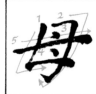

GENTLEMAN

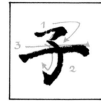

LAND OWNER

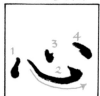

KINGDOM

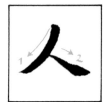

MIDDLE

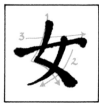

MOTHER

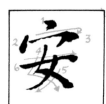

CHILD

HEART

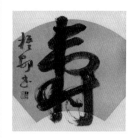

CALLIGRAPHY COMBINES DISCIPLINE...
Japanese children learn to write 960 characters in primary school, adding 1000 more in secondary school.

...AND FREEDOM
You must find a balance between controlling the ink, to tell it where you want it to stay, and playing with it, to find out where it wants to go. Once you achieve basic precision, you can learn to let the ink spread out — or fly out — beyond where the brush touches the paper.

Shinichi Maru-yama at work. See page 85.

MASTERY FIRST, THEN EXUBERANCE

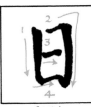

SUN

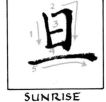

SUNRISE

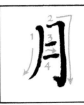

MOON

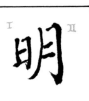

BRIGHT

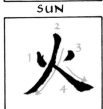

FIRE

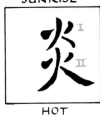

HOT

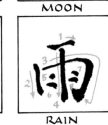

RAIN

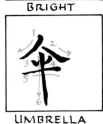

UMBRELLA

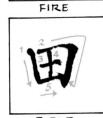

FIELD

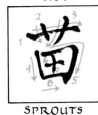

SPROUTS

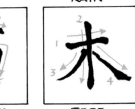

TREE

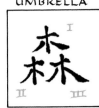

FOREST

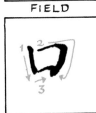

MOUTH

Words can gain new, related meanings by combining with other words.

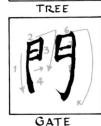

GATE

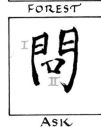

ASK

BIRD

TRADITIONAL HORSE

Many characters lost their like-ness to pictures when simplified in the 1920's.

SIMPLIFIED HORSE

其它繁體

EIGHT DIFFERENT STYLES OF "FISH"

The Kai Shu strokes and characters you have just met can be written in some half-dozen main styles.

ONE CHARACTER CAN SHOW HOW DIFFERENT WRITING STYLES EVOLVED

"Seal script" comes from symbols first scratched on bones to predict the future.	Li Shu, or "Clerical Script," is wide, and the horizontal strokes have triangular ends.	Tsao Shu, or "Mad Grass," style is written quickly in a few continuous strokes.	The Hsung Shu style popular today was simplified in the 1920's.
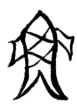	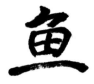		

Many minor styles have evocative names: "Round Delightful Cartoon,"*
"Pavilion Water," "Golden Slim," "New Poetry Willow," and "Mao ZeDong"

*See page 82.

INDIVIDUAL STYLES

While Chinese calligraphers begin by copying historical models, they soon seek their own unique style.

"FISH," WRITTEN FOUR WAYS BY FOUR CALLIGRAPHERS

Linda Liu	Ti-Fen Wang	Y. T. Feng	Hui-Jung Hsieh

Like writers in English who phrase their most serious thoughts in classical Latin, Japanese and Korean calligraphers write philosophy and literature in the original Chinese characters. They write their own national languages in simpler phonetic scripts based on Chinese brushstroke characters.

Robert Indiana
renders the char-
acter for "love"
with rectangular
strokes below in
a poster, and on
page 181 in three
dimensions.

HARD PENS
A broad-edged
dip pen, fountain
pen, or marker
makes a pre-
dictably thick
and thin line,
with no surprises.

A monoline dip
pen, pencil, ball-
point, or marker
makes a line of
unvarying width.

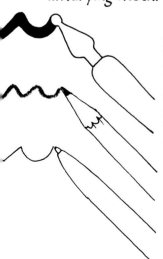

ALIEN PEN STROKES

Two new kinds of modern pens have begun to reshape Chinese calligraphy, replacing its expressive brush line with an inflexible monoline or with the geometrically predictable thick and thin line of a rigid broad-edged pen. The Chinese term "hard pen" describes the crucial distinction between these pens and the flexible brush.

Calligraphers today are experimenting with non-Chinese pens and forms. At right, hard-pen versions of the same four characters, for "American-Chinese friendship," have rigid, predetermined thick and thin strokes.

Most Chinese and Japanese people read and write with modern characters that have lost all variation of line, either in type fonts such as the one above or in everyday script like the ballpoint handwriting shown below.

Read left to right.

ORIGINS OF
CHINESE
PAGE LAYOUT

布
局

CHARACTERS LINE UP ON PAGES
The bamboo slats that Chinese scribes wrote on more than 2500 years ago, still shape the proportions of the written page today.

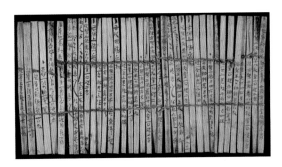

VERTICAL COLUMNS
Written one at a time and stored in bundles, bamboo slats were later sewn into mats and rolled up.

EARLY FORMATS LIVE ON IN TRADITIONAL LAYOUTS
When paper was first made, in sheets, scribes wrote on it the way they were already used to ~top to bottom~ and glued the pages together to keep them in the familiar rolled format. While most paper was eventually written on in sheets and then bound into books, traditional calligraphers preferred to write the old way in columns (and still do), preserving one of the key contrasts between a page of Roman and Chinese calligraphy.

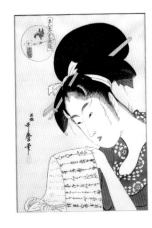

Right, a Japanese courtesan in a 19th-century print is shown reading columns from right to left.

Written in 1948 as a gift, the text of the scroll at right is a passage taken from the preface to a book on the art of calligraphy written during the Tang Dynasty, 618~907 CE. The author describes the "Running Hand" (a style of calligraphy in which the characters are not formed stroke by stroke, but rather sort of abbreviated by joining certain strokes and omitting others) of Wang Hsi-Chih and Wang Hsien-chih, a father and son team famous for their calligraphy. Their artistry is so full of life and vigor that it evokes in the author's mind vivid images:

"Observe in the characters the marvel of suspended needles and hanging dewdrops, of thundering gallops and falling rocks;

The text of the scroll at near right, continued from previous page:

the manner of wild goose flying and wild beasts frightened, of dancing phoenix and startled serpents; the semblance of cleaving banks and tumbling peaks, of perching on a precipice and clutching a crumbling tree! How some are ponderous as laden clouds, and others light as cicada wings! "Lead them, and streams flow; stop, and mountains are secured. Fine and delicate like the new moon just out of the heavenly hori~ zon, they are ranged like stars arrayed along the Milky Way. "Such calligraphy has the exquisite~ ness of Nature not attainable by mere use of force. Truly one may say that these calligraphers excel in both in~ tellect and skill; they are equally perspicacious in heart (or mind) and hand. Their ink is not aimless~ ly activated; each application has a reason."

CLASSIC TEXTS
Two texts, in classic vertical columns that fill the page, each meditate on calligraphy as art.

The scroll at left is translated at far left.

"Writing and painting have the same source."

WAYS TO
ARRANGE
CHARACTERS

In contrast to Western calligraphy's dense blocks of text and precise rectangular margins, Chinese calligraphy balances text with asymmetrical white space that may be as large as the text area.

Beyond classic layouts in vertical columns, calligraphy can be designed for other purposes: as a single character, a horizontal line, or a two-page spread in a book.

MANY CHOICES FOR TEXT LAYOUTS

An 18th century calligrapher transformed this catalogue entry, about the Emperor's summer wardrobe, into an elegant work of art.

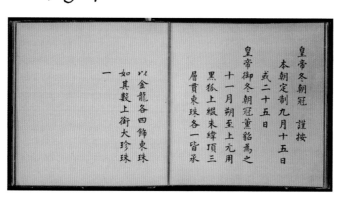

Poet and priest Minh Đức Triều Tâm Ảnh places the character for "heart" next to a poem in Roman letters, which have been used to write the Vietnamese language since the 16th century.

This quotation about peace of mind starts at the right edge with the character for "heart," 心.

The characters for "great idea" reveal the path of the brush between strokes.

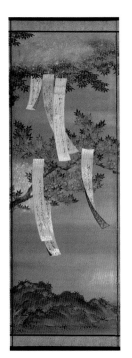

One panel from
the six-panel 17th
century screen at
right that shows
calligraphy hang~
ing from a maple
tree in autumn,
by Tosa Mitsuoki.
Many Japanese
routinely attach
short sayings,
requests, or
thanks to trees
and shrines, in
a custom similar
to the Greek
"thank you"
shown on page 4.

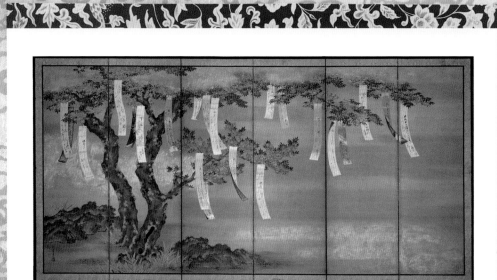

WRITING IS AT HOME, INDOORS AND OUTDOORS
*Calligraphers write characters
on many different objects,
for practical use or
fleeting display.*

A typical small gift
presented at the
Qing court, this
18th century
fan holds
Chinese
poetry
brush~
written
between
its folds.

MODERN HYBRIDS

Like all great art, Chinese calligraphy inspires artists in many other fields.

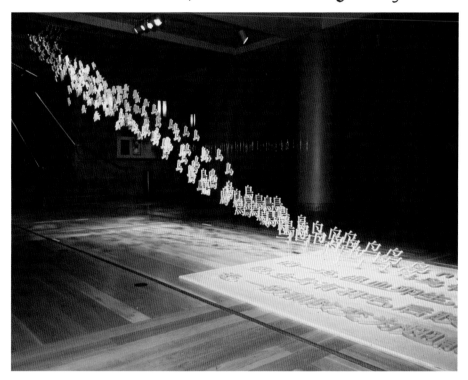

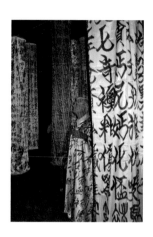

Clusters of brush-written silk columns catch the light and breeze in this installation by Lê Quốc Viet, one of a group of modern Vietnamese calligraphers nicknamed "The Gang of Five." Below, the character for "wind."

CHARACTERS ACT OUT WHAT THEY MEAN Internationally known installation artist Xu Bing lets the Chinese word for "bird" (page 73) take flight in a flock of transparent characters.

VIRTUAL CHINESE

FOUR WAYS TO MAKE ROMAN LETTERS LOOK CHINESE

;CAT — Substitute basic Chinese brush characters for their look~alike Roman counterparts.

Cat — Borrow Chinese brush technique to refresh the motions of your everyday handwriting.

rat — Merge the separate brain functions that see and read, by arranging letters into pictures.

Design your calligraphy with authentic Chinese or Japanese paper, color choices, asymmetric layout, signature stamp, scroll mounting and evocative display.

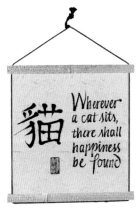

Wherever a cat sits, there shall happiness be found

ROMAN LETTERS
HAVE CHINESE
LOOK~ALIKES

Lowercase letters,
too, have their own
Chinese cousins.

SUBSTITUTIONS

Some Roman capitals already have a Chinese twin; you can invent the rest using Chinese brushstrokes.

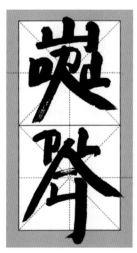

VISUAL KIN
Xu Bing's ingenious "Square Word" script writes the Roman letters in "Word Play" using simple brushstrokes and boxes them to look like Chinese characters.

FORM MERGES WITH MEANING
This logo design replaces the letter Q*with the character for "fish," written in "Round Delightful Cartoon" style. (This character is shown in eight styles on page 74.)

A 魚* UAPETS

VIRTUAL CHINESE

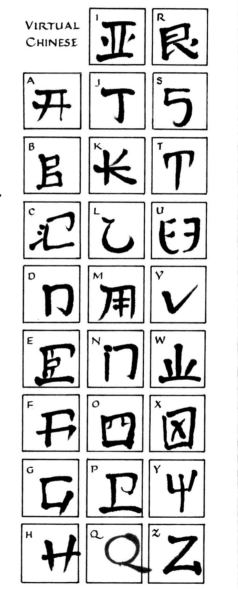

VIRTUAL TAIPEI

Writing with a sustained, confident line, Sandy Diamond turns three words from the *I Ching* into calligraphic art.

Holding a brush at a slant, like a pen, reverses the thicks and thins from where a broad-edged pen would put them. Left-handed calligraphers may find that a brush lets them write many Italic and Roman alphabets that have right-handers' thicks and thins, using a comfortable hand position at last.

THE CHINESE BRUSH LIBERATES YOUR WRITING
Study these letters in Italic family groups but write them in words, with a long, rhythmic motion.

BRUSHY ITALIC

llll uu m BASIC STROKES o s

Use guidelines from page 115 or 167, allowing the letters to float between them. Eventually, brush calligraphy moves beyond guidelines.

acdeqquy "a" BODIES

b h m n p r "b" BODIES

k v w x z SINGLE LINES fijlt DIAGONALS

*These wedges of space help distinguish Italic from other styles of calligraphy.

REORIENT THE PAGE ITSELF

By enlarging a brushy rendering of the word "May," turning it on its side, and making it white, Carl Rohrs creates an abstract, eye-catching frame for a simple typeset schedule.

INK MAKES MEDITATION VISIBLE

Your exploration of brush calligraphy should include the Zen circle, a specialty of Japanese masters but also a timeless challenge for any calligrapher. Slow down and write smoothly, to fill a page with repeated strokes. Take time out between circles to think about their shape and your motion. Don't aim for perfection, or focus on the brush only when it is touching the paper. Don't be afraid to leave the end of the stroke unattached to the beginning.

peace in
oneself
peace in the
world

Circles can add special depth to calligraphy that also includes readable letters, like this slogan by Vietnamese monk Thich Nhất Hạnh.

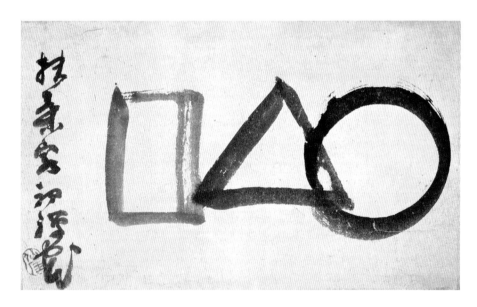

"The Universe," a deceptively simple 200-year-old Japanese painting by Sengai Gibon, has been called "The Mona Lisa of Zen painting."

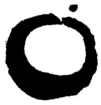

The idea of infinity, as well as its form, can inspire meditation with brush and ink.

Modern Korean calligrapher Hanong Kim, the pen name of Sun Wuk Kim, uses a circle as his symbol for "The Illimitable and the Great Absolute," centering it with a dot.

Many brush-strokes in a calligrapher's life will fall short of Zen perfection, as you can see in "The Chinese Character for Indecision" by one student.

A trail of ink, launched from the brush of Shinichi Maruyama (shown at work on page 73), created the circle at right.

A circle forms the center of "One Road," a 20th century print by Kan Kozaki.

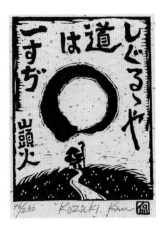

Zen calligraphy pays attention to what happens in the mind of the writer while writing, even more than what happens in the mind of the viewer while looking. Although it comes from a branch of Buddhism, Zen calligraphy appeals to people all over the world, with its balance of informality with precision, imperfection with perfection, and spontaneity with discipline.

SPELL
BY DRAWING

A mouse made from the letters
M-O-U-S-E tries to stare down
a cat made from
the letters
C-A-T.

Two cats made
from the letters
C-A-T monitor a
bird made of the
letters B-I-R-D,
protected by the
letters W-I-N-D-O-W.
Nothing moves
but the tip of a T.

A cat made from
the letters C-A-T
nurses kittens
made from the
letters K-I-T-T-E-N-S,
with her eye on a
nearby bowl of
milk made from
the letters
B-O-W-L.

JOIN VISUAL FORM
WITH LITERAL MEANING

*One of the intellectual delights of Chinese
calligraphy is how much its characters look like what they
mean. In the hands of an inventive calligrapher, letters in
English, too, can take the shape of the word they spell.*

The letters G-I-R-L form a toddler who cradles a doll made from the letter I.

Now 90 years older, carrying a purse made from the letter A, she prods the scenery with an umbrella made from the letter Y in "granny."

The fewer letters in your chosen text, the more dramatic your reader's "aha!" moment will be. To strike a balance between reading the words and seeing the shape, choose a short sentence or single word that will make it easier to emphasize any letter that could be encouraged to suggest a nose, a tail, a paw, or a hoof.

HORSE

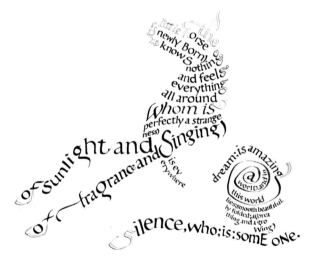

The image of a horse is made, above, from a poem by E.E. Cummings and, right, from drawings, the letters H-O-R-S-E, and archaic Seal Script and standard Kai Shu characters.

SURROUNDING THE PAGE

square *shikishi* format, page 72, has become popular in Japan, where display space at home is limited. It suits single words or short quotations in brush letters.

ELEMENTS OF THE SCROLL

Traditional scrolls frame paintings and calligraphy with elegant textures, colors, and proportions.

Heavy backing, reinforced with a thin overlay of decorative paper or silk, protects the edges of the paper. Colors and textures harmonize with the scale of the art. The backing should eventually wear out and need to be replaced.

Extra length at the top adds one more layer of backing against dust and wear when rolled.

A silk ribbon ties the scroll securely closed or serves as a loop for hanging. Metal eye~ lets above vertical straps distribute the weight evenly.

A slat on top and a dowel below let the scroll roll up without crushing and hang up without sagging.

Decorative weights are sometimes hung on the dowel to keep the scroll from flapping

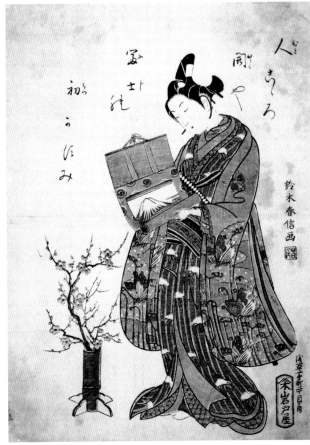

Page lay~ out for this chapter is based on a traditional scroll.

Left, a Japanese actor in an 18th~ century print unrolls a paint~ ing of Mt. Fuji, showing how a typical scroll is constructed.

You can make a chop from a 1" (2.5 cm) block of eraser, by carving out the letters or the background to a depth of ⅟₁₆" (2 mm). An outline helps make the letters of your pen name or initials look Chinese.

If you choose Chinese characters for your chop, they can stand for your name's *sound* or its *meaning* or both, plus some personal significance. A carved handle can add extra meaning:

The design here, for instance, uses three characters, *"ma wen ci,"* which mean "literate thought;" its handle symbolizes a life-long fondness for horses and a name that starts with*"ma,"*which means "horse."

The simplest leaf and bamboo strokes learned by beginners in Chinese painting create a distinctly Asian alphabet style.

CALLIGRAPHIC SPACES

Calligraphy, like all art, interacts with the world around it. Scrolls traditionally hang in the tokonoma, a special alcove in a Japanese house where bonzai, pottery, or seasonal flowers add a rich note of tranquillity. These carefully chosen elements are set in balanced asymmetry.

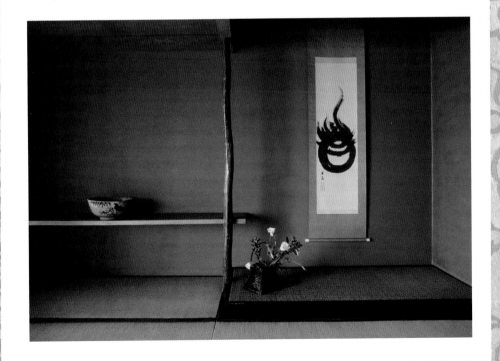

PURE BRUSH ART
Bold diagonal strokes
are anchored by
square seals in gold,
and bracketed by rect-
angles of English text
in a design by calli-
grapher Jan Owen.
Vertical panels echo
characteristic scroll
proportions.

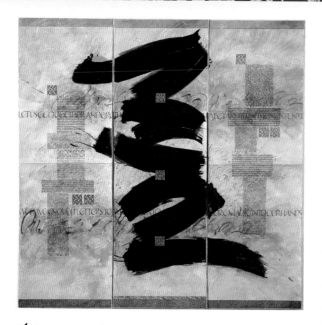

TOWARD NEW VISUAL LANGUAGES

Chinese calligraphy brings out some-
thing surprising in everyone, from painters to politicians
to poets. Many artists use it as a springboard for abstract
compositions or experiments in visual psychology.

AMBIGRAMS TURN CHINA INTO 中国

Sinologist David Moser merges the
English word and the Chinese charac-
ters that mean "China;" they each can be
read by tilting your head left or right.
The artists, linguists, and scientists who
experiment with these figures have
named them "ambigrams."

Chinese Moslem
calligrapher Haji
Noor Deen's
writing looks
Chinese in one
direction, but is
actually Arabic.
Turn it onto its
side and it be-
comes "Allah,"
above, and "In
the Name of
Allah, the most
Merciful, the
most Compas-
sionate," below
(the Bismillah
blessing shown
on page 40).

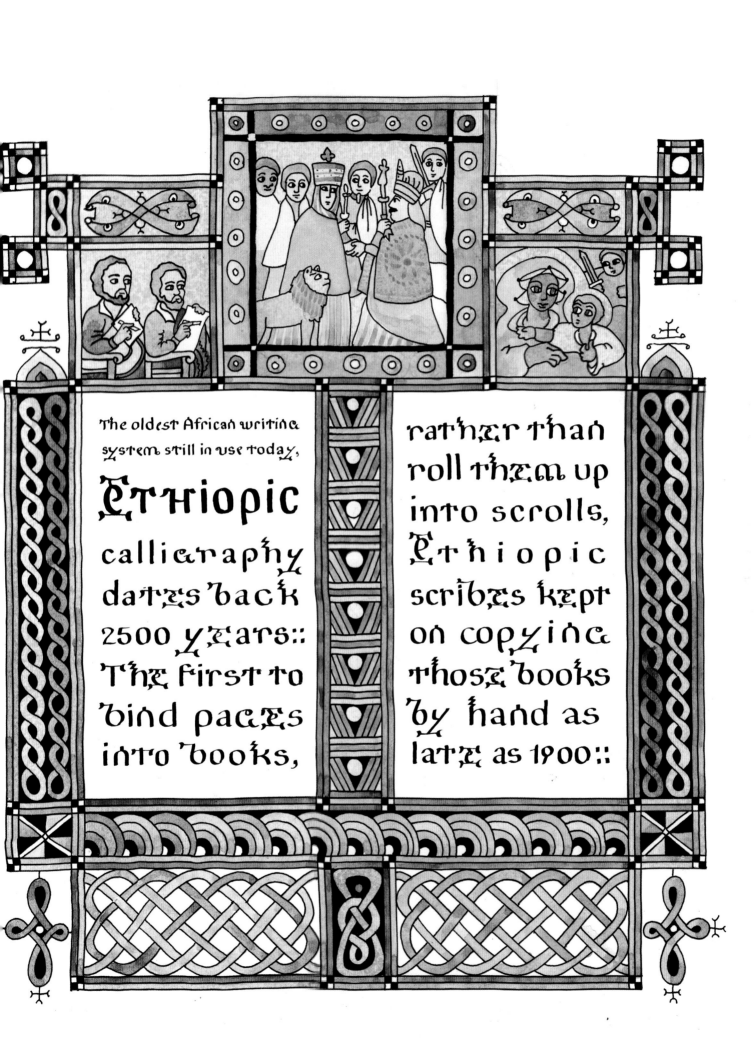

The oldest African writing system still in use today,

Ethiopic calligraphy dates back 2500 years:: The first to bind pages into books,

rather than roll them up into scrolls, Ethiopic scribes kept on copying those books by hand as late as 1900::

hä	hu	hi	ha	he	hø	ho	lä	lu	li	la	le	lø	lo	hä	hu	hi	ha	he	hø
ሀ	ሁ	ሂ	ሃ	ሄ	ህ	ሆ	ለ	ሉ	ሊ	ላ	ሌ	ል	ሎ	ሐ	ሑ	ሒ	ሓ	ሔ	ሕ

Ethiopic Basics

First learn the consonants, shown large below. Six different vowel strokes can then modify each consonant, to make the syllables shown in the borders of this page and the next.

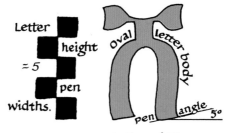

Letter height ≈ 5 pen widths.

oval letter body — pen angle 5°

Letter width = ¾–⅞ letter height.

𝔈THIOPIC

FOUR LETTER WIDTHS

Line	⎮
Single wide	ለ
Double wide	ሠ
Triple wide	መ

tä	tu	ti	ta	te	tø	to
ተ	ቱ	ቲ	ታ	ቴ	ት	ቶ

Consonants*

BASIC STROKES ⎮ () ኗ ' ⫶ ∷ ፤ ৬

ሀ	ለ	ሐ	መ	ሠ	ረ	በ	ቀ	ነ	ቸ
hä	lä	ḥä	mä	'sä	rä	bä	qä	nä	čä

ከ	ሸ	ወ	ዐ	ዠ	የ	ደ	ጀ	ገ	ጠ
kä	zhä	wä	'ä	žä	yä	dä	jä	gä	ṭä

ጨ	ጸ	ፀ	ፈ	ተ
chä	pä	dẓä	fä	tä

* This selection of consonants omits a dozen nearly identical Ethiopic sounds, making it simple to use this alphabet to transliterate names from English.

mä	mu	mi	ma	me	mø	mo	šä	šu	ši	'sa	'se	'sø	'so	rä	ru	ri	ra	re	rø
መ	ሙ	ሚ	ማ	ሜ	ም	ሞ	ሠ	ሡ	ሢ	ሣ	ሤ	ሥ	ሦ	ረ	ሩ	ሪ	ራ	ሬ	ር

bä	bu	bi	ba	be	bø	bo	qä	qu	qi	qa	qe	qø	qo	nä	nu	ni	na	ne	nø
በ	ቡ	ቢ	ባ	ቤ	ብ	ቦ	ቀ	ቁ	ቂ	ቃ	ቄ	ቅ	ቆ	ነ	ኑ	ኒ	ና	ኔ	ን

čä	ču	či	ča	če	čø	čo	kä	ku	ki	ka	ke	kø	ko	zhä	zhu	zhi	zha	zhe	zhø	zh
ቸ	ቹ	ቺ	ቻ	ቼ	ች	ቾ	ከ	ኩ	ኪ	ካ	ኬ	ክ	ኮ	ዠ	ዡ	ዢ	ዣ	ዤ	ዥ	ዥ

Practice on African guidelines from page 15.

wu	wi	wa	we	wø	wo	'ä	'u	'i	'a	'e	'ø	'o	ža	žu	ži	ža	že	žø	žo
ዉ	ዊ	ዋ	ዌ	ው	ዎ	ዐ	ዑ	ዒ	ዓ	ዔ	ዕ	ዖ	ዠ	ዡ	ዢ	ዣ	ዤ	ዥ	ዦ

Using ink made of plant soot and pens made from reeds,* Ethiopic scribes wrote onto parchment made of goatskin. To preserve its durability, they did not bleach the skin. This strong background tone necessitated widely spaced letters with simple, heavy strokes, and pictures with dark outlines, dramatic patterns, and bright colors.

Space between letters

Space between lines ≈ the height of one letter.

≈ the width of a single letter.

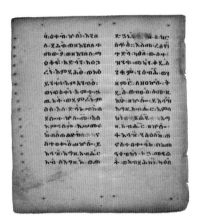

Materials Shaped the Ethiopic Letter and Page

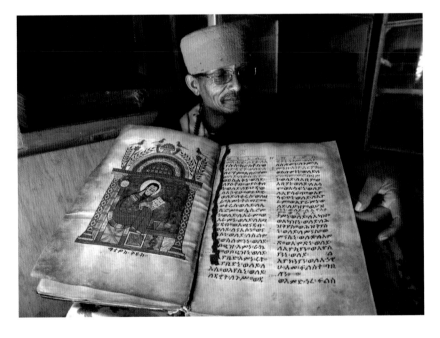

Near the edge of this parchment page, you can see tiny holes that were punched through the left and right margins of several sheets at a time and then connected with a scribing tool—the identical technique used for centuries by European calligraphers to ensure that their guidelines would stay the same from page to page.

This traditional Ethiopic manuscript balances two columns of red and black letters against a picture of St. Matthew writing

i	yu	yi	ya	ye	yø	yo	dä	du	di	da	de	dø	do	jä	ju	ji	ja	je	jø	jo
	ዩ	ዪ	ያ	ዬ	ይ	ዮ	ደ	ዱ	ዲ	ዳ	ዴ	ድ	ዶ	ጀ	ጁ	ጂ	ጃ	ጄ	ጅ	ጆ

i	gu	gi	ga	ge	gø	go	ṭä	ṭu	ṭi	ṭa	ṭe	ṭø	ṭo	chä	chu	chi	cha	che	chø	cho
	ጉ	ጊ	ጋ	ጌ	ግ	ጎ	ጠ	ጡ	ጢ	ጣ	ጤ	ጥ	ጦ	ጨ	ጩ	ጪ	ጫ	ጬ	ጭ	ጮ

i	pu	pi	pa	pe	pø	po	dzä	dzu	dzi	dza	dze	dzø	ćzo	fä	fu	fi	fa	fe	fø	fo
	ጱ	ጲ	ጳ	ጴ	ጵ	ጶ	ጸ	ጹ	ጺ	ጻ	ጼ	ጽ	ጾ	ፈ	ፉ	ፊ	ፋ	ፌ	ፍ	ፎ

*See how to mix ink and cut a reed pen, on pages 27 and 28.

VIRTUAL ETHIOPIC

You can borrow some of the letterforms directly from the Ethiopic alphabet (shown in brown ink below) and construct the others from basic strokes (black ink).

Use calligraphic moderation; if you import too many look-alikes, your reader may give up the effort to read them as Roman letters.

This distinctive Ethiopic crown and base can frame the Roman E or appear in other letters.

BASIC STROKES

Review Ethiopian letters and syllables on the previous two pages.

a b c d e f g

h i j k l m n

o p q r s t u

v w x y z &

Add floppy ears or bubble feet to vertical letter strokes, leaving ample white space around letters.

A broad-edged reed pen, metal dip pen, or marker shapes the thicks and thins of Virtual Ethiopic calligraphy. If you cut or buy the nib at an angle, you can hold the pen in a more comfortable writing position. Even the thinnest strokes are not very thin.

STRAIGHT NIB

OBLIQUE NIB

STRONG HUES SUIT ROBUST LINES *Ethiopic pages feature bold geometric shapes drawn freehand, with sophisticated color choices that enhance lively patterns. Chapter openings, sections, and holy names are emphasized by red ink or large letter size, rather than single initials.*

Ethiopian manuscript design inspired this birth announcement, which weaves the names of newborn twins and their parents into a knot.

This design centers on a picture traditionally believed to protect the reader from harm, echoing an Ethiopian proverb about the kind of friendship that never burns out. Angels are said to have half-closed eyes ◖ while demons have round, staring eyes ◉.

Genuine love and friendship is like hot glowing charcoal that is covered over with gray ashes; even if you come back to it much later, you need only poke it a little and it will rekindle to warm you anew

In lieu of authentic, expensive parchment, the texture and color of paper that is usually intended for use with pastels can provide a background for Virtual Ethiopic calligraphy. Its tones complement the heavy letters and warm, strong pigments of Ethiopic manuscripts.

OLD LETTERS, MODERN ART

Ethiopic calligraphy symbolizes ancient national roots while it inspires new art.

Bold Ethiopic letters stand out against black fabric.

Intense Ethiopic colors glow behind heavy calligraphic symbols in this large painting by Wosene Worke Kosrof.

Arabic writing along the right edge of the Coptic liturgy below transliterates archaic Ethiopic lettering for modern worshippers.

In this set of stamps celebrating 2500 years of the alphabet, the letters spell out "Addis Ababa," the capital of Ethiopia, when arranged by value.

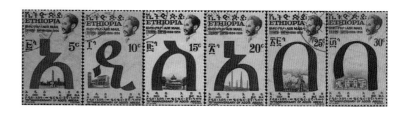

REEK CALLIGRAPHY

GREECE GAVE ENGLISH THE WORDS FOR ALPHABET, PAPER, AND INK, AND FOR CALLIGRAPHY ITSELF.*

FOR NEARLY 3000 YEARS, SCRIBES HAVE SHAPED THE GREEK ALPHABET, WITH EVERYTHING FROM PEBBLES TO PIXELS•THEY BEGAN BY SCRATCHING INSCRIPTIONS ON METAL AND CARVING THEM INTO STONE•IN ATHENS, THEY WROTE THE CLASSICS OF DRAMA, VERSE, AND PHILOSOPHY ON PAPYRUS•IN THE FIRST MILLENNIUM, THEY COPIED THE CHRISTIAN BIBLE ON PARCHMENT•AND IN THE RENAISSANCE, ITALIAN DESIGNERS CREATED TYPEFACES TO PRINT NEWLY REDISCOVERED GREEK CLASSICS ON PAPER•

TURKISH RULE OF GREECE FROM 1453 TO 1832 SUPPRESSED THE ALPHA−BETA, DRIVING IT FROM ATHENS INTO THE SMALL VILLAGES, TO SURVIVE IN PENMANSHIP AND HANDICRAFTS, UNTIL GREEK NATIONHOOD REVIVED IT•TODAY ALL THESE ERAS OFFER IDEAS FOR INSPIRED ALPHABET DESIGNS•

* Derived from the Greek words for A and B, papyrus, encaustic, and beautiful writing.

Early Greek mosaics were first built outdoors, with low resolution letters made of pebbles or square stones in a grid. They used a limited palette of earth tones: russet, ocher, and gray.

THREE GREEK TECHNIQUES SHAPED THE ALPHABET, LONG BEFORE PENS.

1. SMALL OBJECTS LINE UP TO FORM LETTERS

Ancient Greeks could make letters with scarcely any tools at all, simply by arranging pebbles or tiles into rows and grids. Low resolution simplified each letter's structure to straight lines and essential strokes. Glued down to stay put and grouted to resist wear and weather, Greek mosaic letters have lasted centuries.

 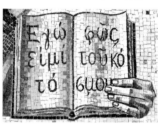

Working indoors, later mosaicists used ceramic tiles in many colors and gold, trimming some of them to make the growing number of curved and diagonal strokes in Greek letters.

2. A STYLUS PLOUGHS FURROWS INTO SOFT SURFACES

The line scratched by a stylus in wax or soft metal is visible because of contrasting color under the surface or shadows cast by dug-up material. Resistance kept the strokes that shaped the Greek letters short, shallow, straight, and stiff.

Greek students could correct their mistakes and erase fin~ished lessons by rubbing the wax smooth again with the flat end of the stylus.

A model Greek alphabet (read-ing from right to left) is incised on the rim of this wax-coated Etruscan writing tablet from the 7th century BCE.

3. A CHISEL EXCAVATES A TRENCH

Greek letters were also carved out of hard materials like wood, stone, and marble. Shadows make the grooves easy to read; red or gold paint often helps heighten the contrast.

Large letter size and the choice of marble rather than stone let carvers shape smooth curves.

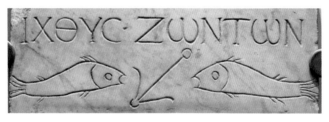

This 3rd-century Christian epitaph, ΙΧΘΥC ΖΩΝΤΩΝ, *ickthus zonton*, or "fish of the living," refers to how the two strokes of CHI, the first letter of "Christ," look like a stylized fish; 2000 years later, it still symbolizes belief for modern Christians who may not know of its calligraphic origins.

GREEK MANUSCRIPT LETTERS EVOKE MOSAIC, STYLUS, AND CHISEL FROM THE PAST.

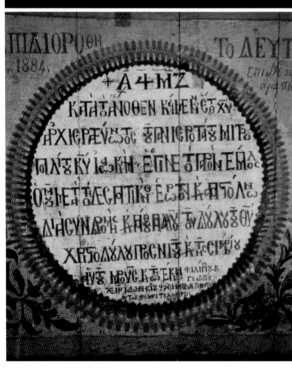

Long after smooth parchment, reed and quill pens, and permanent inks transformed Greek from rigid scratches into flowing curves, scribes still chose the older, squarer letters to dignify important words.

These 19th century capitals interlock ingeniously.

Scratched or carved letters can also be used to make an impression in soft clay; or a metal die can strike an image into metal. Although pressing and striking reverses the image, this was not a problem for early Greek letters, which do not lose their meaning when reversed. Greek, in fact, was read in both directions until about 500 BCE; sometimes the letters also flipped over when the line of writing reversed. This was called *boustrophedon*, literally "as the ox ploughs."

This 5th-century BCE coin shows the owl, symbol of Athena and of Athens, ΑΘΕ.

GREEK LETTERS SPAN THIRTY CENTURIES.

Early Greek scratched letters spread or shrank, flipped or rotated, taking many forms.
Classical carved letters were of nearly equal height and width, forming grids.
Handwritten capitals crowded together, narrowing to save page space.

ALPHA

BETA

GAMMA

DELTA

EPSILON

ZETA

ETA

THETA

IOTA

KAPPA

LAMBDA

MU

NU

XI

OMICRON

PI

RHO

SIGMA

TAU

UPSILON

PHI

CHI

PSI

OMEGA

Letters have joined or left the alphabet, and changed their form.

GREEK GUIDELINES

> Start
> here

Black and shades of reddish-orange characterize calligraphy in early Greek art.

WHATEVER WRITES ᵀₕₑ LETTER SHAPES ᵀₕₑ PAGE

Greek scribes have designed many different layouts for their letters, governed by what they wrote with and wrote on.

Scratched or painted letters were lined up in any orien~ tation, fitting into irregular spaces on objects or around pictures.

On this kylix from the 4th century BCE, the last four letters, Y, X, O, and Ψ, were additions to the existing alphabet.

A few of these letters have dropped from use.

Classical mosaics and carved letters filled rect~ angular wall panels, floors, plinths, plaques, and stelae.

Early manuscript letters were laid out with neither punctuation nor spaces to mark words and sentences.

single red initials were eventually added to start paragraphs, blossom~ ing into whole lines of decorated capitals written in color and gold.

ICONS IN MANUSCRIPTS SUGGEST THEIR OWN PAGE DESIGNS

Icons and miniatures offer the modern calligrapher many ideas, not just for letters but also for manuscript page layout, ornament, and binding.

Eastern Orthodox Christians focus intense devotion on icons, the stylized portraits of their favorite saints. Illuminators often showed St. Mark writing or holding his symbol, a gospel.

This saint's writing table holds an ink pot and pen rest. Don't believe everything you see in a picture, however. This scene perpetuates three calligraphy myths. In fact, manuscript pages were written on before, not after, they were bound into a book; scribes wrote on slanted worktables, not on their laps; and they did not leave fluffy fibers on the feathers that they cut into pens.

This vertical scroll page includes thin red lines to guide the scribe's margins.

Below, Jesus holds a Bible open to John 14: 6~7, "I am the way and the truth and the life..." By his shoulders, *Zoo~ dotes*, ζωοδότης, translates to "life giver." Colors and gold leaf were lavished on icons more than on letters.

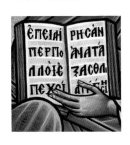

A curlicued red ZETA starts this scroll's text; a pen stroke cross ends it. Wide bands of gold paint separate the lines of writing.

A thick coat of red pigment protects the edges of this book's pages from dust.

Many Greeks today find spiritual contentment in painting faithful copies of favorite icons and the calligraphic texts they often include.

FAR-FLUNG GREEK CALLIGRAPHY

Classical Greek letters underpin much of the Western world's writing. For centuries, the journeys of conquerors, explorers, traders, and missionaries spread the alphabet around the Mediterranean and beyond in all directions. Everywhere that Greek calligraphy went, it put down roots that grew into local scripts.

NORTH

Larger-than-life letter statues in Armenia's Alphabet Park commemorate the 1600-year survival of this national script. Some familiar forms, such as PHI (φ), attest to its Greek origins.

Greek letters were adapted by 4th-century monks to introduce Christianity to Georgia and Armenia, then further modified to create Cyrillic script for missionaries to 9th-century Russia.

A 9th-century Nubian manuscript fragment.

SOUTH

Christian manuscripts in Greek also reached 5th-century Africans in Ethiopia, Egypt, and Nubia, where some of these ancient languages are still spoken and written today.

WEST

When Greek calligraphy arrived in 5ᵗʰ-century Ireland, it brought Byzantine decoration with it. Combining the Greek alphabet with local runes, Celtic scribes developed its heavily out-lined, intricately interlaced borders into a major art form.

THE EXTENDED FAMILY of GREEK CALLIGRAPHY

Abstract and ornate, XPI, the Greek CHI, RHO, and IOTA that ab-breviate *Christi* dramatize this gospel first page from the *Book of Kells*. The text continues in Latin with *gen-eratio* in much smaller Celtic uncials. Follow-ing a principle called "the hier-archy of scripts", scribes wrote the opening words of any document in older languages and scripts.

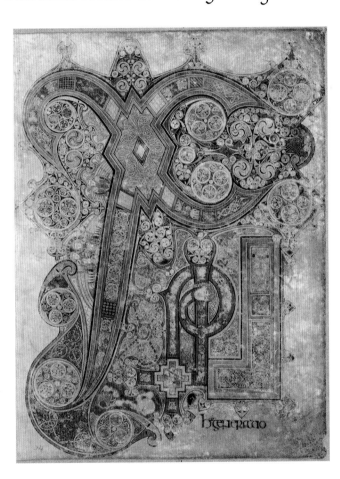

① Review the Ethiopic alpha-bet on page 92.

② Review the Cyrillic alpha-bet on pages 164~166 in the Russian chapter.

③ Review the Armenian and Georgian alpha-bets on page 176 in the Rus-sian chapter.

④ Review runes and the Celtic alphabet on page 58.

⑤ Review the Roman alphabet in *Learn Calli-graphy* and other books by Mar-garet Shepherd.

EAST

Greek writing survived centu-ries of foreign rule in Cyprus.

Cypriote artist Hambis Tsangaris uses ancient letterforms in this logo for his *skoli charaktikis*, "Printmaking School of Hambis."

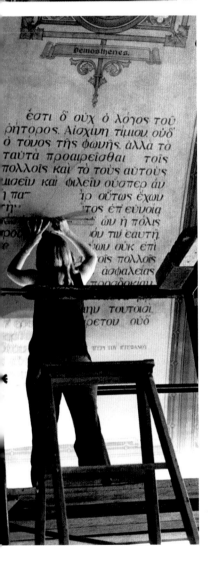

GREEK CALLIGRAPHY'S LEGACY IN AMERICA

While Greek already has a special connection with English, where 25% of the words come from Greek roots, it also stars in the political history of the United States. Athenian democracy inspired the founding fathers, who even considered making classical Greek the official written language of the new nation.

Greek is still central to the academic world as well. Less than a century ago, every educated person was expected to have a reading knowledge of classical Greek as well as Latin and sometimes Hebrew. Classicists today require Greek, of course; seminarians can't do without it; and mathematicians and physicists need its alphabet letters to express their ideas.

Shown at left in a recent restoration, a speech by Greek orator Demosthenes from the 4th century BCE adorns the century-old Boston College debating hall.

Greek letters are featured in many university seals and academic associations.
A symbol of excellence, the Phi Beta Kappa key is awarded to college seniors for high achievement in a well-rounded curriculum in the sciences and liberal arts.

Even campus groups without scholarly ambitions can dignify their fraternities and sororities with Greek letter names.

VIRTUAL GREEK

FOR ENGLISH-SPEAKING CALLIGRAPHERS

ANACHRONISM

Modern life and thought is full of ideas inherited from the Greeks, making it easy to choose texts for Virtual Greek designs.

Reconfigure Roman capitals with the stiff pen strokes, odd angles, and reversed characters of pre-Roman forms.

OUTLINE

Arrange the contours of your text into geometric panels, or let them follow the shape of specific Greek objects.

SURFACE

Scratch or carve letters into clay, or write on papyrus, to evoke Greek materials.

HUMAN DECOR

Include a figure from ancient, classical, or medieval Greek art.

Add border motifs and colors like those shown here at right.

Key Egg Wave
and
dart

RECONFIGURE ROMAN CAPITALS

Emphasize what Greek and Roman calligraphy don't have in common by choosing distinctly pre-Roman monoline letter strokes and angular letter shapes, and reversing a few letters.

THOSE THAT KNOW DO; ARISTOTLE

THOSE THAT UNDERSTAND, TEACH.

Reshape round letters into rect-angles or tall rhomboids.	Reverse some letters, but not enough to con-fuse the reader.	Energize square letters by prying up their horizon-tal strokes.	Skew a few diagonals to look less familiar.

VIRTUAL GREEK

Letter width ≈ ⅔ letter height.

Letter height ≈ 9 pen widths.

Practice Virtual Greek letters on the guidelines from page 101.

Write with a monoline pen, which does not vary from thick to thin.

ADD A BLUE BORDER
Use pen strokes to make a simple band of decoration above and below the text. Keep the repeats even by pre-measuring with light pencil marks to erase later.

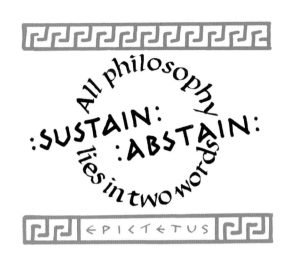

All philosophy
:SUSTAIN: :ABSTAIN:
lies in two words

EPICTETUS

When you design a letter, a block of text, or a rectangular page, you can make use of the central Greek visual principle of the Golden Ratio, a proportion of 1 to 1.618 based on the geometry and mathematics of the natural world. This ratio also underlies the pleasing proportions of Greek classical architecture.

Add extra depth to a quotation by making the author's name an integral part of the design, rather than just tacking it on as an afterthought.

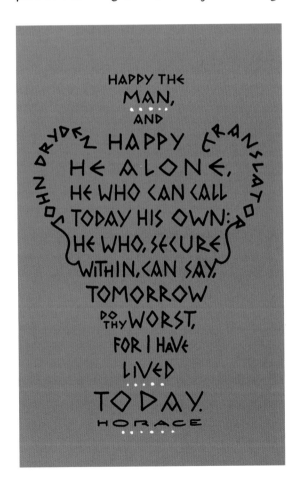

HAPPY THE
MAN,
AND
JOHN DRYDEN HAPPY TRANSLATOR
HE ALONE,
HE WHO CAN CALL
TODAY HIS OWN:
HE WHO, SECURE
WITHIN, CAN SAY,
TOMORROW
DO THY WORST,
FOR I HAVE
LIVED
TODAY.
HORACE

SHAPE A TEXT
Choose a Greek~ themed text with enough words to fill up a real or abstract silhouette. Plan your design in a series of pencil sketches and rough pen drafts, so the letters go exactly where you want them when you ink the final version.

A terracotta background strengthens the sense of a distant time and a far-away place, contrasting with the timeless human insight of the text.

OUT OF THE PAST AND OFF THE PAGE

Greek calligraphy was shaped by many materials before it ever reached the written page. Bring out its long life history with designs that call for authentic old techniques—forceful chisel lines in stone, reed pen strokes on textured papyrus, mirror images, threads of needlework, or backlit bits of colored glass.

Greek letters can be tatted in lace or embroidered on cloth.

In the 1960's, restaurant supply company executive Leslie Buck created a disposable cup to appeal to the many Greek owners of New York's pizzerias, lunch counters, and take-out shops. The blue, white, and gold cup, now a design icon, combines simple borders, an ancient amphora, and steaming coffee cups with a friendly slogan in classic Virtual Greek letters.

Echoing both early mosaics and Byzantine stained glass, "zoe" and "phos," "life" and "light," intersect at their shared OMEGA.

Papyrus, in common use around the ancient Mediterranean, is still widely available today, in tones from near-white to deep brown. Its construction of crossed strips guides horizontal writing on the front side or vertical on the back.

CALLIGRAPHY

is the physical manifestation of an architecture of the soul

P · L · A · T · O ·

The reflection of this store sign is a reminder of the Roman alphabet's legacy from Greek: letters that can still be read even when reversed.

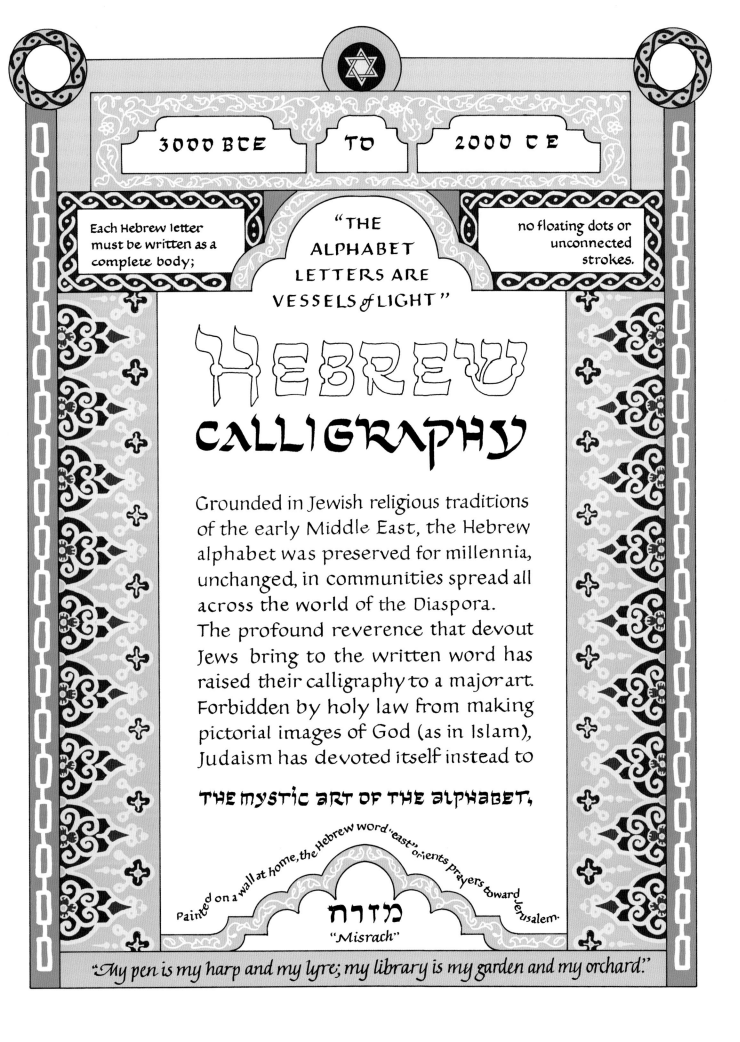

3000 BCE **TO** **2000 CE**

Each Hebrew letter must be written as a complete body;

"THE ALPHABET LETTERS ARE VESSELS *of* LIGHT"

no floating dots or unconnected strokes.

HEBREW CALLIGRAPHY

Grounded in Jewish religious traditions of the early Middle East, the Hebrew alphabet was preserved for millennia, unchanged, in communities spread all across the world of the Diaspora. The profound reverence that devout Jews bring to the written word has raised their calligraphy to a major art. Forbidden by holy law from making pictorial images of God (as in Islam), Judaism has devoted itself instead to

THE MYSTIC ART OF THE ALPHABET,

Painted on a wall at home, the Hebrew word "east" orients prayers toward Jerusalem.

מזרח
"*Misrach*"

"My pen is my harp and my lyre; my library is my garden and my orchard."

PAPYRUS OR PARCHMENT

REED OR FEATHER

The custom of enlarging certain letters in the Torah

WHAT TO WRITE ON AND WRITE WITH

is justified by fables about their supposed personalities.

PAGES

Early Hebrew scribes in the desert wrote their sacred texts on rolls of papyrus at first. Later they changed to parchment, for durability, when migration took them to colder, wetter climates.

Instead of binding their pages into books, however, they stitched the edges together to resemble papyrus scrolls from the past; this format also let them write only on the smooth side of the parchment skins.

Columns made pages.

Pages made scrolls.

The search for more durable materials led scribes to experiment with many kinds of pages,

PENS

Broad-edged pens came at first from reeds and later from feathers.

Harden a large feather in hot sand for at least one day. With a sharp knife, scrape out the tip and strip half the shaft.

Cut off ½ ~ 1" (1-2 cm) diagonally.

Cut curved shavings away from the back.

Cut straight down to square off the nib, or angle it to allow a different arm position.

Cut a ¼" (.5 cm) slit.

even writing on thin metal sheets. Some of the Dead Sea Scrolls survived 21 centuries on rolls of copper.

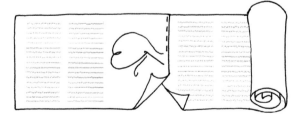

Pages and pens are made from goats, calves, reeds, turkeys, and geese.

SIX BASIC PRINCIPLES · AND · SIX BASIC PEN STROKES

Some letters of the Torah are written small; perhaps a

FUNDA~ MENTAL BUILDING BLOCKS

long-ago scribe's errors that have been sancti~ fied by custom.

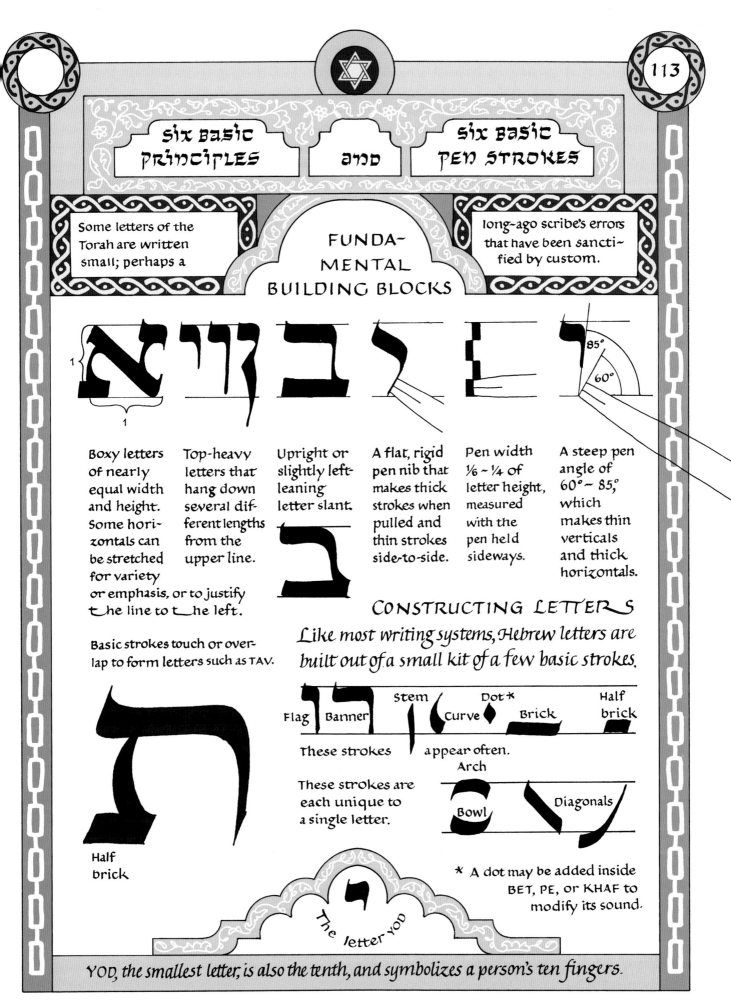

Boxy letters of nearly equal width and height. Some horizontals can be stretched for variety or emphasis, or to justify the line to the left.

Top-heavy letters that hang down several dif-ferent lengths from the upper line.

Upright or slightly left-leaning letter slant.

A flat, rigid pen nib that makes thick strokes when pulled and thin strokes side-to-side.

Pen width ⅙ ~ ¼ of letter height, measured with the pen held sideways.

A steep pen angle of 60° ~ 85°, which makes thin verticals and thick horizontals.

Basic strokes touch or over-lap to form letters such as TAV.

CONSTRUCTING LETTERS

Like most writing systems, Hebrew letters are built out of a small kit of a few basic strokes.

Flag | Banner | Stem | Curve | Dot * | Brick | Half brick

These strokes appear often.

These strokes are each unique to a single letter.

Arch | Bowl | Diagonals

Half brick

* A dot may be added inside BET, PE, or KHAF to modify its sound.

The letter YOD

THE ALPHABET in LETTER FAMILIES

Almost all Hebrew letters stay between the guidelines.

BASIC STROKES
MAKE TWENTY-SEVEN HEBREW LETTERS

Most strokes are pulled to the right and downward.

FINAL FORMS

Below, whenever TZADI, NUN, KHAF, PE, or MEM come at the end of a word, the final stroke changes its length and direction.

FAMILIES

FLAG

ז ו י
ZAYIN VAV YOD

FLAG AND BRICK

ש צ ט נ ג
SHIN TZADI TET NUN GIMEL

ץ ן
TZADI SOFIT NUN SOFIT

BANNER

פ כ ה ח ד ר
PE BET HEH KHET DALET RESH

ף ך
PE SOFIT KHAF SOFIT

Squeeze this stroke in by using a corner of the pen.

These are the only letters with an un-connected stroke.

BANNER AND BRICK

כ ת
KHAF TAV

ם
MEM SOFIT

SINGLES

מ ARCH
MEM

ס BOWL
SAMEKH

ק LONG STEM
KOF

ל SERIF
LAMED

א DIAGONAL
ALEPH

con·son·ant

ע DIAGONAL
AYIN

Vowels are usually inferred from context, or can be added to consonants as small marks.

PRACTICE GUIDELINES FOR HEBREW CALLIGRAPHY

אבגדהוזחטיכךלמםנןסעפףצץקרשת

start here

Be חזק strong!

"At the end of a book of the Torah and at the beginning of something difficult, we say *chazak!*"

Rather than write in the book, copy these guidelines or print out from margaretshepherd.com

HEBREW PAGE DESIGN

Creative page design and ingenious pen techniques

LINES AND ORNAMENTS

stretch the possibilities of the Hebrew alphabet.

Curlicues crown the letters of "In the beginning…"

In this passage, where Moses parts the waters of the Red Sea, scribes always stretch the letters and space the words to look like a brick wall.

Lines of text are bent to make curves, patterns, and pictures. in this 13ᵗʰ~century calligram.

Unlike European scribes, Hebrew calligraphers do not exaggerate and decorate single initials —in fact, there are no special capital letter-forms at all. Instead, a whole word or a short phrase is enlarged and dressed up with extra pen strokes and painted ornament around, on, and inside the letters.

This gilded wedding date, accented with dots, flower buds, curlicues, and a Star of David, is a detail from the *ketubah* on page 117.

Three strokes of the pen add a fleur-de-lis onto a 1524 letter ZAYIN by Tagliente.

Feisty cartoon people and animals pose as letters in the 1476 Kennicott Bible.

The Book of Esther is often richly decorated.

When any Hebrew letter appears alone, it stands for a number in the mystical Kabbalah.

CALLIGRAPHY DESIGNS FOR SPECIAL PURPOSES

The last word of the Torah is *Ysrael*,

SACRED WORDS AND HUMAN PROMISES

which must be spaced to end at the center of the column.

TORAH
Using a quill pen on parchment, an expert scribe must hand-copy all 304,805 letters of Judaism's holy text, the Torah. After being read it is encased in a cloth cover, decked with a medallion, and placed in an ark.

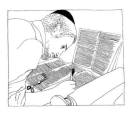

A richly decorated ketubah, Rome, 1797.

MEZUZAH
A small shrine (about the size of a thumb) on the door frame of a Jewish house holds a tiny hand-lettered scroll carrying a passage from Deuteronomy that blesses whoever comes in or goes out.

KETUBAH
A written contract, often elaborately decorated, makes an official record of a Jewish marriage ceremony.

Over the centuries, ketubah artists have lavished naive folk art as well as formal illumination on these family heirlooms.

Dozens of rules prescribe materials and techniques to be used for copying the Torah.

NEW DIRECTIONS FOR HEBREW CALLIGRAPHY

AN ANCIENT SCRIPT, REBORN

Bygone customs and local art shaped other letter styles,

as well as giving rise to cursive script for daily use.

The revival of Hebrew as a living language, and the 1948 founding of Israel, breathed new life into the Hebrew alphabet. While still firmly rooted in the religious past, it has evolved more in a few decades than most calligraphy changes in centuries.

Tiny letters outline large ones in "My Beloved is Mine," a *ketubah* by Enya Keshet.

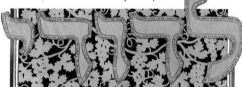

Detail

The Hebrew letters that spell "love" form a huge sculpture by Robert Indiana.

Modern pens and new techniques inspire fresh alphabet styles.

A disk nib makes lines all the same width and round at the ends.

Round or square* dots can punctuate plain strokes.

A box nib makes square-ended strokes when held at 90°... or sharp-ended strokes when held at 45°.

*see above.

A split pen outlines strokes.

An archaic letterform written on real papyrus evokes an earlier age.

Strokes and serifs represent the Hanukkah candles in a menorah, and their flames.

WHEN HEBREW AND ROMAN BLEND

FOR ENGLISH SPEAKERS

Hebrew, Arabic, Greek, and Roman letters all were derived from

ancient Aramaic phonetic symbols written with a a broad-edged pen.

VIRTUAL HEBREW CALLIGRAPHY

Interweave Hebrew and English in visual counterpoint.

שלום PEACE SHALOM

Make readable Roman by transplanting some look-alike letters, rotating others, and improvising the rest from Hebrew strokes and serifs.

SHALOM

Upside down ⌐LAM and SHIN⌐

Explore different facets of Hebrew by combining it with other languages— either closely akin or unrelated.

THE HOLY *ETHIOPIA* LAND
The Holy *EGYPT* Land
THE HOLY *ISRAEL* LAND

A 29-DAY JOURNEY FOR YOUR MIND AND SPIRIT

Early Hebrew ALEPH mirrors A.

"The...scribe is the spiritual ancestor of the sage."

HEBREW PLUS ENGLISH

Calligraphy techniques help balance two languages.

SCRIPTS BALANCE EACH OTHER

Use contrasting letter size, weight, slant, pen shape, and ink color.

CONGRATULATIONS!

Judaism's age-old focus on the written word has guaranteed Hebrew calligraphers an ongoing role in modern life, giving them many occasions to put their art to use.

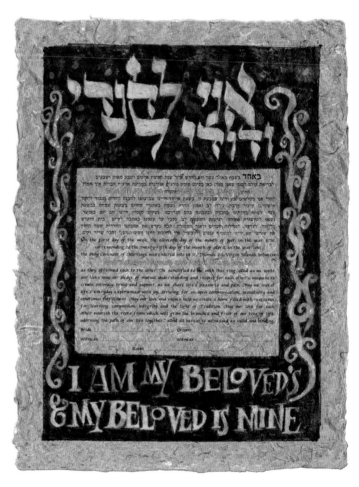

This modern ketubah by Sivia Katz includes a translation of the Hebrew marriage agreement into English, surrounded with an intense green and blue border on textured yellow-sage paper.

Multicolored psalms of praise in Hebrew and English form "Halleluyah Rainbow," a design by Betsy Teutsch for the top of a tambourine.

" A letter is a half~remembered picture."

VIRTUAL HEBREW

Warning: if you can read Hebrew, this alphabet will confuse you.

TECH-NIQUES OF TRANSFORMATION

Review Hebrew calligraphy on page 114.

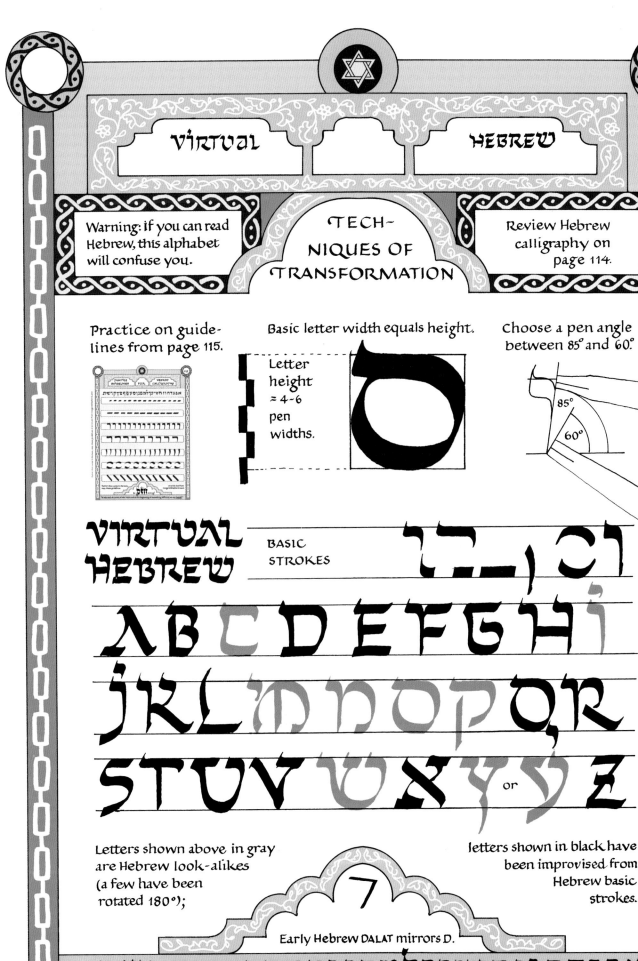

Practice on guide-lines from page 115.

Basic letter width equals height.

Letter height ≈ 4-6 pen widths.

Choose a pen angle between 85° and 60°.

85°

60°

VIRTUAL HEBREW

BASIC STROKES

A B C D E F G H

J K L M N O P Q R

S T U V W X Y Z

or

Letters shown above in gray are Hebrew look-alikes (a few have been rotated 180°);

letters shown in black have been improvised from Hebrew basic strokes.

7

Early Hebrew DALAT mirrors D.

אבגדהוזחטיכךלמםנןסעפּףצץקרשת

PEN VARIATIONS on VIRTUAL HEBREW

MORE LETTER STYLES

Different pen nibs can change the mood of basic letters,

making them light and festive, or plain and practical.

STRIPEY VIRTUAL HEBREW

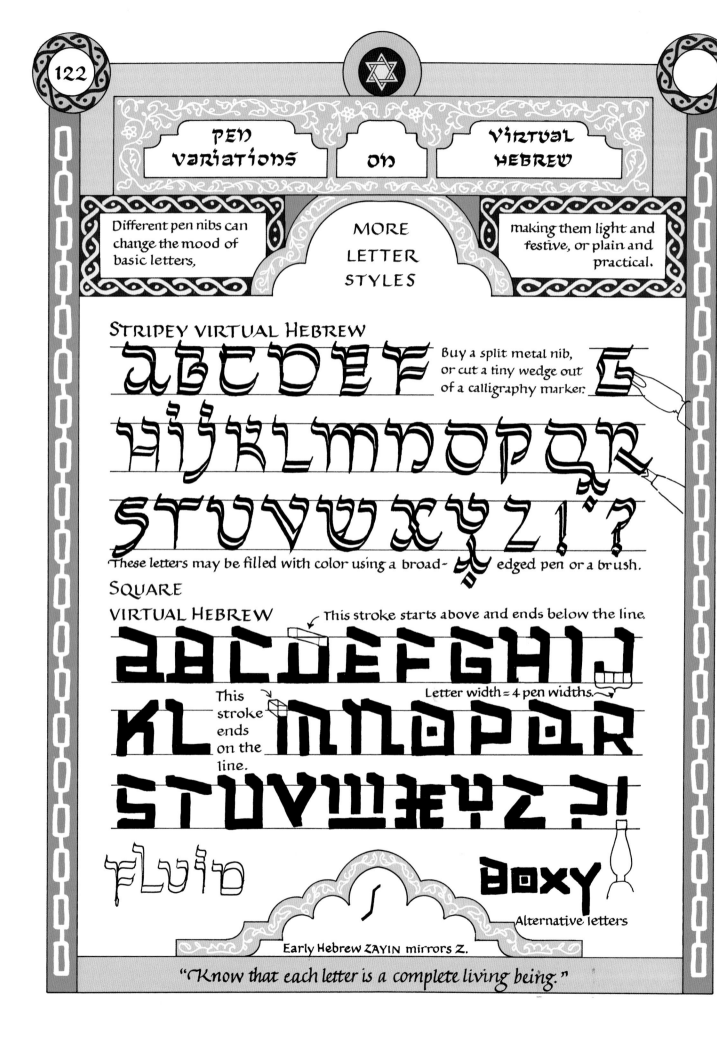

Buy a split metal nib, or cut a tiny wedge out of a calligraphy marker.

These letters may be filled with color using a broad-edged pen or a brush.

SQUARE VIRTUAL HEBREW

This stroke starts above and ends below the line.

This stroke ends on the line.

Letter width = 4 pen widths.

FLUID

BOXY

Alternative letters

Early Hebrew ZAYIN mirrors Z.

"Know that each letter is a complete living being."

VIRTUAL HEBREW in EVERYDAY DESIGNS

Balance the style of Hebrew letter serifs and strokes

MATCH LETTER STYLE WITH TEXT TOPIC

with the readability of Roman letter shapes.

American calligraphers balance Hebrew and Roman letters on the page, or cross-breed them to create Virtual Hebrew.

This 1940 campaign button uses hybrid letters to appeal to Jewish voters.

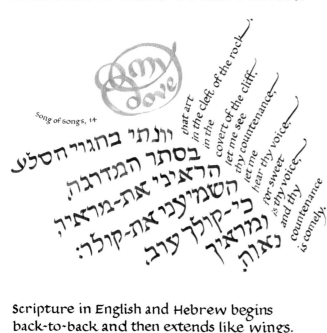

Song of songs, 14

that art in the cleft of the rock, in the covert of the cliff, let me see thy countenance, let me hear thy voice, for sweet is thy voice, and thy countenance is comely.

Scripture in English and Hebrew begins back-to-back and then extends like wings.

Required of Yale students in the late 1700s, Hebrew still appears on the University's traditional shield.

LUX ET VERITAS

Wordplay inspires this holiday greeting.

Help keep the in

KLEZMER VORKSHOP

Virtual Hebrew, textured paper, and a framed miniature of Jerusalem combine to echo an antique musical genre.

"Our involvement with letters must not...become deadly serious."

BEYOND HEBREW

Hebrew calligraphy carries distinctive graphic identity

HEBREW PLAYS WELL WITH OTHERS

whenever it combines with another country's art and words.

Inventive scribes have taken Hebrew letters in new directions by merging them with local Roman alphabet styles or building them from flexible brushstrokes.

THOU

Detail

Although classically trained in traditional calligraphy, 20<u>th</u> century artist Ben Shahn based his distinctive Hebrew and Roman letters on American roadside signage improvised by amateurs, which he admired for its originality and vigor.

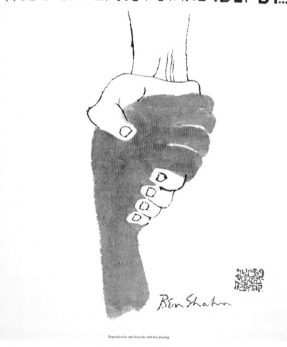

לא תעמד על-דם רעך
"THOU SHALT NOT STAND IDLY BY"...

Ben Shahn

Reproduced in 1983 from the 1966 first printing.

In a graphics juggling act, Roman letters with Hebrew shapes and serifs imitate Chinese brush characters that spell out a kosher soy sauce brand name based on a Yiddish exclamation. Designed by company founder Ed Scher.

"Oh, that my words were written! Oh, that they were inscribed in a book!"

INDIAN

DEVANAGARI*

TIBETAN*

THAI*

A vast mosaic of vividly contrasting religions, castes, races, and climates,

India is so diverse that over a dozen scripts are needed to print its money.

The Sanskrit language was first written down in the 5th century BCE using Brahmi, ancestor of today's Devanagari.

India's scripts, unlike its languages, share roots with Aramaic of the ancient Middle East,

making them distant cousins of Hebrew and Arabic, and of our own Greek and Roman calligraphic forebears.

Most of India's 22 official languages are written in Devanagari and closely related alphabets.

Devanagari scripts have also been adapted to some 200 languages far beyond its borders,

creating an alphabet family that stretches from the mountain ranges of Tibet to the jungles of Thailand.

* These three alphabets represent the major kinds of calligraphy that grew from ancient Brahmi.

Calligraphers across South and Southeast Asia could choose from two kinds of long, narrow palm fronds.

Soaked, dried, and mellowed, palmyra or talipot leaves provided a smooth, flexible writing material that resisted heat, damp, and insects.

Scribes scratched early texts on both sides of heavy palmyra-leaf pages, using a sharply pointed stylus.

An oily sludge of fine ash was then rubbed on and wiped off to make the scratched letters permanently visible.

Bold Indian scripts were redesigned with thin diagonals and curlicue strokes by the scribes of Sri Lanka

and Southeast Asia, to eliminate long or straight strokes that would split their delicate talipot leaves.

Once written, the pages were stacked between stiff covers, drilled, and threaded loosely together.

Scribes also wrote on copper strips, bark-fiber paper, woven horsehair coated with lacquer, or slats of split bamboo.

Even after scribes began to use paper, they accordion-folded it to re-create the page proportions they liked.

Parchment never gained acceptance for writing calligraphy because of religious laws, climate, expense, and its social association with low-caste tannery workers.

A *pothi*, or palm leaf manuscript, could also be made as a miniature, or trimmed into a fanciful shape.

Indian scribes cut a reed with a sharp knife to make a broad-edged pen.

Cut off a reed.

Whittle a curve.

Cut point at 90°

Slit point.

Optional oblique *

See how to cut a reed into a pen on page 27, and how to prepare ink on page 28.

Most Indian letter styles require a 120° pen angle. As shown here, you must shift how you position the pen in your hand or curl your arm around your writing.

Achieve the 120° pen angle more comfortably with your usual hand position by cutting your nib at a slant. *

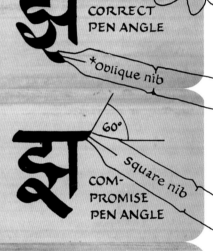

120° Square nib

CORRECT PEN ANGLE

*Oblique nib

If it is still hard for you to write with such an obtuse pen angle, changing it to an acute pen angle of 60° will let you unwind your arm. While this pen angle also makes thick horizontals and thin verticals, the curved strokes will broaden and narrow in different places, and the stroke endings will slant the opposite way.

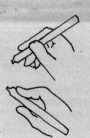

60° Square nib

COMPROMISE PEN ANGLE

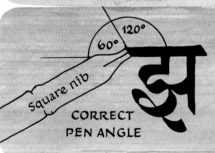

120° 60° Square nib

CORRECT PEN ANGLE

The 120° Indian pen angle, so problematic for right-handers, is an advantage for left-handers. (Pushing rather than pulling some of the strokes is smoother with a calligraphy marker or a reed pen than with a metal pen.)

Monoline nibs, which write uniform lines, let right- and left-handers use any angle.

Thiruvalluvar, a 1st century poet, holds a stylus upright in this detail. His finished palmyra-leaf pages lie in a stack on the floor before him.

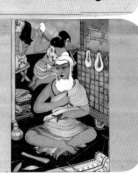

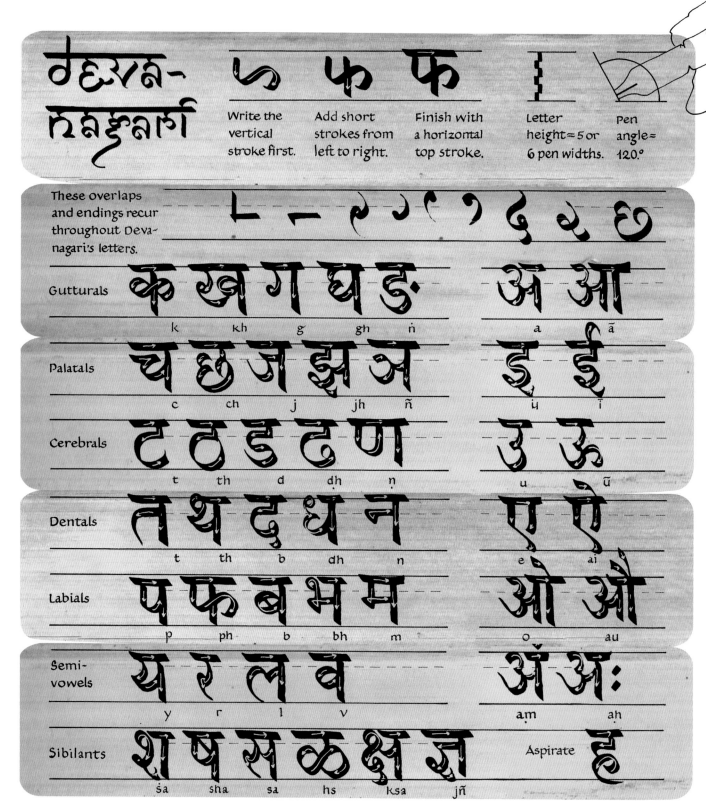

Write the vertical stroke first.	Add short strokes from left to right.	Finish with a horizontal top stroke.	Letter height ≈ 5 or 6 pen widths.	Pen angle ≈ 120.°

These overlaps and endings recur throughout Devanagari's letters.

Gutturals
क ख ग घ ङ
k kh g gh ṅ

अ आ
a ā

Palatals
च छ ज झ ञ
c ch j jh ñ

इ ई
i ī

Cerebrals
ट ठ ड ढ ण
t th d dh ṇ

उ ऊ
u ū

Dentals
त थ द ध न
t th b dh n

ए ऐ
e ai

Labials
प फ ब भ म
p ph b bh m

ओ औ
o au

Semi-vowels
य र ल व
y r l v

अँ अः
aṃ aḥ

Sibilants
श ष स ळ क्ष ज्ञ
śa sha sa hs ksa jñ

Aspirate
ह

For convenience, letters are grouped here by their pronunciation in classical Sanskrit.
Calligraphy by Stewart Thomas

Devanagari letters stay between the dotted line just above center and the solid lower line, to leave room for the long stroke on top. Thai capitals stay between the solid lines; their small letters stop at the dotted line. Tibetan letters cling to the upper guideline but descend to several lower levels. Turn the paper upside down, and end their shorter strokes on the dotted line now just below center.

Start
here

Start
here

Rather than write in the book, copy these guidelines or print out from margaretshepherd.com

PEN STROKES MAKE LETTERS
The sound "a" automatically follows an individual consonant.

ta / tai

If a different vowel sound is needed, it is placed over or under the consonant. If a consonant comes next, it forms a ligature.

LETTERS MAKE WORDS
A horizontal stroke along the top of a row of letters indicates that they form a word.

Most scripts related to Devanagari do not have this top line.

WORDS MAKE SENTENCES
Two dots mark the end of a Devanagari phrase or sentence.

SENTENCES MAKE PARAGRAPHS
Lines of writing should be separated by about the height of one letter.

तैलाद्रक्ष जलाद्रक्ष
रक्ष मां श्लथबंधनात
आखुभ्यः परहस्तेभ्यः
एशः वदति पुस्तकं *

Palm leaf proportions limit paragraph size to 5–10 lines of lettering arranged in a long horizontal format.

PARAGRAPHS MAKE PAGES
Filled with text, page numbers, pictures, and short vertical borders,

narrow leaves must also accommodate binding holes at one end, at both ends, or in the middle of the page.

PAGES MAKE BOOKS
Loose pages and strong wooden covers are threaded on twine to form a book.

The finished book may be further protected in a cloth wrapping and a storage box.

*A copyist's colophon ends one book with this plea in Sanskrit, "Protect me from water, protect me from oil, and protect me from being loosely tied. Protect me from mice and from strangers' hands. Thus says the book."

ADDING COLOR AND ORNAMENT

Buddhism's original emphasis on chanting out loud, reinforced by its distrust of earthly pleasures, confined early scribes to writing simple pages of unadorned letters. Rich and influential patrons, however, eventually persuaded them to embellish their manuscript pages with colored lettering, ornate borders, and intricate illustrations.

JAVA

Pigmented inks let the calligrapher accent certain letters and words in red, or write whole manuscripts in white, blue, gold, or silver.

TIBET

INDIA (Jain text)

Background tones range from off-white shades of buff and cream, to intense colors, to paper blackened with carbon from smoke.

THAILAND

BURMA

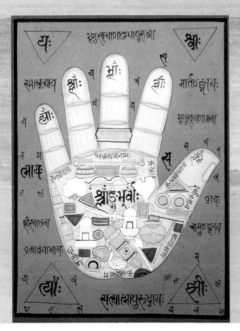

TIBET

BEYOND
MANUSCRIPTS
Bold, vividly colored calligraphic designs help readers remember

the rules for a propitious marriage, the shape of the future, and the spiritual map of the body.

INDIA ① You can see the footprints of India's Devanagari calligraphy as it spread and evolved along with Buddhism. Follow one letter, M, on its travels as it changes its style but keeps its identity.

म

TIBET ②

མ་

Alphabet, page 140

Mahayana Buddhists in Tibet believe that every spoken or written repetition of the prayer "Om mani padme hum" brings enlightenment one step closer.

Copies of the mantra are rolled up inside handheld wheels like the one at left, which people whirl while praying. Rows of large wheels outside monasteries, like those shown on page 141, are given a spin by anyone passing by.

Tibetan top strokes are written first, not last, and they do not extend beyond the letters.

Pen angles vary from 60° to 120°.

A flexible brush, held upright, may be used instead of a rigid pen. Review basic Chinese brush technique on pages 66~69.

Dots separate letters.

Squared off on top, many letters descend to a sharp point.

Consonant-vowel combinations do not merge side to side but stack up vertically.

"Om," the word that starts the mantras above, has inspired hundreds of calligraphic interpretations.

B YOGA CENTER

"Om" forms a yoga studio's logo. Designed by Kyle McCreight~Carroll.

...AND EAST TO SOUTHEAST ASIA

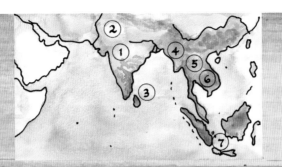

The scripts that carried the texts of Theravada Buddhism southeast from India to Sri Lanka and beyond developed thinner strokes, less line contrast, rounded letter bodies, floating parts, and swashed crowns.

SRI LANKA ③

Sri Lankan Sinhalese script is made of curlicues with a flowing, pressure-sensitive line. In a memoir, Michael Ondaatje likens it to "the small bones of baby birds."

BURMA ④

Directly across the Bay of Bengal from South India and Sri Lanka, Burmese scribes constructed their letters almost exclusively from segments of delicate circles.

THAILAND ⑤

Alphabet, page 142

Thai calligraphy combines flattened oval arches, delicate little bubbles, and detached vowels. Its strong vertical strokes sometimes slant, and spacing between lines is generous.

CAMBODIA ⑥

Basic Cambodian letter bodies have one, two, or three arches made with pleated serifs and dimpled curves, surrounded by a cluster of vowel marks and garnished with tiny circles.

⑦ Scripts related to Devanagari can be found as far away as Java. See Javanese calligraphy on page 131.

The far-flung family of Devanagari alphabets can be written with at least four different kinds of writing tools.

Stylized clouds fill many Asian pictures.

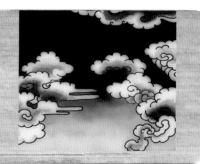

A broad-edged pen makes predictable thicks and thins; the scribe can reshape these endings by pulling ink out with one corner of the nib.

Nib moves flat on the page.

Nib moves on one corner.

A flexible brush puts in different thicks and thins than a rigid pen, while it softens and freshens the strokes.

WIDE — Brush presses heavily.

THIN — Brush presses lightly.

The letter strokes of a monoline pen stay the same weight, no matter what their direction or pen angle.

Uniform line width through-out the letter

A flat oval nib makes the rounded endings and low-contrast thick and thin strokes of Burmese "Tamarind Seed" script.

Medium-thick horizontal lines

Very thick vertical lines

A fat marker can also make low-contrast letters.

The horizontal stroke that ties together the letters of Devanagari calligraphy is aptly known as a "power." Even when punctuated by an occasional break, it sweeps the word along in an eye-catching motion. In addition, repeating the letters' short verticals and robust curves gives this group of scripts special graphic strength. The compound word shown below, "satchitananda,"* displays a range of visual ideas.

This curved top stroke unifies the letters into a visual melody,

with grace notes added by swashes, tendrils, and one red dot.

This top stroke pulls the word into a circle, with letter strokes radiating outward, while

Calligraphy here and above,

by Stewart Thomas.

it elegantly separates to show the word's three compo~ nent parts.

Leaf motifs soften these plain letters, making them seem like part of the world of nature.

Rich brown and green add to a sense of slow ripening and organic growth.

"Now"

In these typical Tibetan designs, a softly scalloped swash, accented with a thin line, cradles a short word written in brush script.

"Life"

*A compound of *sat* मत्, *cit* बित्, and *ananda* ग्रानंद्, meaning existence, consciousness, and a state of bliss.

Creative artists who push the limits of design have built on traditional South Asian scripts. Much of their calligraphy looks

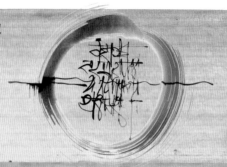

at brushwork, circular forms, and signature seals in new ways while it honors the integrity of the original letters.

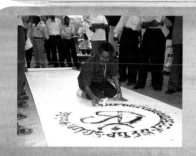

Left, master calligrapher and teacher Achyut Palav writes Devanagari in a circle. Above, a brushy blue stroke contrasts with his strong horizontal and vertical swashes.

Jean-François Bodart makes a meditative circle out of the repeating descenders of a Tibetan mantra, right. The seal means "fish" and its muscular tension when in motion.

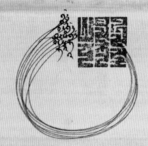

Bodart repeats curved descenders, above. While never overlapping, they suggest a circle, echoing the red "stream of existence" rectangular seal that anchors the floating line.

Calligrapher Tashi Mannox gives his Tibetan-inspired letters subtle black-over-gray backgrounds: lines behind "Black Hum," below, and text behind "Heart of Emptiness, right.

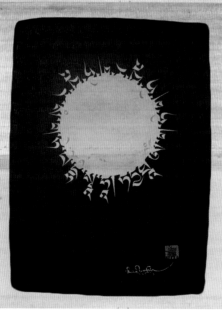

Thai letters seem to trickle out the corner of this lively design.

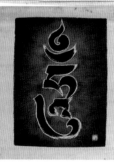

See the whole mantra, Om mani padme hum, on page 132.

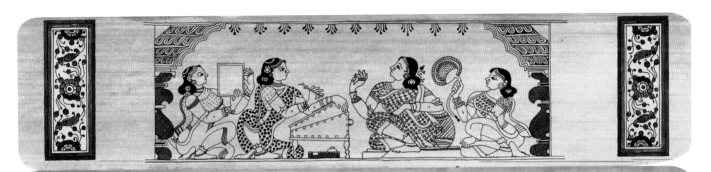

You can add the intense visual flavors of India, Tibet, and Thailand to your Roman calligraphy.

A LONG DASH ON TOP
Attach simplified Roman letters to the typical horizontal top stroke.

CELEBRATE

BRUSHSTROKES
Write a Tibetan Buddhist mantra in English with a flexible brush.

A PLAYFUL LINE
Add Thai arches, loops, bubbles, and flames to monoline Roman letters.

Above, writing a love letter, from a 19th century copy of the *Lavanyavati*, a courtly romance.

INDIAN PEN TECHNIQUES TRANSFORM ROMAN LETTERS

Sharing alphabetic roots in the ancient Middle East, both Roman and Indian scripts are based on phonetic symbols written from left to right. They employ broad-edged pens on similar surfaces made of plants, but use different techniques.

Practice with Indian guidelines on page 129. Review Devanagari calligraphy on page 128.

Make thick and thin strokes with a broad-edged dip pen, fountain pen, or marker.

The pen width should equal some 1/5 – 1/8 the height of the letter.

BOLD

LIGHT

Holding the pen at an Indian pen angle of 120° will make thick horizontal strokes and thin vertical strokes. Compromising with a more familiar Roman pen angle of 60° will reconfigure the curves and stroke endings.

Review pen angles on page 127 for right-handers and left-handers.

120°
CORRECT PEN ANGLE

COMPROMISE PEN ANGLE
60°

Virtual Indian

Based on Devanagari.

Write top stroke last.

Write lower strokes first.

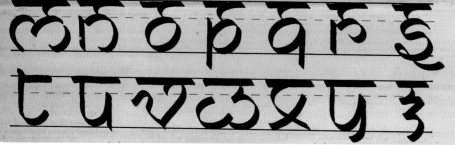

Use vowels as decorations.

Make little marks with the corner of the nib.

Devanagari's most distinctive element is its long horizontal top stroke.

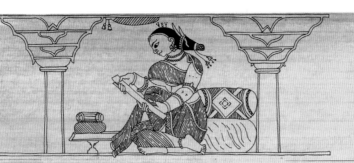

Below, four ways to connect letters to the top line:
- Extend across
- Float beneath
- Add a stroke
- Barely touch

| CROSS | FLOAT | STROKE | TOUCH |

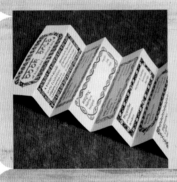

To imitate the narrow proportions of palm leaf pages, separate the blocks of text with vertical borders and pictures, and allow for binding holes if needed. These pages can be assembled into versatile booklets by accordion-folding a whole sheet, or cutting it into single pages and stringing them together on a cord.

Don't dilute the distinctive flavor of Virtual Indian calligraphy by laying it out with standard Roman page design.

RABINDRANATH TAGORE

Death does not extinguish the light: it only puts out the lamp because the dawn has come.

Indian calligraphy offers a change from a typical Western page's vertical block of text, large initial, and leafy border, as shown on page 59.

Pictures and their frames can span two leaf pages or more, as long as the breaks are incorporated into the manuscript's overall design.

When you color your pictures and borders using the bright hues of an Indian palette, don't omit hot pink, "the navy blue of India."

Above, reading a love letter, from a 19th-century copy of the *Lavanyavati*, a courtly romance.

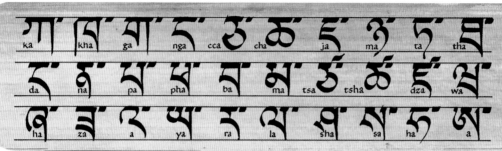

ka	kha	ga	nga	cca	cha	ja	ma	ta	tha
da	na	pa	pha	ba	ma	tsa	tsha	dza	wa
ha	za	a	ya	ra	la	sha	sa	ha	a

Write the Tibetan alphabet with a broad-edged pen at an angle of 60° or 120°, or with a brush held upright as shown on page 69.

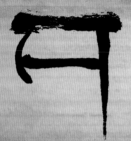

To give Roman letters the calligraphic flavor of Tibet, soften the curves, loosen the joints, narrow the top stroke to the width of the letter, sharpen the descenders, separate the letters by dots, and allow space between lines of lettering

VIRTUAL TIBETAN

WRITTEN WITH A BRUSH

BASIC STROKES

CIRCLE
One stroke

SPIRALS
In Out

Use the Indian guidelines on page 129, turned upside down to place the dotted line below center.

B C D E F G H I J K L M N

Look-alikes from the alphabet above are in orange; letters improvised from basic strokes are in black.

Dots separate letters. Add decorative strokes sparingly to heighten their effect.

O P Q R S T U V W X Y Z

See examples of Tibetan calligraphy on pages 131 and 132.

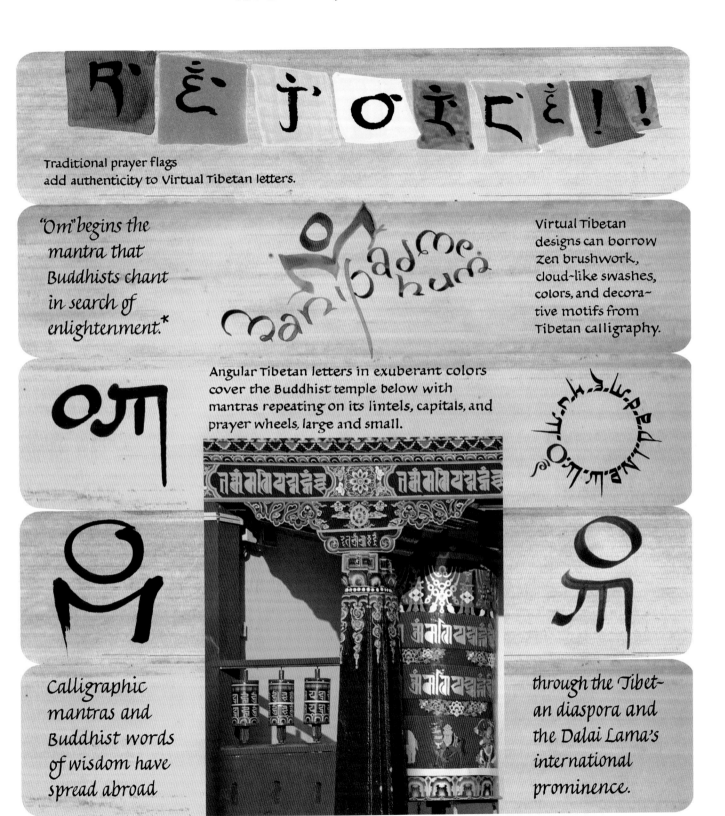

Traditional prayer flags add authenticity to Virtual Tibetan letters.

"Om" begins the mantra that Buddhists chant in search of enlightenment.*

Virtual Tibetan designs can borrow Zen brushwork, cloud-like swashes, colors, and decorative motifs from Tibetan calligraphy.

Angular Tibetan letters in exuberant colors cover the Buddhist temple below with mantras repeating on its lintels, capitals, and prayer wheels, large and small.

Calligraphic mantras and Buddhist words of wisdom have spread abroad through the Tibetan diaspora and the Dalai Lama's international prominence.

*Literally "the jewel in the lotus," om mani padme hum is interpreted many different ways, including the infinitely repeating mantra on page 180.

ROMAN LETTERS ADD THAI CHARACTERISTICS

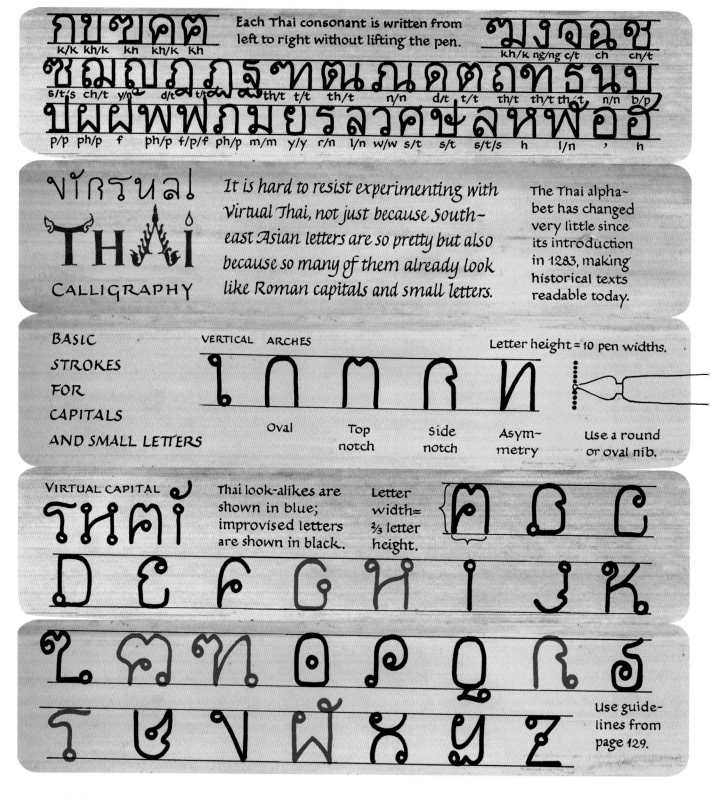

Each Thai consonant is written from left to right without lifting the pen.

k/K	kh/k	kh	kh/K	kh		kh/k	ng/ng	c/t	ch	ch/t

| s/t/s | ch/t | y/n | | d/t | t/t | th/t | t/t | th/t | | n/n | d/t | t/t | th/t | th/t | th/t | n/n | b/p |

| p/p | ph/p | f | ph/p | f/p/f | ph/p | m/m | y/y | r/n | l/n | w/w | s/t | s/t | s/t/s | h | l/n | ' | h |

It is hard to resist experimenting with Virtual Thai, not just because South-east Asian letters are so pretty but also because so many of them already look like Roman capitals and small letters.

The Thai alphabet has changed very little since its introduction in 1283, making historical texts readable today.

THAI CALLIGRAPHY

BASIC STROKES FOR CAPITALS AND SMALL LETTERS

VERTICAL ARCHES

Letter height ≈ 10 pen widths.

Oval — Top notch — Side notch — Asymmetry — Use a round or oval nib.

VIRTUAL CAPITAL

Thai look-alikes are shown in blue; improvised letters are shown in black.

Letter width = ⅔ letter height.

A B C D E F G H I J K L M N O P Q R S T U V W X Y Z

Use guidelines from page 129.

Cambodian, Burmese, and Javanese scripts, while similar to Thai, are based on rounder letter bodies.

ORNAMENTS COME FROM THE OTHER ARTS

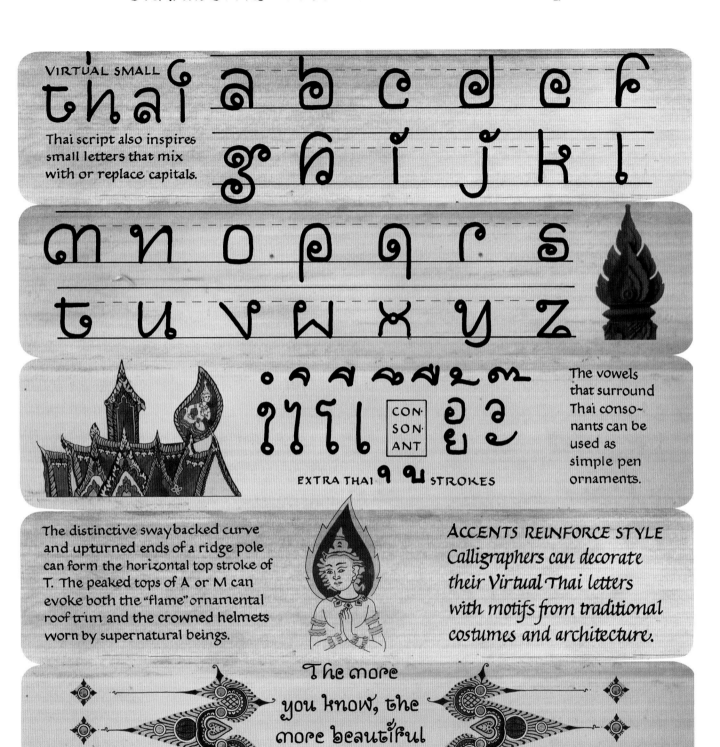

VIRTUAL SMALL

thai

a b c d e f
g h i j k l
m n o p q r s
t u v w x y z

Thai script also inspires small letters that mix with or replace capitals.

CON-SON-ANT

The vowels that surround Thai conso~ nants can be used as simple pen ornaments.

EXTRA THAI ๆ ฃ STROKES

The distinctive swaybacked curve and upturned ends of a ridge pole can form the horizontal top stroke of T. The peaked tops of A or M can evoke both the "flame" ornamental roof trim and the crowned helmets worn by supernatural beings.

ACCENTS REINFORCE STYLE
Calligraphers can decorate their Virtual Thai letters with motifs from traditional costumes and architecture.

The more you know, the more beautiful everything is.

DIFFERENT STREAMS FLOW FROM A COMMON POOL

India's cultural vigor comes from constantly producing and absorbing people, ideas, words, and art. Indian calli~

graphy has adapted to a stream of new formats and texts without losing its own visual identity.

The horizontal stroke that makes Devanagari script so distinctive can play various roles; in the festival logo above, for instance, it mimics a strip of film.

strong horizontal lines, a hallmark of Devanagari calligraphy, can be made obvious, above center, or understated, right.

GLAMOUR

What look like two separate lines, left, actually join under the M to enclose the jeweled *bindi* that an Indian woman often applies to her face.

English words in Roman letters can imitate "Tamarind Seed" letters.

See page 134.

The smallest trickle of water can wear away even the hardest block of granite.

This Virtual Burmese design is written with an oval disk pen in thick, glossy dark brown ink on yellow-orange paper and filigreed in red.

SADNESS IS NOT MUCH USE

The Dalai Lama

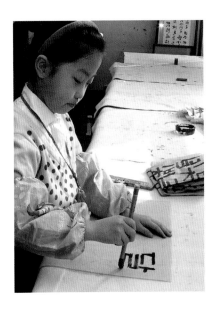

KOREAN CALLIGRAPHY

Left, a child practices Korean calligraphy, her cuffs protected from ink by plastic arm guards. Below, "Hangul" (Korean).

한
글

WHILE MOST SCRIBES INHERIT ALPHABETS THAT HAVE TAKEN CENTURIES TO EVOLVE, A LUCKY FEW CAN WRITE WITH SCRIPTS DESIGNED FROM SCRATCH.

CREATED BY A VISIONARY KING MORE THAN 500 YEARS AGO, KOREAN WRITING TODAY IS ADMIRED THE WORLD OVER FOR ITS LOGIC, VIGOR, SIMPLICITY, AND ELEGANCE.

This 18th-century *Munjado* screen elaborates the eight Confucian virtues: shamefulness, integrity, righteousness, etiquette, trust, loyalty, brotherhood, and filial piety. Animals and flowers replace some of the star-studded strokes. By this time, Chinese characters in Korea were mainly for scholarly and ceremonial use.

THE HANGUL ALPHABET "TEACHES CORRECT SOUNDS TO THE PEOPLE…"

Although Koreans have always spoken their own unique language, they wrote it with characters borrowed from China until 1443, when King Sejong introduced a simple and logical phonetic alphabet he had designed.

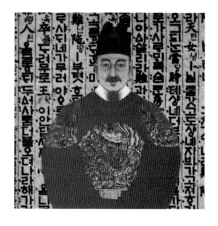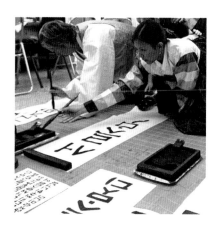

A VISIONARY LEADER'S LEGAGY TO MODERN CALLIGRAPHY

King Sejong the Great is shown with a page from his alphabet edict, which includes both new Hangul letters and old Chinese characters.

Preparing to celebrate National Hangul Day, 21st century exchange students in tradional Korean costumes learn to write the alphabet.

LOGICAL LETTERING

Korean calligraphy was invented specifically to make writing easy for everyone. For basic strokes you need only a dot, four straight lines, and a circle. You will build letters out of strokes, syllables out of letters, words out of syllables, and pages out of words.

DESIGNED *for* EVERYBODY

Custom-tailored to the sounds of the Korean language, Hangul letters raised Korea's literacy rate by letting common people learn to read and write without spending years on the 1500 Chinese characters even a farmer would need for simple transactions.

While ordinary Koreans embraced their pragmatic alphabet from the start, the upper classes clung to the use of Chinese characters for centuries, mocking Hangul with nicknames for being so simple it could be learned "in one morning" or "by girls." Japanese conquest in the early 20th century nearly wiped out the use of Hangul.

Only after World War II brought independence did politicians make Hangul a badge of national identity. Today, counterbalancing the popularity of global English, Korean artists have discovered how very modern their alphabet is. Innovative calligraphers, printmakers, typographers, clothing designers, and painters now feature it in their creative work.

WHAT TO WRITE ON

Choose Chinese or Japanese paper (brand name,"Sumi"), or news~ print. Pad your page with two more sheets to absorb excess ink.

MAKE A GUIDELINES GRID
• Fold and unfold your practice paper to leave crease marks about 1" apart (2.5 cm) or less.

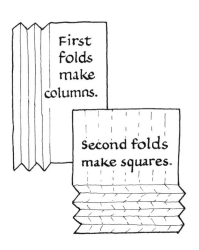

First folds make columns.

Second folds make squares.

Smooth out folds.

Practice.

• Review pages 64~ 67 in the Chinese chapter, to learn more about paper, ink, and brushes.

Learn the basic strokes in the order and direction shown here, repeating each one at least eight times.

BASIC STROKES

DOT
Vertical, horizontal, and circle strokes start with a dot.

VERTICAL

HORIZONTAL

DIAGONAL
Arch the diagonal strokes slightly.

Start with a dot.

End with a dot.

CIRCLE
Calligraphers like to start the circle stroke with a dot. The end of the stroke may close the circle but does not have to.

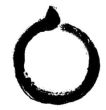

WHAT TO WRITE WITH

A calligraphy brush or a brushy marker makes the most interesting, authentic, and appealing letter strokes.

Review on pages 67~69 the Chinese brush techniques shared by Korean calligraphy— preparation, position, and practice.

The brush stays upright. Your wrist can flex less when you sit, stand, or kneel higher than your writing sur- face to write larger letters. Whatever your position, your forearm should not rest on the paper.

Korean calligraphers used to sit cross-legged or kneel (Korean floors were heated); you can choose to sit or stand, at a desk or a low table.

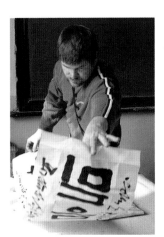

Don't be surprised if the ink soaks all the way through the paper.

STROKES CONNECT TO MAKE TWENTY-FOUR LETTERS

Letters grow from left to right and from the top down. Horizontal strokes precede vertical, but not always; follow the stroke direction arrows and sequence numbers. The main forms change their sounds systematically with each added stroke.

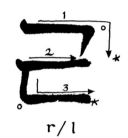

r / l

VOWELS

single-stroke forms

i

ŭ

Two-stroke forms... ...which change pronunciation when a third stroke is added

a ya

ŏ yŏ

o yo

u yu

Letters are grouped horizontally into families by basic shape and vertically by number of strokes.

Korean letters are about 20% wider than their height.

CONSONANTS

Basic forms... ...which change pronunciation when more strokes are added

°Don't lift the brush here.
✗Do lift the brush here.

k/g kh

n t/d th

s ch/j tsh

Angles show where strokes may lean away from the horizontal or vertical axis.

This stroke can leave the circle open or close it.

Below, four strokes in different configurations

ng h

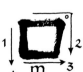 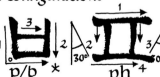

m p/b ph

The letterforms actually represent the shape of the mouth when speaking the sounds.

SYLLABLES

LETTERS CLUSTER IN BOXES

To construct a syllable, put together a consonant, a vowel, and sometimes one more consonant, fitting them inside a box.

This systematic chart of 140 consonant/vowel combinations helps you find the syllables you need, to write the sound of an English name or pronounce a Korean word.

Consonants \ Vowels		ㅏ a	ㅑ ya	ㅓ ŏ	ㅕ yŏ	ㅗ o	ㅛ yo	ㅜ u	ㅠ yu	ㅡ ŭ	ㅣ i
ㄱ	k/g	가	갸	거	겨	고	교	구	규	그	기
ㄴ	n	나	냐	너	녀	노	뇨	누	뉴	느	니
ㄷ	t/d	다	댜	더	뎌	도	됴	두	듀	드	디
ㄹ	l/r	라	랴	러	려	로	료	루	류	르	리
ㅁ	m	마	먀	머	며	모	묘	무	뮤	므	미
ㅂ	p/b	바	뱌	버	벼	보	뵤	부	뷰	브	비
ㅅ	s	사	샤	서	셔	소	쇼	수	슈	스	시
ㅇ	ø/ng	아	야	어	여	오	요	우	유	으	이
ㅈ	ch/j	자	쟈	저	져	조	죠	수	슈	즈	지
ㅊ	tsh	차	챠	처	쳐	초	쵸	추	츄	츠	치
ㅋ	kh	카	캬	커	켜	코	쿄	쿠	큐	크	키
ㅌ	th	타	탸	터	텨	토	툐	투	튜	드	티
ㅍ	ph	파	퍄	퍼	펴	포	표	푸	퓨	프	피
ㅎ	h	하	햐	허	혀	호	효	후	휴	흐	히

The syllable chart decorates this modern kimchi jar by Jeanée Redmond.

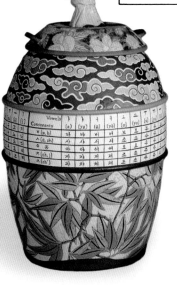

Now you can read and write Hangul, a script that inspires sa lang (love).

Korean scribes imitated Chinese calligraphy at first by writing downward in vertical columns. Although most everyday writing now goes across from left to right, like English, calligraphers still prefer to write Hangul in traditional layout.

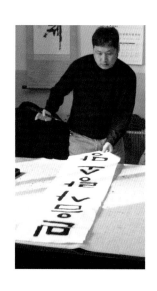

Standing at a desk lets the calligrapher write with large, smooth brushstrokes.

"Remembering," by modern Korean calligrapher Hanong Kim, the pen name of Sun Wuk Kim, follows the customary Korean square grid layout but enlivens the texture with variations in brush pressure and stroke spacing.

WŌRDS

BRUSH TECHNIQUES ENRICH PAGE TEXTURE

Like other brush scripts, Korean calligraphy offers the adventurous writer these elements to vary:

Stroke weight* can vary a little or a lot, from letter to letter or from stroke to stroke.

Letter size can vary from page to page, and even on the same page.

Stroke length can extend freely beyond the walls of the syllable's imaginary box.

PEN BRUSH

펜 붓
족

BRUSH

붓

FREEDOM

BRUSH INK PAPER

*By slowing down, or pressing down, or both at once.

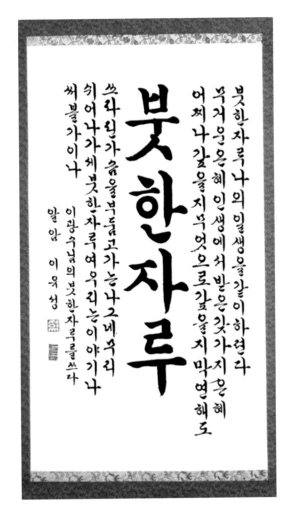

151

PAGE DESIGNS
BALANCE AN ASYMMETRIC PAGE

Hangul calligraphy is characterized by clean lines, strong brushstrokes, artfully uneven textures, and balanced asymmetry.

INK RECORDS THE RHYTHMS OF THE BRUSH In "Blue Spicules II" by Hanong Kim, ink is diluted down to gray and written with a very wet brush. The artist has encouraged it to soak into the paper unevenly, creating a halo of paler gray around the stroke wherever the brush has paused or pressed.

Bundles of horizontal strokes help stabilize the energy of slightly off-center vertical strokes.

Above, Aram, the pen name of Yoo Sung Lee, writes in elegant Hangul, "One brush is all I need for the rest of my life."

Below, Kuwaiti citizens visit an exhibition of Korean calligraphy.

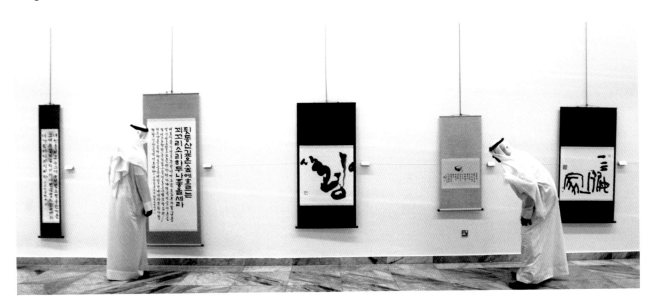

THEN AND NOW

The Hangul alphabet has been designated Korea's National Treasure #70, and is celebrated every October 9 with Alphabet Day. Its modern lines make it easy for artists to incorporate into their work.

"Hibiscus" features the national flower.

The calligraphy of Myoung-won Kwon, left, places the second syllable of the word for "love," 사 랑, along with its mirror image, under a roof made by the first syllable. The text is a poem that uses the imagery of two people in love whether they face each other or sit back to back.

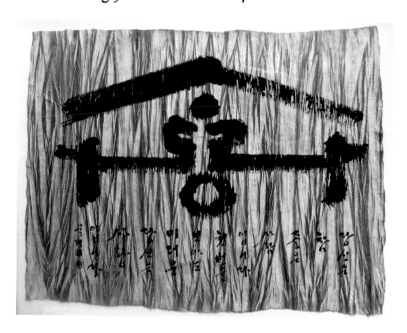

Below and right, artist and typographer Darim Kim builds on Hangul's square proportions.

Letter outlines break open at some of the spots where they touch, turning the words of the national anthem into a maze.

Letters cluster at the intersections of a trellis covered with the shadowy illusion of leaves on the paper.

VIRTUAL KOREAN

For English ~ speaking calligraphers

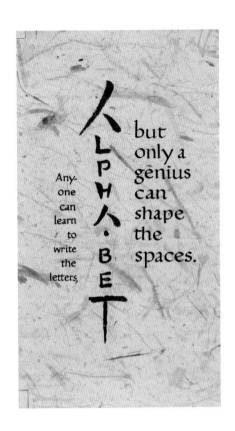

Any-one can learn to write the letters, but only a genius can shape the spaces.

WORLD WITHOUT END

What thou seest, WRITE

BORROW LOOK-ALIKES

Techniques of Korean brush calligraphy give Roman letters timeless Asian elegance.

ECHO KOREAN LAYOUT

Korean page design reconciles brushstrokes of varying weights and letters of different sizes, balancing them against carefully planned areas of white space.

ADD TRADITIONAL EXTRAS

You can strengthen your design with classic Korean color, paper, and ornament. Hang it as a scroll.

THIN WHITE LETTERS IN A RED BOX LOOK LIKE A SIGNATURE STAMP

VIRTUAL KŌREAN

Writing on absorbent paper with a calligraphy brush, or a brushy marker, adds Asian ambience to Roman letters.

Make a practice grid as shown on page 147.

You can improvise half the Roman letters using Korean basic strokes (gray). Write the rest by borrowing (black) or rotating (blue) whole letters.

Yin and yang, at the center of Korea's flag, symbolize balance, a crucial concept in Korean letters.

A dot starts these strokes.

BASIC STROKES

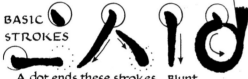

A dot ends these strokes. Blunt point

Korean visual flavor comes from the alphabet's strong bones, its wide proportions, and a sprinkling of unique forms.

Brushstrokes do not spiral, zig zag, or overlap themselves.

Many letters have wide proportions.

This appealing letter is unique to Korean calligraphy.

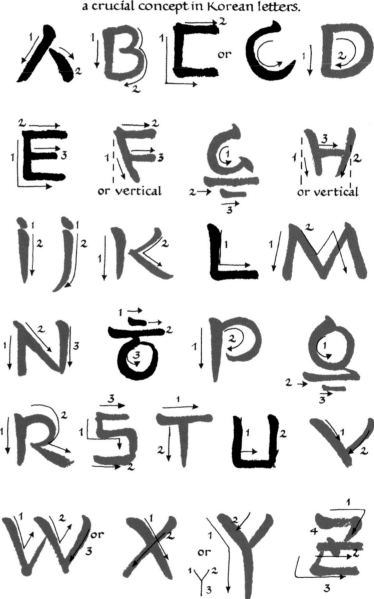

is all

we need

Classic Korean clouds frame brush letters.

Hanji paper is made in a rich spectrum of colors. Its textures vary from light and airy to thick and tough, with inclu~ sions of bark, twigs, leaves, and sparkles.

Viewers who don't know Korean will read vertical calligraphy more easily if you lay out just a word or two in a column or turn a line of lettering 90°.

Enrich your design with the textures and colors of Korean Hanji paper; add simple ornament and your signature.

In this design by HiJoju, the pen name of Ju~hyung Jo, masses of lotus blossoms and leaves frame Korean~style lowercase Roman letters. Note the characteristic Korean brushstrokes in the sharp endings for K, L, and H, and the understated little strokes on top of O and G.

Based, like Roman capitals, on pure geometric forms, Hangul shares many of its visual characteristics with the alphabet.

한글 (HANGUL)

ㅂㅅㅎㅇㅂㄴ

HANGUL

HANGUL

Hangul evolves at left into Roman, arguably its distant cousin, in this sequence by Darim Kim.

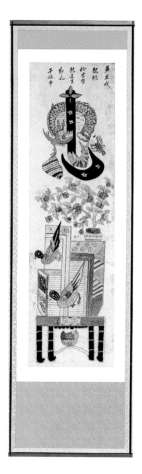
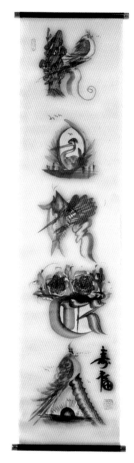

NEW OLD ART

FORMS OUT OF THE PAST

Virtual Korean calligraphy has other moods than the sturdy stoicism of Hangul. It can flex its fingers and play with ink and paper. Today's calligraphers update the vibrant Munjado characters shown on page 145 into charming souvenirs by loading their brushes with a rainbow of different ink colors. Munjado, which raised folk art to fine art in the 17th and 18th centuries, now inspires extravagant inked letters that spell out words in English for tourists.

Above left, in a detail from page 145, a *Munjado* panel elaborates one of the eight Confucian principles, loyalty. The Chinese character is made of a flexed bow aimed at the "heart" already seen on pages 72 and 78. It is further stylized to suggest a long-haired woman seen from the back, wreathed in a dragon. This *Chaekkori* genre portrays the books and writing materials of a Confucian scholar's study. Above right, a modern, multicolored rendering of K-O-R-E-A echoes these traditions.

OFF THE PAGE BUT STILL ON PAPER

Paper itself is thought to have first come from Korea to Japan in the 6th century CE, and from there to China. Korean artists take pride in using Hanji paper's wide variety of colors and textures in their work. Many household objects, both ordinary and exquisite, are still made from this paper.

This candle shade of Hanji paper combines English and Korean words for "light." A liner of translucent vellum keeps the cut out shapes flat.

MONGOLIAN CALLIGRAPHY

Genghis Khan first united the tribes of Central Asia in the early 13th century, and then went on to conquer an empire that would soon reach from the gates of Vienna to the Sea of Japan. To administer it, he adapted the Uighur writing system, which his scribes spread to every country he conquered. Although it did become the most widespread writing in Asia, the Mongol alphabet and its empire shrank back to its original boundaries after three hundred years.

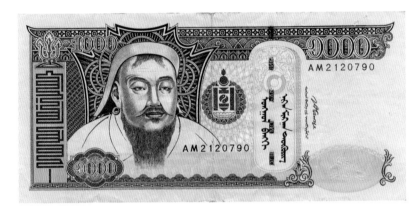

Today's printed money includes, from left to right: "Mongolia" in square script; Genghis Khan; the Soyombo★ national seal; "Mongolian National Bank" in brush script; and the bank president's signature sideways in Cyrillic.

Resisting the next five centuries of encroachment by Arabic, Chinese, and Cyrillic script, as well as the influence of Tibetan texts, Mongolians have hung on to their unique vertical calligraphy. It continues to play a vital role in artistic, religious, and political life.

Mongolian writing is a distant cousin of the Roman alphabet, as it derives from 8th-century Sogdian, which came from Aramaic, which originally descended from Phoenician. Some scholars believe that the Mongols carried this idea of a phonetic alphabet all the way to Korea.

The upturned stroke that ends "Mongolia" suggests the toe of an embroidered boot, emblem of nomad culture.

★ see page 185.

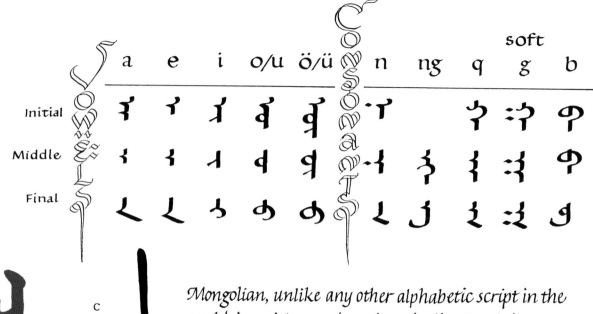

VOWELS	a	e	i	o/u	ö/ü	CONSONANTS	n	ng	q	g (soft)	b (soft)
Initial											
Middle											
Final											

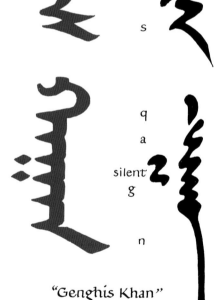

c
i
n
g
g
i
s

q
a
silent
g

n

"Genghis Khan"
in pen letters...

... or in flowing
brush script.

Mongolian, unlike any other alphabetic script in the world, is written and read vertically. Its eighteen consonants and five vowel signs join each other to spell out sounds; as in Arabic script, they take different shapes at the beginning, middle, or end of a word.

The letters connect along a spine, with points on the left and curves on the right until the end of the word, where a long stroke may extend left, right, down, or around in a circle. Most words are written with one or two strokes. Dots are added after each word is completed.

Mongolian was written with a broad-edged reed pen until the 18th century, when contact with China prompted a change to the flexible brush. (See how to choose and hold a brush, on pages 65~69.) This choice has given Mongolian scribes a variety of expressive lines.

Hold the broad-edged pen at a flat angle plus or minus 10°. You can cut the nib at a right or left slant to make holding the pen more comfortable for right- or left-handers. (See how to cut a reed pen on page 27, a technique suitable also for a marker.)

BRUSH POSITION

PEN ANGLE

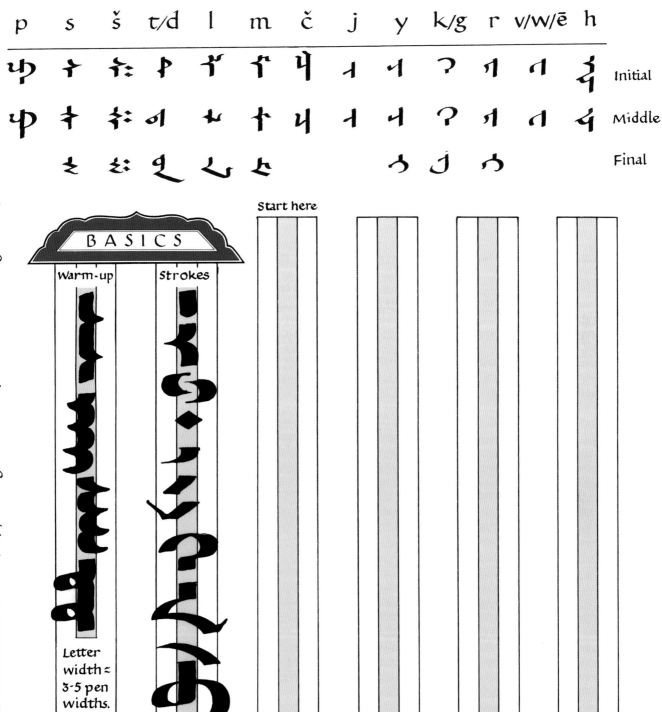

p	s	š	t/d	l	m	č	j	y	k/g	r	v/w/ē	h	
													Initial
													Middle
													Final

BASICS

Warm-up · Strokes

Start here

Letter
width ≈
3-5 pen
widths.

Spine

Mongolian terminology makes
the script seem to come alive;
calligraphers talk of a letter's
spine, belly, elbow, shin, and
tail. Another set of images
evokes a mouth with corners,
long teeth, canines, and molars.

VARIATIONS Equally at home with reed pen, flexible brush, or woodcut block, Mongolian letter artists play with their script using calligraphy techniques familiar to scribes everywhere in the world.

These variations on the word "person" are taken from…

PAGE LAYOUT INTEGRATES ECLECTIC LETTERS, SYMBOLS, AND BORDERS

Buddhist texts came to Central Asia in South Asian formats.

Although palm leaves themselves do not grow in Mongolia, copyists fit the vertical script onto paper that they cut or folded into the same narrow horizontal page layout that characterized South Asian and Tibetan texts, page 126.

These symbols mark the opening of a text, a visual way to say "ahem."

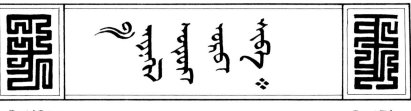

BUYOAT
"Merit"

OLJEI
"Good fortune"

Columns are lined up from left to right. Words in 'folded' script flank or frame the text.

Black and white borders use many Chinese motifs.

 Good luck symbols

 The sign for soothing a crying child.

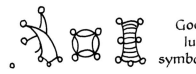

These little pen strokes mark the end of a text.

...a 1978 booklet of 100 scripts published in Inner Mongolia to inspire scribes and designers.

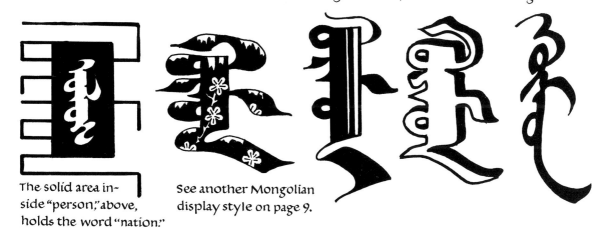

The solid area inside "person," above, holds the word "nation."

See another Mongolian display style on page 9.

Calligraphers love to play with Mongolian script, creating pictures out of phonetic letters.

The word "aguls," for "mountain," stretches and repeats to outline a landscape under the word for "cloud." Dots hover as birds.

Misty triangles form the points of A, the first letter of "mountain."

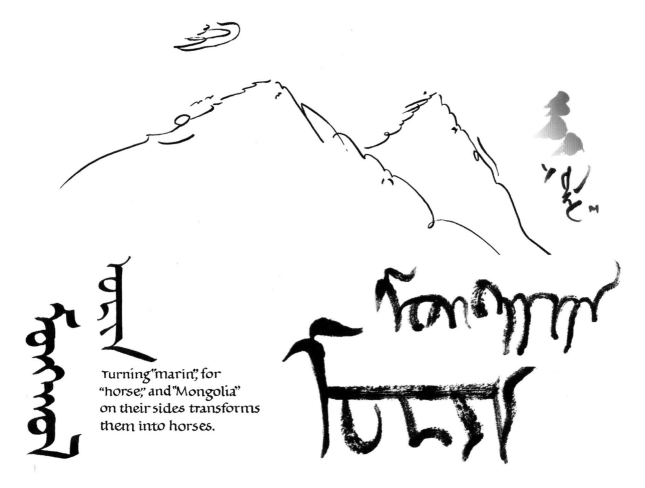

Turning "marin," for "horse," and "Mongolia" on their sides transforms them into horses.

162

"LUCKY," 8 WAYS
Borrowing a Chinese idea, Mongolian calligraphers create signatures and talismans by packing letters into circles or squares. Words can fold in English, too.

VIRTUAL MONGOLIAN LETTERS SUGGEST NATIONAL STYLE

When writing Virtual Mongolian, choose letterforms that start high and end low, right; connect some of them but separate others to keep them legible, left.

This poster by language historian and calligrapher Delger combines vigorous brush letters, gray shading, Mongolian tents and their round skylights inside O, G, and A, a banner flying from L, vertical Mongo~ lian script, and three red signature stamps (including the artist's face).

The easiest Roman letters to connect are shown larger.

RUSSIAN CALLIGRAPHY

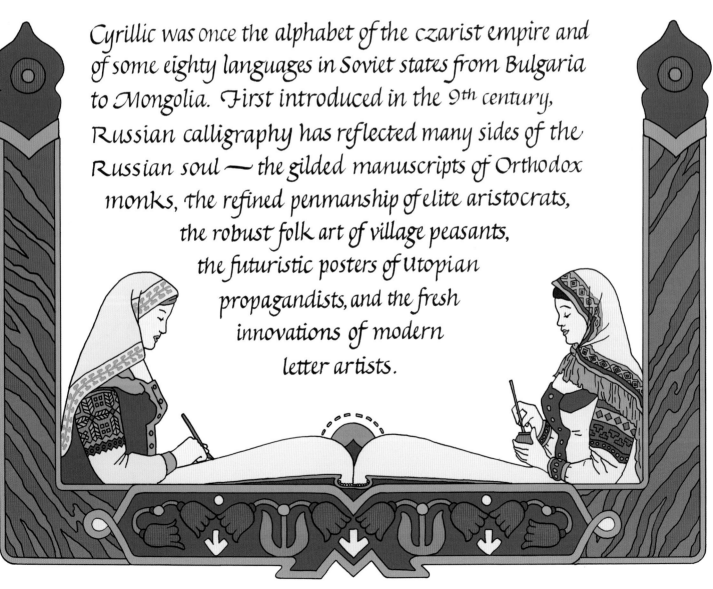

Cyrillic was once the alphabet of the czarist empire and of some eighty languages in Soviet states from Bulgaria to Mongolia. First introduced in the 9th century, Russian calligraphy has reflected many sides of the Russian soul — the gilded manuscripts of Orthodox monks, the refined penmanship of elite aristocrats, the robust folk art of village peasants, the futuristic posters of Utopian propagandists, and the fresh innovations of modern letter artists.

COMMON ROOTS, DISTINCTIVE BRANCHES

FAMILIAR ROMAN TECHNIQUES

The Cyrillic alphabet got its name from St. Cyril, who in fact designed it for his brother's mission to the Moravians in what is now Bulgaria. From there, still named after Cyril, the letters made their way to Russia.

Derived from the Greek alphabet, and oriented toward Europe during much of its history, Russian calligraphy shares many techniques with Roman. Quill pens, parchment pages, and many centuries of medieval monastic copying shaped both scripts similarly. When Renaissance typographers created fonts of coordinated capital, lowercase, and italic type, Cyrillic designers followed suit.

Geometric analysis of Cyrillic letters, as shown below, uses the same approach as Albrecht Dürer's 1525 Roman capitals.

Letter height ≈ 8 pen widths.

Letter width ≈ ¾ ~ ⅞ letter height.

When held at 45° the pen makes thick or thin diagonals.

When held at 30° the pen makes thick verticals and thin horizontals.

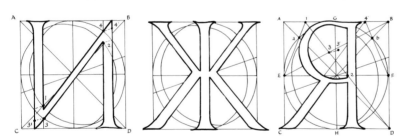

THE CYRILLIC ALPHABET

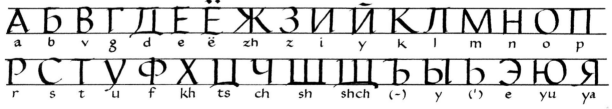

silent E To soften preceding consonant

BASIC LETTERFORMS

If you triage the Russian letters, based on how much they look like Roman, you can focus on the ones that you don't know.

JUST LIKE ROMAN

А В С Е К М Н О Р Т Х (Ё) These dots are seldom used today.

VAGUELY FAMILIAR

These letters rearrange the basic Roman strokes.

Г И Й П У Ц Ш Щ З Б Ъ Ы Ь Э Ю

The small strokes circled here play important roles.

UNIQUE

Each of these individualists seems to make its own rules.

Д Л Ф Ч Ж Я

CHOICES FOR A PERSONAL STYLE

Over the years, Russian calligraphers have improvised many different forms for these letters, often adapting strokes from one letter to reshape another.

А А А А А Д Д Л Л Л

М М М У У У Ч Ч Ч

Ф Ф С С Э Э Р Р Р

Ж Ж Ж Ж Ж Ж Ж

Collect your own letter variations from the
Russian calligraphy that you read and write.

CYRILLIC

The letters are grouped together by their shape.

BASIC STROKES Most are pulled right or down.

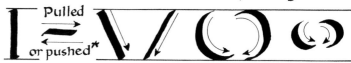

Pulled or pushed

RECTANGLE

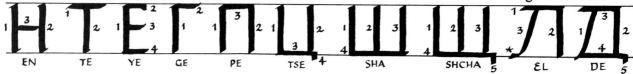

оо ← Obsolete

Extra-wide, atypical Ш derives from Hebrew ש.

These could also be diagonal letters.

EN	TE	YE	GE	PE	TSE	SHA	SHCHA	EL	DE

DIAGONAL 45° pen angle

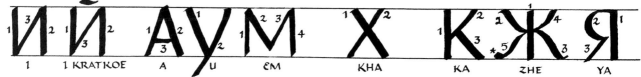

1	1 KRATKOE	A	U	EM	KHA	KA	ZHE	YA

CIRCLE

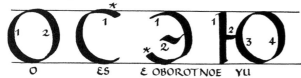

O	ES	E OBOROTNOE	YU

A tight fit vertically, these two half-circle strokes spread wider than a circle.

HALF CIRCLE

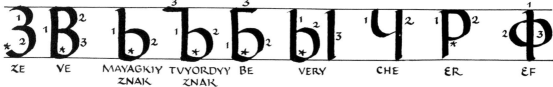

ZE	VE	MAYAGKIY ZNAK	TVYORDYY ZNAK	BE	VERY	CHE	ER	EF

LOWER-CASE

Like Roman, Cyrillic includes lowercase letters, made by first shrinking the caps about ⅔, then lowering a few of them or changing their shape.

Capitals shrink; three letters sink below the baseline; three letters change their shape.

Cyrillic Guidelines

Start
here

THE MANY ROLES OF RUSSIAN CALLIGRAPHY

Cyrillic calligraphy was the domain of the privileged few for nearly a thousand years. As literacy grew in the 20th century from 28% to 99% in 60 years, however, the written word gained central importance as the visual voice of Russia's artists.

Monastic scribes in the Orthodox Church copied illuminated manuscripts of the liturgy and gospels;

20th-century posters harnessed the genius of Russian graphic artists to the purposes of Soviet propaganda.

Today's designers push the boundaries of traditional calligraphy in pursuit of individual expression.

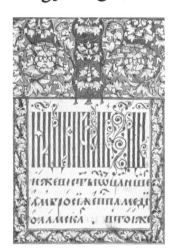

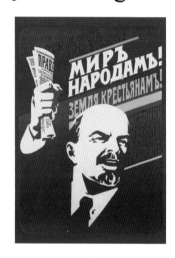

From *The Life of Saint Anthony Abbot*, the first line of bright red Old Slavonic letters is stylized with straight lines and rigid spacing until it is almost too abstract to read.

Lenin brandishes a copy of ПРАВДА, *Pravda*, the official state newspaper, and proclaims, "All power to soviets! Peace to all nations! Land to peasants! Factories to workers!"

This contemporary design by influential teacher Leonid Pronenko mingles poetry from Aleksandr Pushkin's *Ruslan and Ludmila* in among a sheaf of red strokes and blue waves.

Before the typewriter, telephone, or Internet, staying in touch across Russia's vast distances required voluminous correspondence in fine penmanship.

Words written by hand kept political resistance alive in 20th-century Russia, because even after technological progress had made communication easier in other countries, the Soviet government's stranglehold on printing presses and duplicating machines made hand-copying an essential tool for the samizdat (self-published) network of opposition writers.

Russian children still start to learn cursive handwriting as early as age seven, practicing thick and thin strokes with ink and a crowquill pen.

Many illustrators imitated the early 20th-century letter designs of Ivan Bilibin.

Both inside and outside Russia,
a misty nostalgia for the folk arts of pre-industrial villages gave rise to a graphic style that combined peasant crafts, fairy-tale images, Palekh lacquer boxes, tall medieval capitals, and imported Art Nouveau letters.

CALLIGRAPHIY
КАЛЛИГРАФИЯ

Ivan Gulkov derives his abstract letters from Old Slavonic, page 168, and edges them in carved patterns from rustic cabins.

Villu Toots, who inspired a generation of Estonian calligraphers, uses a flowing brush line to transform pens into candles, below.

see an Arabic-Cyrillic hybrid on page 56.

Vasil Chebanik balances an asymmetric Cyrillic alphabet around a repeated vertical line, left.

VERONICA LIGHT

Below, Dmitry Babenko layers alphabets from several languages in multicolored complexity.

RUSSIAN CALLIGRAPHY TODAY

Russian letter artists have inherited a legacy of traditional letters that inspire creative modern designs. Cyrillic is not Russia's only writing system; national associations include Arabic, Chinese, and Mongolian calligraphy from the republics with ethnic minorities.

VIRTUAL RUSSIAN CALLIGRAPHY

Substitute a few—but not too many!—Cyrillic look-alikes for their Roman counterparts.

You do not really understand something until you can explain it to your grandmother. (Russian proverb)

Imitate the styles of calligraphy from Russia's past, using a variety of pens:

Narrow capitals from illuminated medieval manuscripts

Delicate handwritten script from personal correspondence

Monoline block letters from the flowering of political poster design

Manuscript

Penmanship

MONOLINE

Animate letters of the alphabet with colored creatures and foliage

172

CREATE A HYBRID

You can add vivid Russian flavor without losing legibility, by substituting a few Cyrillic letterforms for the Roman letters they resemble.

Review the Cyrillic alphabet on page 166 and the alternate letter choices on page 165.

LOOK-ALIKES — ЦЩ MIRROR IMAGES — ЯИЄЭ IMPROVISED LETTERS — АЛ

These look-alikes are relatively common in English, easy to read, and unmistakably Russian. If you don't add too many of them, your left brain will read the meaning of the words in English at the same time your right brain senses the Russian origins.

THICK AND THIN STROKES
VIЯTUAL CYЯILLIC
MONOLINE STROKES
An all-purpose alphabet

Letter width ≈ ¾ ~ ⅞ letter height.

Letter height ≈ 8 pen widths.

BROAD-EDGED NIB — DISK — SQUARE — MONOLINE NIBS

ABCDЄ or ЭFGH
Add a crossbar to Л.

IJKLШNOPQ
Turn Щ upside down.

ЯSTUVШЖЧЗ

Practice with guidelines from page 167.

VARY THE SERIF, SLANT, SHAPE, OR PEN TO EVOKE A TIME AND PLACE

Calligraphy techniques can give your Roman letters overtones of an earlier Russia.

FRIEND

My Dearest,

COM-RADE!

MEDIEVAL MONASTERY

Letter width ≈ ⅜ letter height.
Letter height ≈ 10 pen widths.
Broad-edged pen
Condensed spacing
Boxes decorate strokes
Rosebud serif

CZARIST PENMANSHIP

Letter width ≈ ⅝ letter height.
Letter slant 75°
Coiled swashes and serifs
Flexible crowquill pen
Oval letter body
Long ascenders and descenders

UTOPIAN FUTURE

Letter width ≈ letter height.
Letter height ≈ 5 pen widths.
Letter slant optional
Monoline square or disk pen
Geometric lines
No serif

SYNTHESIZING RUSSIA'S PAST

The friendly, quirky shapes of this eclectic alphabet are based on medieval initials, blended with the flowing curves of early 20th-century Art Nouveau.

Named after a much-loved Russian illustrator

Letter height ≈
6 pen widths.

Add small curlicues with a corner of the calligraphy pen as you go along, or with a crowquill pen or a pointed paintbrush later on.

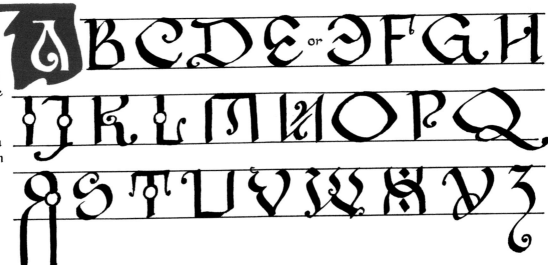

By reversing certain letters in mock~Russian style, this sign turns "The People's Republik" into "The People's Pub."

A logo for a quintessential Russian sport gets extra flavor from an emblematic chess knight atop a blue onion dome from the Kremlin.

VIRTUAL RUSSIAN DESIGNS

Art Deco letters, idealized workers and peasants, diagonal composition, and dramatic red accents energize this dynamic design for a 1929 travel brochure. A few small Cyrillic letters are camouflaged in the landscape.

Sophisticated letters capture the essence of Russian fairy tales, right, with shimmering flames, glowing colors, and exotic plumage.

In this classic Constructivist layout for a 2008 campaign poster, designers David Oei and Carolyn Hesselink boldly juxtapose blue and red backgrounds, big and small block capitals, and tilted verticals.

THE FIRSBIRD
AND OTHER
RUSSIAN FAIRY TALES

Illustrated by Boris Zvorykin

Edited and with an Introduction by Jacqueline Onassis

THE RUSSIAN TEA ROOM

Forming this noted restaurant's monogram, three genteel, delicate script capitals evoke the lace, caviar, and samovars of a vanished era.

Virtual Cyrillic letters offer a choice of styles to evoke different eras from the past— medieval manuscripts, pre-Revolutionary handwriting, folk art revival, or Constructivist propaganda. Period scripts like those shown here establish a time; ornaments define a topic; rich colors, often underpinned with red, evoke a place. Whatever the era, Russian calligraphy can lend its distinctive national flavor to the Roman alphabet.

BEYOND RUSSIAN

ALONG THE PATH TO CYRILLIC

*Four centuries before Cyrillic reached
Russia, 5ᵗʰ-century missionaries brought
Eastern Orthodox Christianity into Georgia
and Armenia. The alphabets adapted
from these Greek texts to fit local languages
took root, grew, and thrived. Despite years
of outside rule and political suppression,
they have survived as an emblem, and a
weapon, of independence. Modern calli-
graphers have found new ways to give these
unique letters the audience they deserve.*

This medal cele-
brates the 1600ᵗʰ
birthday of the
Armenian
alphabet.
(Detail
at left.)

Georgian calligraphy looks best with round
letter bodies, long ascenders, pretty swashes,
and extra space between lines.

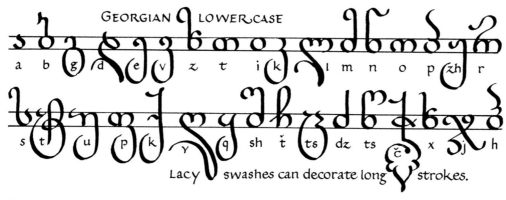

EVERYONE HAS THE RIGHT TO ENJOY THE ARTS *UDHR Article 28
United Nations*

GEORGIAN LOWER CASE

a b g d e v z t i k l m n o p zh r

s t u p k q sh t̆ ts dz ts č x j h

Lacy swashes can decorate long strokes.

Georgian calli-
graphers use
many different
styles, like this
Gothic version
of L by Alexan-
der Mikaberidze.

ARMENIAN CAPITALS

Letter height ≈ 4 pen widths. Pen angle = 0°~5°

A B G D E Z Ē Ě T' Z I L X C K H J Ļ Č

M Y N Š O Č P J́ R̄ S V T R̄ Ç W P̣ K̇ O F

Armenian looks like Ethiopic (pages 91~96), another script derived from Coptic.

OTHERWORLDLY

The scripts in this book have invited you to step outside the way you usually read and write, to see the written word through other people's eyes. Once you feel at home beyond the Roman alphabet, however, there are still more frontiers of calligraphy to explore, where letters, syllables, and characters are not the only systems available to capture meaning, and sight is not the only way to read.

In this chapter you will broaden your horizons in every direction. You will discover writing you can hear or touch, writing with four dimensions, writing that vanishes after a second, writing made of strings or jet trails, writing that no one has read for a thousand years, and writing that exists only in the imagination. Each one encourages you to linger and explore it.

DOTS

DOTS TO BE READ WITH YOUR EARS

Morse code first let people send alphabetic signals over long distances 150 years ago. Letters are made of between one and four long or short taps of a key. At first, signals were decoded at the other end by a technician who listened to and transcribed them; later they were decoded by machine into strips of printed words and pasted on a page for delivery by telegram messenger. Although eclipsed by recent telecommunications technology, Morse code still offers artists an alphabet of abstract visual texture.*

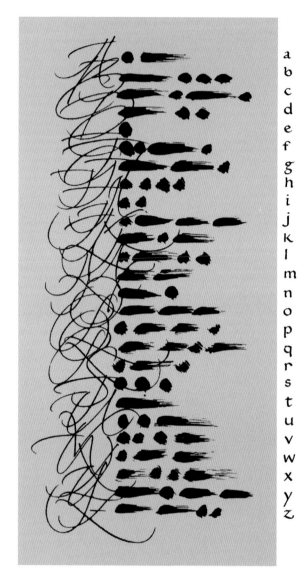

a
b
c
d
e
f
g
h
i
j
k
l
m
n
o
p
q
r
s
t
u
v
w
x
y
z

In this design Rick Cusick contrasts the lacy pen swashes of overlapping swash capitals with the bold brush dots and dashes of Morse code.

The more often a letter occurs in English, the fewer dots or dashes it requires.

Protocols for Morse code in print prescribe leaving a space the size of one dot between parts of the same letter, of three dots between letters, and of seven dots between words.

1
2
3
4
5
6
7
8
9
0

*Numerals each use five dots or dashes. The logic that they follow is shown in this chart.

A flat circle pen writes blunt dots and dashes.

A broad-edged pen tapers their endings.

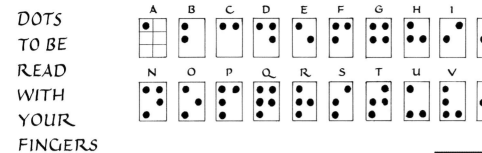

DOTS
TO BE
READ
WITH
YOUR
FINGERS

Braille, a simple system introduced in 1824, makes a set of up to 63 characters by raising dots in selected sectors of a six-dot cell.* A person who cannot see letters in ink can still feel the configuration of these raised dots with trained fingertips.

*Recent expansion to eight dots allows 255 characters. Special systems facilitate math and music transcription into Braille.

Although audio books and text-to-speech technology have reduced the need for Braille, its alphabet still helps the sight-impaired navigate the daily world of elevators, directional signs, and product labels. Thus retired from its day job, Braille has moved into the creative sphere, inspiring all kinds of artists to work its rich texture into designs that can be felt as well as seen. Both blind and sighted artists have invented Braille art in media from wallpaper, ceramics, and jewelry to embroidery, food, tattoos, and graffiti.

Penis Sired Sire Iris
Sir Den Pein Reoin
Side Dips Indri Pi
Rind Ride Dries Snipe
Inside is SnipeTrid
Prise Ped Pride Sip Id
Rin Irides Ne Rid Si
Send Prised Iris Nisi
Drips Rend Pried Rinse
Sine Ripen Nerd Dire
Spine Pen Nerds Diner
Spinier Sen Spider Sri
Sned Sipe Ser Sins Rip
Sine Spied Dips Pined

Spire Ripe Snip Spin
Pines Red Pin Pes Pine
Spend Rein Res Ides In
Ire En Nip Pie Snide
Drip Side Dip Desire
Sped Spine Siren Din
End Sniper Die Dies R E

In this wall plaque, artist Ron Esplin's strategically placed Braille dots double as the O in "focus."

Blind artist and culinary expert Julie Woods lines up her Braille biscuits to spell "inspired," then turns its letters into handwritten anagrams. Oversize dots on the I's add visual humor.

THREE DIMENSIONS

Ages ago, objects that evolved into letters had to give up their depth when they migrated from the real world onto a flat surface; today's calligraphers are moving them off the page and back into the third dimension. Abandoning pen and ink for materials that stand up on their own—or appear to—liberates letters to do surprising things.

A pen-stroke shadow can create on a flat page the illusion of solid forms with sharp edges.

When laser technology emerged a half century ago, artists were quick to see the creative potential of hologram images. The word "Boston" on this admission badge seems to recede into infinity. Because holograms are complicated to print they resist counterfeiting.

TWO DIMENSIONS ON THE PAGE CAN CREATE THE ILLUSION OF THREE DIMENSIONS IN THE MIND

The Buddhist mantra from page 132 repeats endlessly around a Möbius strip, below, an object that can be thought of as having one, two, or three dimensions.

SHALLOW DEPTH, BUT REAL
Flat but solid letters can exist in what seem like two and a half dimensions when they leave the support of a background. If they are flexible, they can be rolled, twisted, or folded into three-dimensional surfaces; if they are rigid, they can frame whatever lies behind them as though they were a window to somewhere else. Sunlight adds visual depth to free-standing letters by making them cast shadows in dramatic and ever-changing shapes.

Outdoor letters, "Music Stage Space" in Greek, cast abstract shadow images.

A perching goose lends a sense of scale to a statue by Robert Indiana of the Chinese character for "love," which is also shown flat on page 75 and in three-dimensional Hebrew on page 118.

EXTREMES OF SIZE

Although the moderate human scale of handwritten books has governed most two-dimensional calligraphy for 2000 years, books themselves range from miniature to enormous, with adventurous calligraphers constantly testing the limits of big or small a work of art can be. They push their three-dimensional letters, as well, to both extremes, making huge earth-works that can be read only from the sky or tiny letters on a grain of rice.

WRITING OUTSIDE THE BOX

Because letters have been written on flat surfaces for so long, most calligraphers use surfaces to bring them into the third dimension, by carving shallow marks, following natural contours, or cutting letters out of thick slabs as if using a cookie cutter. A few innovators, however, have begun to treat the sides and top of a solid letter as readable surfaces, too.

NATURE IMITATES CALLIGRAPHY

The Russian word for "bug" starts with Ж, the Cyrillic letter nicknamed "the bug," from page 166. Here it projects a rainbow of moths onto walls and ceiling.

Vast geoglyphs made some 2500 years ago in the Peruvian desert portray animals, geometric figures, and humans. Symbols like this enigmatic "candelabra" in Paracas cover many acres.

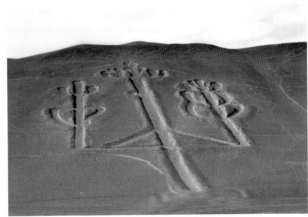

This Chinese character means "rice."

THE FOURTH DIMENSION

Time is a crucial dimension of a work of art. It takes time to see a statue, watch a dance, or hear a symphony. Even reading this book is a four-dimensional experience, since you can see only two of its pages at any time.

Sky writing impresses people by its extravagance~not just its huge size but its brief life.

The fourth dimension also measures the length of an object's life, in seconds, days, or centuries. Time isn't the same size for every kind of writing. While any "dance of the pen" may turn out by mere chance to be art for the moment or art for the ages, calligraphy is usually intended to last a short or long time. You can choose either extreme.

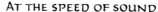

A B C D E F G H I J K L M N O P Q R S T U V W X Y Z oops (delete)

SMALL-TIME LETTERS

A short life span may be an artistic asset.

INVISIBLE INK

Pavement writers in China write calligraphy, and some-times political opinion, in water that disappears quickly.

MESSAGES IN A FLASH

Semaphores were devised to keep military messages secret by lasting a second and leaving no trace. The flags do not add meaning but simply make the arm positions easier to see.

AT THE SPEED OF SOUND

Shorthand systems that write words as fast as they are spoken have been around since antiquity. Pitman and Gregg alphabets, while time-consuming to learn, allow rates of 250 to 300 words per minute. Although touch typing and audio technology have reduced the need for short-hand, it is still used in various forms by journalists and doctors. The reporter's notes below read "The new owners of The Book Shop in Hayward, California, are planning a celebration of the store's 50th anniversary."

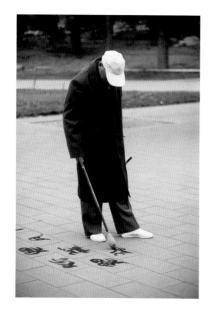

THE BIG TIME

A number of factors help calligraphy last a long time. Scribes may make astute choices of materials suited to the local climate, such as papyrus for dry desert air, or parchment for constant damp. Social stability also helps any man-made object survive. And random whims of fashion may attach, or reattach, value to a work of art to save it from destruction; the same illuminated medieval manuscripts that were given to Victorian children to cut up for scrapbooks, for instance, would come to be treasured as priceless collectors' objects only two generations later.

Nothing that lengthens the life of a calligraphic artifact, however, guarantees its immortality. Even at best, writing may outlive its readers, as with history's darlings, the long-lived and much-studied hieroglyphics of ancient Egypt.

A stylized Egyptian pen, jar, and palette form the hieroglyph for "scribe."

Hieroglyphics were originally written with a reed frayed into a brushy stub, which made slightly varying ink strokes.

Painted, pictorial hieroglyphics made texts into decorative friezes. Carved strokes all maintained the same width. And when used later in manuscripts with Greek and the demotic letters that grew out of hieroglyphics, a broad-edged pen made the strokes thick and thin.
(See how to cut a reed pen, page 27.)

Writing on papyrus adds a note of real~ism.

Drama~tize a name by enclos~ing it in a car~touche.

R.I.P.

Cuneiform characters emerged as a writing system in what is now Iran. Derived from pictures around 3400 BCE, they fluctuated from 500 to 1000 letters. They were used for everything from commercial invoices on small lumps of unfired clay to memorial inscriptions that covered the surface of monumental bas reliefs.

Make long wedges with the stick's sharpest edge.

3" long (8 cm)

Make small triangles with the stick's flat end. ▲ ▼

To create your own virtual Cuneiform, whittle a wooden chopstick or other stylus into three sides and a flat end. Press it down nearly horizontal; don't drag it. Change its position in your hand to point the wedges in different directions.

Use soft clay or its equivalent.

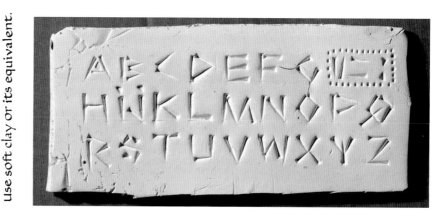

PRE-COLUMBIAN MAYA, AZTEC, AND INCA WRITING

Like hieroglyphics and cuneiform, these three now disused writing systems from the calligraphic past once served powerful empires in the Americas, before the arrival of Europeans and their languages opened the door to the Roman alphabet.

In Central America, Maya writing and related Aztec used similar symbol sets. Their richly detailed glyphs and complex calendars are slowly being deciphered.

MAYA SCRIBE AND CALENDAR

INCA MESSENGER AND QUIPU

In Peru, Inca rulers devised the quipu, strings of knotted cords for calculating and record-keeping. These were carried around the empire by special runners.

Knots in quipu strings converted data into base-ten numbers, which historians think recorded tax levies and spread proclamations. While a simplified knot code is still used in the Andes, no surviving quipu has been matched with any of the extant few transcriptions made by the Spanish conquerors. The quipu system itself was almost unique, although knotted cords were briefly tried in early China, and they still form part of the devout Jew's prayer shawl.

A selection of enigmatic symbols from the Phaistos Disk:

NOT JUST DEAD BUT SILENT

Some writing from the past has not been deciphered yet, most tantalizingly the Phaistos Disk from Crete. Scholars disagree strongly about what it means and whether its characters are pictures or letters.

1, 2, 3. Flame of past, present, future.
4. Sun and moon = Mongolians' origins.
5. Weapons above and below.
6. Fortress walls made by justice and honesty.
7. Fish with unsleeping eyes maintain a vigil.
8. Rectangles form a bulwark.

ENDANGERED SCRIPTS:
ON THE BRINK OF EXTINCTION

Undeciphered scripts, from languages no longer spoken, are like closed doors to the past. Such silenced scripts, however, help focus attention on those in danger. Unique scripts are being kept alive through political and scholarly support for dwindling groups who speak rare languages, keeping the door open long enough for them to document what the writing means. Like the benefits of biodiversity, every endangered script that is preserved contributes to a richer visual legacy for artists in the calligraphic world.

A FEW LETTERS SURVIVE
Above, an extinct writing system may be captured, like an insect in amber, by a few surviving symbols. The emblem of Mongolia was created in the 17th century, when scholar and monk Bogdo Zanabaza invented Soyombo, a logical set of symbols that didn't otherwise catch on.

ENDANGERED NAXI SCRIPT
Dongba script may be nearing extinction as the Naxi, a tiny ethnic minority, give up its use. Its characters represent clusters of meaning, and serve as memory aids in worship.

This character stands for the three legendary sages who created the art of Tibetan, Chinese, and Dongba calligraphy.

consonants, showing
suggested mouth shapes

Vowels

IF ONLY

ALPHABETS FROM THE POSSIBLE FUTURE

At the other extreme of time, some writing systems look forward to a Utopia where the inconsistencies and inefficiencies of today's alphabets will be eliminated. Reformers from Charlemagne and King Sejong (pages 146) to Alexander Graham Bell and King Njoya (pages 12~14) have dreamed of an idealized calligraphic future where writing—accessible to everyone—will fit itself to speech without a gap or a pinch.

VISIBLE SPEECH

Intent on teaching the deaf to speak words they could not hear, Alexander Graham Bell spent much of the money from his telephone patent to promote the alphabet of his father, Alexander Melville Bell. Its letters actually look like the position of the tongue and lips to suggest pronunciation.* George Bernard Shaw, a tireless crusader for logical eating, speaking, and spelling, was inspired by Bell to include Visible Speech in his play *Pygmalion*, from which *My Fair Lady* was made. A notebook and a chart in Visible Speech can be seen briefly but clearly in the film version.

* True also of the Hangul alphabet from Korea shown on pages 145~152.

BLISSYMBOLICS DEPICTS A WORLD OF COMMON MEANINGS

Some 900 pictographs and ideographs of the Blissymbolics system, much like Chinese characters, represent meaning rather than sound.

Designed near the end of World War II to serve as an international written language, these symbols have instead turned out to be useful in compensating for disabilities. People who suffer from cerebral palsy, stroke, and developmental delay, as well as children who cannot read yet, have an expressive outlet in writing or reading Blissymbolics. Even the subtle poetic imagery of E.E. Cummings has been "translated," and new vocabulary words are added often to accodate more ideas.

MIND IDEA KNOWLEDGE FACT
Systematic variation refines a word's meaning

A sentence in Blissymbolics declares:
"I love to write mail."

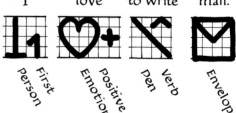

First person Positive Emotion Verb pen Envelope

UTOPIAN
First in a long line of fictional alphabets.

AN OLDER LOOK AT A BETTER WORLD

The word "Utopia" itself was coined by Thomas More for his 1516 book, as the name of an idealized paradise. Like so many Utopians to come, he provided it with its own writing system.

a b c

ONCE UPON A TIME

All utopian designs are, essentially, descriptions of how a future world could—or should—work, making them next of kin to science fiction. Whether they write a social critique, a bedtime story, or a futuristic thriller, authors and illustrators can add an extra dimension to their invented universe with a custom-designed alphabet.

In *On Beyond Zebra!,* Dr. Seuss invents letters to write his collection of silly sounds, like "floob."

In "How the Alphabet Was Made," from *Just So Stories,* Rudyard Kipling tells the tale of a little girl who improvises letters to send messages to her father. The illustrations show how things and their pictures could have inspired the sounds and shapes of letters.

OFF-WORLD ALPHABETS
Ingenious writing systems proliferated in the worlds of late 20th and 21st century science fiction novels, comic books, movies, games, and TV series.

The alien ABC's shown below have been sampled from dozens of science fiction alphabets, each based on a different principle. Devoted fans use them to write calligraphic designs in the fictional languages spoken in these fantasy worlds and have created digital typefonts from most of them.

GREETINGS FROM THE HUMAN RACE ON THE BLUE PLANET

This message disk, placed on board the 1977 space probe Voyager 1, was written in the truly universal language of mathematics, to make it intelligible to any civilization it reached.

ATLANTEAN
Designed to look proto-alphabetic, in the film *Atlantis: The Lost Empire.*

AUREBESH
For *Star Wars VI: The Return of the Jedi.*

KLINGON
For the language of an alien race in *Star Trek.*

KRYPTONIAN
For Superman's home planet; from DC Comics.

MARAIN
For the *Culture* series, about hyper-logical aliens.

a b c

MATORAN
For the constructed world of Lego's *Bionicle* series.

STANDARD
For *Commander Keen* computer games.

TENCTONESE
A cursive script for the *Alien Nation* series.

VISITOR
For the extra-terrestrials in the miniseries.

ZENTRADI
Mostly single-stroke letters for the *Robotech* series.

THE CALLIGRAPHY OF MIDDLE EARTH

J.R.R.Tolkien brought a natural talent for calligraphy, as well as a lifetime of academic scholarship in philology, to bear on the invented alphabets and languages for his saga *The Lord of the Rings*. He maintained that he wrote the story to accommodate the languages, not the other way around. Although he always disavowed real-world analogies, his Dwarvish runes and Elvish scripts seem to prefigure their Celtic counterparts, pages 57~62.

Elvish script surrounds the central image on the dust jacket of the trilogy.

The masthead design by Patrick Wynne for *Vinyar Tengwar*, Journal of the Elvish Linguistic Fellowship, evokes Tolkien's style from *The Hobbit*.

TÉNGCÇUÄR

Although rearranged here for transliterating the sounds of English, Tengwar is organized systematically by letter shape when it is used to write the languages of Middle Earth, as illustrated in the appendix to *The Lord of the Rings*, in the final volume.

Vowels are added above and below consonants.

Letter height ≈ 5 pen widths.

KHAZÂD

A special writing system of angular runes provides different characters, for the harsh consonants of Dwarvish words.

Dwarvish runes fill a border on the title page of *The Lord of the Rings*.

FROM THE RED BOOK
*Basic strokes from
Middle Earth's calli-
graphy readily lend
themselves to the real
world's Roman letters.*

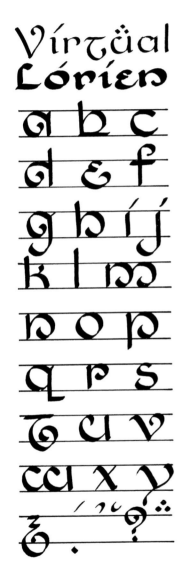

Virtüal
Lórien

Choose guidelines that fit
the letter size you need:

Whenever I draw a circle,
I immediately want to
step out of it.

BUCKMINSTER FULLER

JOURNEY'S END

*"...AND THE END OF ALL OUR EXPLORING..."
Whether you travel the earth or journey in
your imagination, the scripts you bring home
as souvenirs will enrich everything you write.
The art of calligraphy lets everyone create—
and share— a world of beautiful writing.*

NUMERALS

What we call Arabic numerals actually came from India to Europe around 1200 CE, via trade with the Islamic world.

Authentic numerals shown here in gray have their counterparts in the virtual numerals that follow them. Use the pen size and pen angle specified on each alphabet page, and write on the corresponding guidelines.

1234567890
Universal Product Code

Alphabet page	Script	Guidelines page	1	2	3	4	5	6	7	8	9	0 or 10
14	Bamum	15										
22	*Virtual Bamum*											
38	*Arabic*	39										
49	*Virtual Arabic*											
50	*Ronde*											
51	*Legende*											
58	Runes	115										
	Letters stand for numerals.											
60	*Virtual Runes*											
	use also for Virtual Greek.											
72–73	Chinese	70–71										
82	*Virtual Chinese*											
83	*Brushy Italic*											
92	Ethiopic	15										
94	*Virtual Ethiopic*											
100	Greek	101										
114	Hebrew	115										
	Letters stand for numerals.											
121–122	*Virtual Hebrew*											
122	Devanagari	129										
138	*Virtual Devanagari*											
140	Tibetan	129										
140	*Virtual Tibetan*											
142	Thai	129										
142–143	*Virtual Thai*											
148	Korean	147										
154	*Virtual Korean*											

Mongolian

Virtual Mongolian		
	1	
	2	
	3	
	4	
	5	
	6	
	7	
	8	
	9	
	0	

Virtual Mongolian

Alphabet pages 158–159

Guidelines page 159

INDEX
classified by topic

WRITING SYSTEMS

GUIDELINES

These are also available to print out at margaretshepherd.com.

MATERIALS

Arabic letters evoke a seated musician in this poster design by Mehdi Saeedi.

DESIGN TERMS

General calligraphy terms are defined in Visual Vocabulary, page 6.

CREDITS

Vietnamese New Year's wishes say "Study hard!"